WATERCOLOR
You Can Do It!

Cincinnati, Ohio

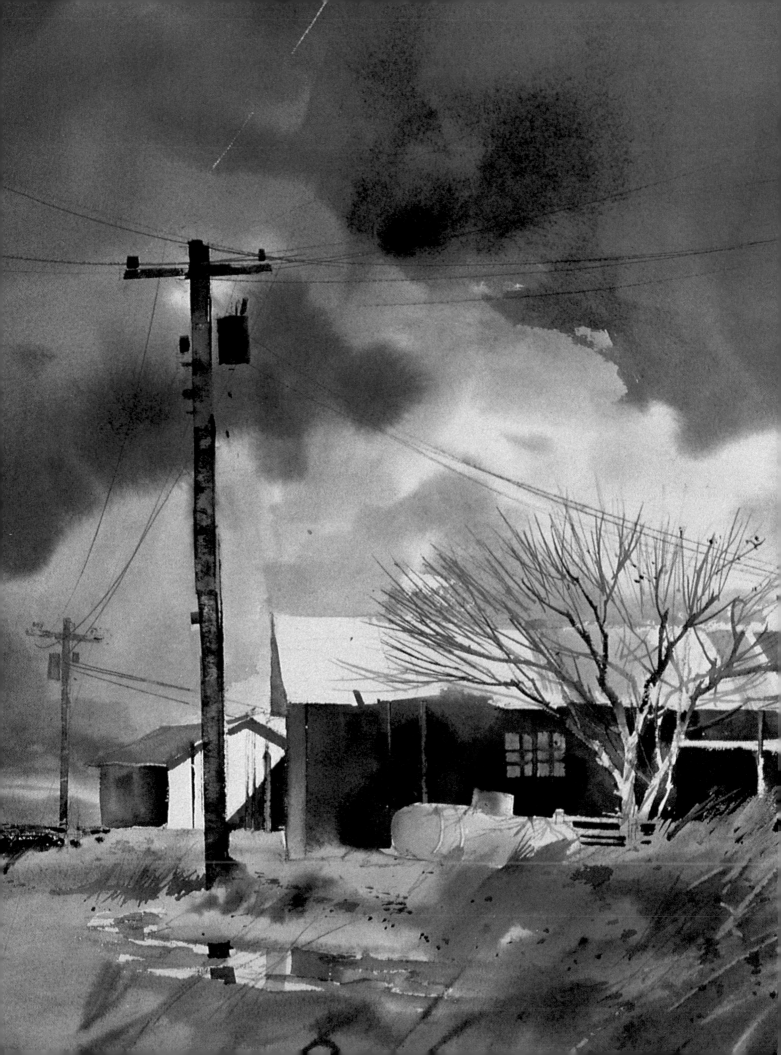

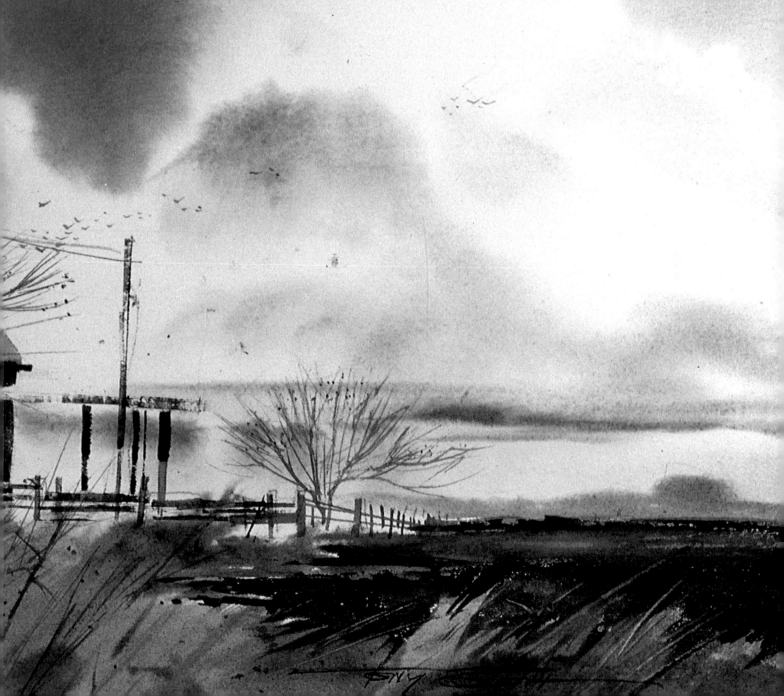

TONY COUCH

WATERCOLOR

You Can Do It!

Published by North Light Books, an imprint
of F&W Publications, Inc., 1507 Dana
Avenue, Cincinnati, Ohio 45207.

Manufactured in Hong Kong
First Printing January 1987
Second Printing April 1987

**Library of Congress Cataloging-in-
Publication Data**

Couch, Tony.
 Watercolor, you can do it!

 Bibliography: p.
 Includes index.
 1. Watercolor painting—Technique. 2. Art-
ists' materials. I. Title.
ND2430.C68 1986 751.42'2 86-23597
ISBN 0-89134-188-9

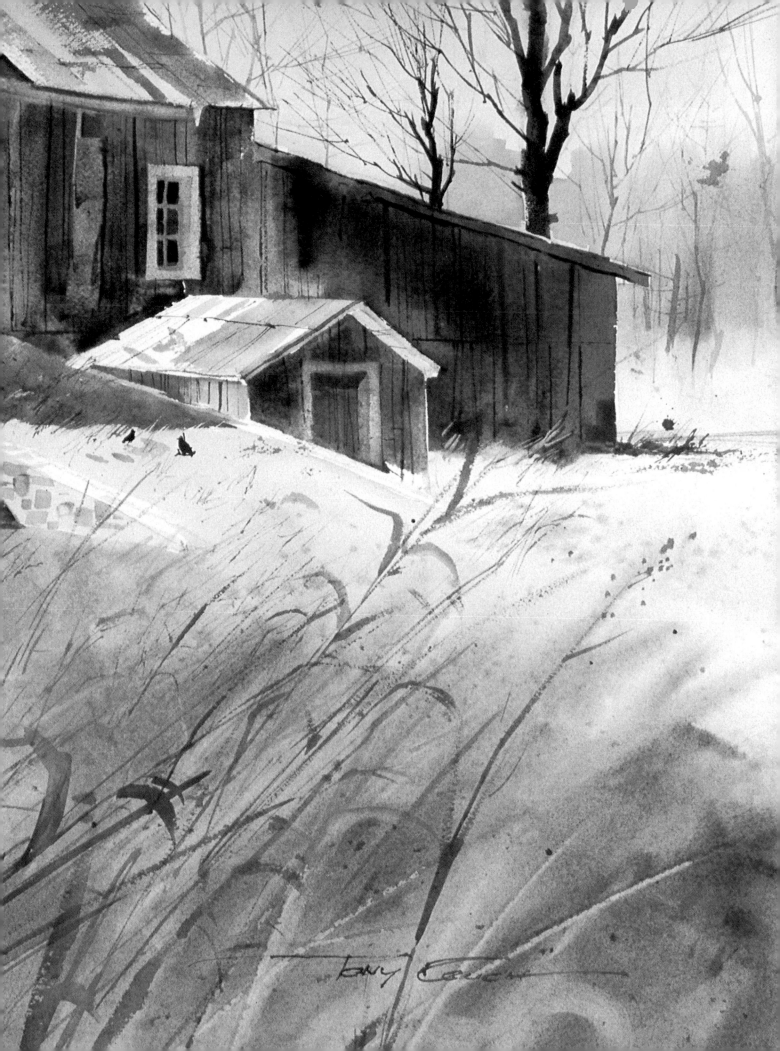

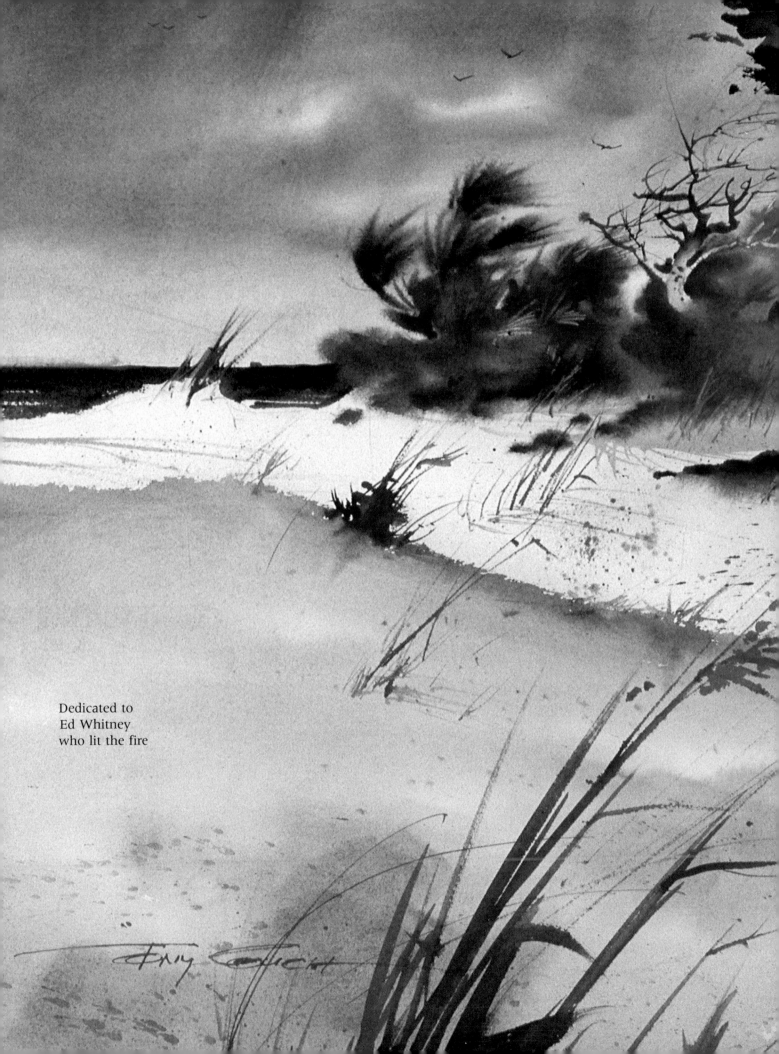

Dedicated to
Ed Whitney
who lit the fire

Putting together a book takes a lot more time and effort than I had at first dreamed, and I am grateful for the considerable help and encouragement I received en route.

Particularly from the rest of the team: my wife, Bonnie, who watched the store and put out the fires while I wrote and painted, and Steve, Colleen, Anne, Belinda, and Tony Jr. who aided in various ways.

And Ril Donato of the Donato Photo Works for sterling darkroom production; the outstanding painters in chapter 15 and The Cleveland Museum of Art for giving permission to use their work; Gail Novak and the Belgian vice consul Paul Quaghebeur who posed for photos; North Light editor Fritz Henning who will wait four years for a book; editors David Lewis and Greg Albert for their enthusiasm and valuable help, and all those prodding students who asked, "When is your book coming out?"

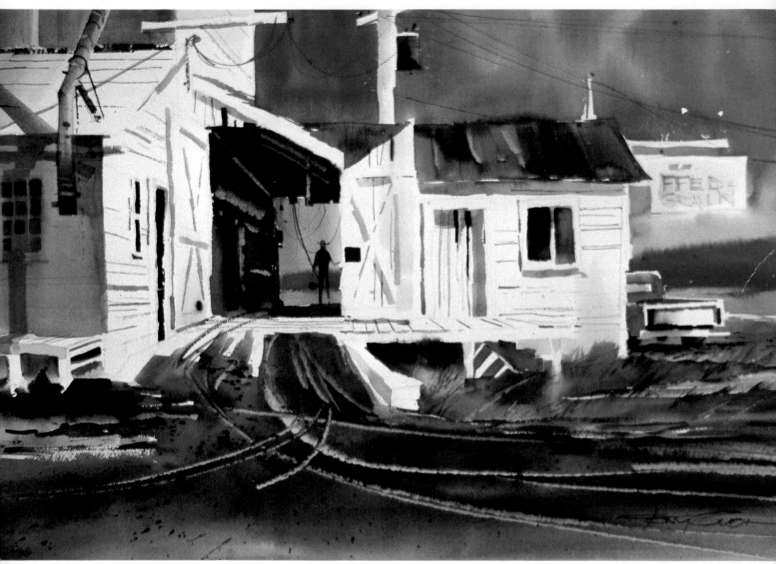

Grain,
15" × 22"

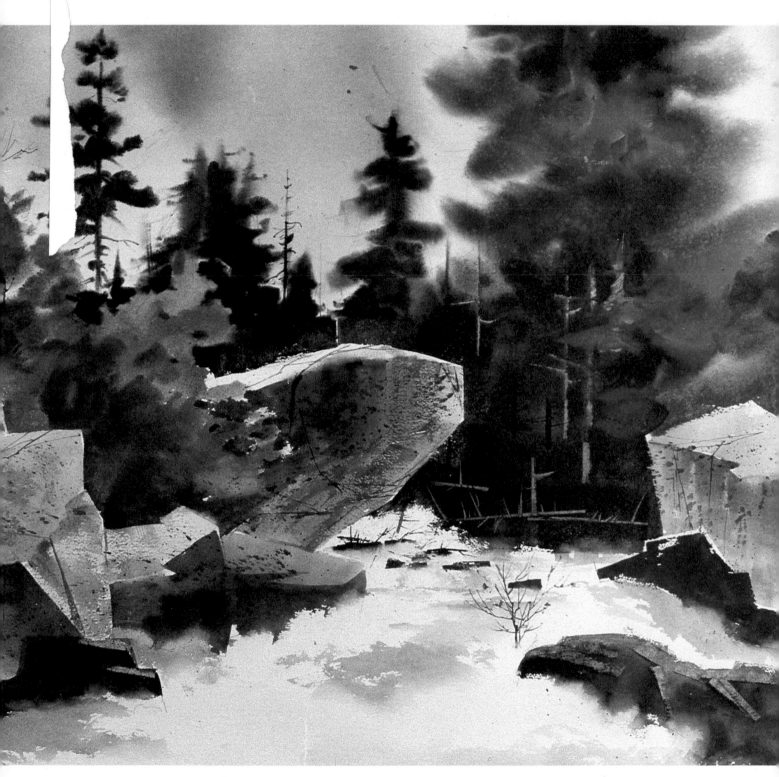

Avalanche,
22" × 30"

Drydock,
15" × 22"

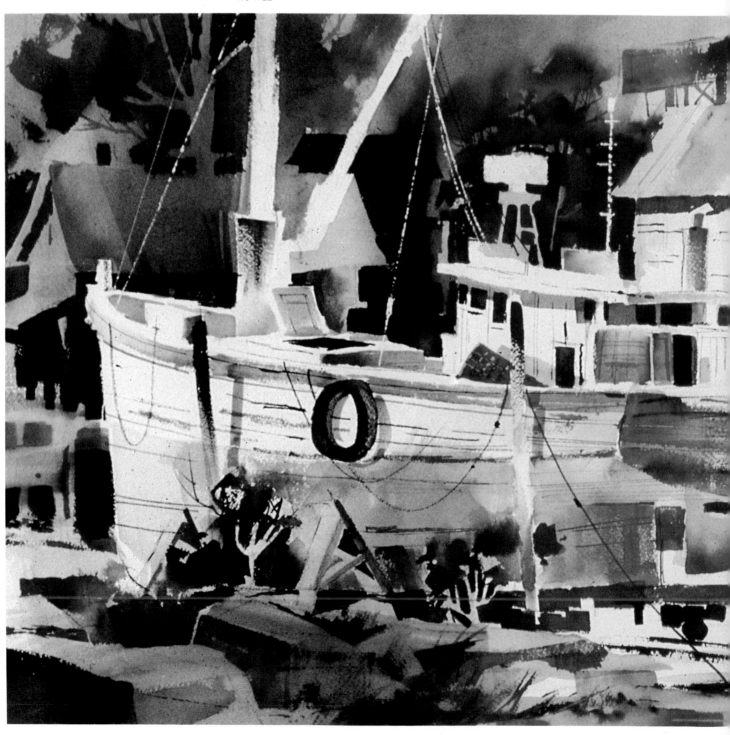

Equipment
What I Use and Why

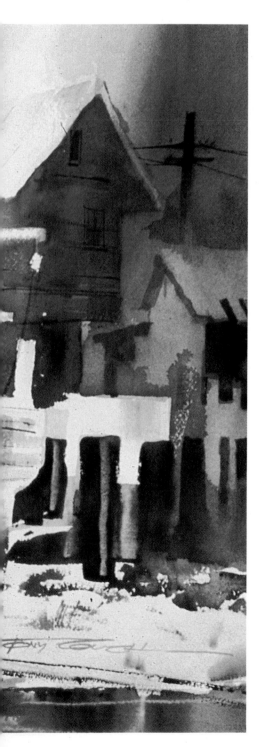

In general, watercolor artists use the same equipment and supplies, with differences dictated by personal taste.

Here's a list of what I use—you may want to add to or subtract from it. While good equipment is a help, there is no magic in tools; award-winning paintings have been painted with the most simple of them.

PALETTE

You can paint with only a plain white plate or a butcher tray for a palette. Put a puddle of each color near the edges, and use the middle for mixing. There's an economic advantage, however, in using a palette with a cover: it will keep the pigment moist and soft so you can paint another day without first scraping off and throwing away the old paint. It's impossible to get the dark, rich values and bright chroma you need when working with dried, hard pigment.

Paint will normally stay moist in a closed palette for four days or so. Keeping a moist sponge in the palette will keep the paint moist a little longer, but mold may form on the paint.

Painting every day is the best solution. Few can, so the next best course is to keep a spray bottle (hardware store variety) of water near the palette. If you haven't been painting, open the palette every fourth day or so and spray the paint. It only takes seconds, and your paint will remain soft indefinitely; you'll never again have to waste it.

Keep the spray bottle with you when you paint. The pigment has a way of drying as you paint—particularly outdoors.

Beyond this, you'll need a palette with deep wells—about one-inch square or larger—so plenty of pigment can be kept in each. There is no way you can paint broadly and boldly, as you should, without a large brush, and a large brush is useless unless it has a large well from which to pick up paint! Keep the well at least half full. I use a Robert E. Wood palette.

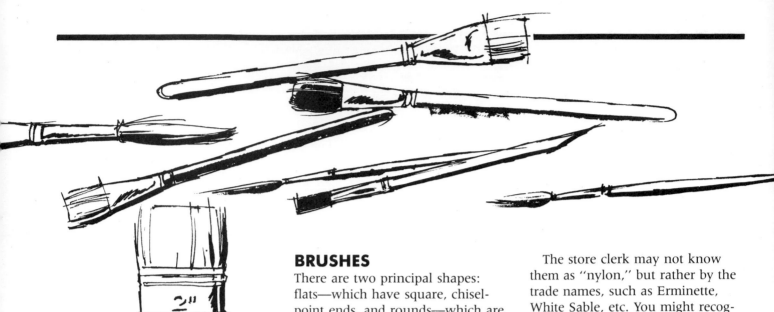

BRUSHES

There are two principal shapes: flats—which have square, chisel-point ends, and rounds—which are round and end in a point. They come in all sizes, but I use only a two-inch, a one-inch, and a one-quarter-inch in the flats and a #8 round and a "rigger." The rigger is a small, round brush with longer hair. Since many art store clerks don't know the term "rigger," you'll have to be more specific. Grumbacher makes one called "series 4702." A #3 or #4 is good.

The flats are used for angular shapes and particularly for sharp, crisp corners. The rounds make curved shapes easier to paint. I use a rigger for the thin lines (calligraphy).

In general, I paint with as large a brush as possible for the shape being painted to force myself to paint broadly and boldly. Still, there are smaller shapes that require smaller brushes. Buying a brush size to fit every possible size shape would delight the brush manufacturers, but it is neither practical nor necessary. I find the few I mention here enough.

I start with and probably paint 90 percent of most paintings with the large two-inch and one-inch flats. The smaller shapes and details are painted last with the smaller brushes.

Brushes are made of various types of hair, the optimum being red sable, which has become expensive. White nylon brushes are now available, however, and work every bit as well, but are priced lower.

The store clerk may not know them as "nylon," but rather by the trade names, such as Erminette, White Sable, etc. You might recognize their snow-white appearance.

PAINT

Tube paint is the best, as its toothpaste consistency readily allows varying amounts of paint to be scooped onto the brush. Of several brands on the market, I know Winsor & Newton is good, as are Grumbacher and Liquitex. I'm not familiar enough with the rest to comment, which is not to say they should not be used. What you need is transparent watercolor. Gouache, tempera, and casein are also watercolor, but they're opaque, and in this book, we're concerned with transparent painting. In general, the brand isn't important as long as the paint is permanent—that is, it should not fade on the painting in a few years.

The colors I use are all permanent in the major brands. They are

lemon yellow or Hansa yellow

New gamboge or cadmium yellow

raw sienna or yellow ochre

burnt sienna

cadmium orange

cadmium red

alizarin crimson

Thalo purple

viridian or Thalo or Prussian green

Winsor or Thalo or Prussian blue

ultramarine blue

ivory black

How the pigment is arranged on the palette is unimportant as long as each can be located readily while you're painting.

Since you'll be thinking "cool or warm" and "light or dark" as you paint, it makes sense to arrange the palette that way. Put the cools on one end and the warms on the other, and within these groups, arrange them from light to dark.

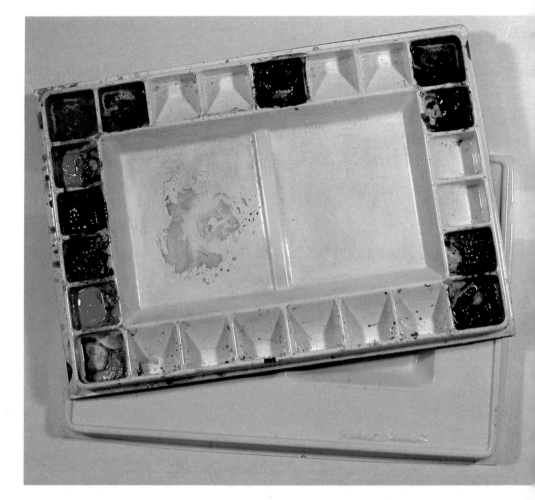

A palette with deep wells and a cover to keep the paint moist is ideal. How the pigments are arranged is unimportant as long as each can be located readily while you are painting.

PAPER

Watercolor paper is available in four weights (thicknesses) and three textures. The weights are 400, 300, 140, and 75 pound, or close variations thereof. The thickness of the paper increases with the weight. The textures are hot-pressed (smooth), cold-pressed (medium/rough), and rough. Texture does not influence the price, but weight does; the price increases with the weight. Watercolor paper comes in 22-by-30-inch sheets, loose or in a quire of 25. It is also available in a larger 25-by-40-inch "elephant" sheet, and in a roll of 43 inches by 10 yards.

You will find paper in "blocks" in sizes smaller than 22 by 30 inches. These are pads of the same paper, usually 140 pounds glued at the edges on all four sides. They can be separated with a knife.

There are several brands of paper on the market, and each produces slightly different painting results. Since this could be confusing to a novice painter, I recommend picking a brand and staying with it until you've reached a degree of proficiency. If you paint very long, you'll learn to use the best you can buy—for better results and because the difference in the price of papers is not great.

Since a given texture is the same in all weights, there is little advantage in using one weight over another, except for price. Some painters, however, prefer the thick 300- and 400-pound sheet because it

Although there is nothing wrong with "stretching," it is time-consuming and entirely unnecessary, because you can either clamp the paper as you paint and accomplish the same thing or ignore it altogether. If you ignore the slight wrinkling that may occur as you paint, you'll find it makes no difference, and the 140-pound sheet will revert to a perfectly flat condition as it dries.

In any case, a completed painting can be placed in your framer's dry mount iron (don't let him dry mount it!) for two minutes, and it'll be as flat as it was when it came out of the quire.

I use 140-pound cold-pressed 22-by-30 full sheets or cut them in half for a 15-by-22 half sheet. I either wet both sides and clip the sheet to a board so it will stretch as I paint or clamp it to the board and ignore the stretch. It dries flat either way.

EASEL

You don't have to have an easel—I painted for years without one—but easels are practical outdoors, even if expensive. You'll find them in art supply stores and advertised in art magazines. I use a French easel.

The simplest way to paint without an easel is to lay your board on the ground, with a small rock under the far end to tilt it toward you. Then sit on the ground and spread your gear around you. Better yet, bring a folding card table with you outdoors and paint standing up. You probably wouldn't want to use the easel indoors, as it's more convenient to paint standing at a table.

won't wrinkle as they paint. But this minor handicap is easily overcome in the 140-pound sheet by "stretching" it as some painters prefer or by simply ignoring the slight wrinkling as many others do, including myself! Wrinkling *is* a problem with 75-pound paper, and although it can sometimes be stretched successfully, it too often tears away from the tape, staples, clamps, or whatever is used to fix the paper to the board. For this reason, I avoid 75-pound paper.

Stretching is a process of soaking a new sheet of 140-pound paper in water and then fixing it on all sides to a board. The board can be made of anything, and the "fixing" medium can be tape, staples, clamps, tacks, or whatever you can think of. If you use tape, it should be brown paper tape, such as a butcher might use, and not masking or "freezer" tape. The glue on the masking tape is too weak, and the paper will pull away from it as it dries.

The theory is this: when paper is soaked, it will expand. After allowing about five minutes for expansion, the paper is fixed to a surface. The paper will try to contract to its original size as it dries, but, being fixed, cannot and will instead dry stretched to the expanded size. The advantage is that the paper cannot expand when wet again (as when painting on it), avoiding wrinkling.

BOARD

You'll need a board to support the paper while painting. Any size board will do if you tape, pin, or staple the paper to it, but if you clamp it, the board must be only slightly larger than the paper you use. This is so that the clamp, which fits over the edge of the board, can reach the paper. I use a 16-by-23-inch board for the half sheets and a 23-by-31 for the full sheets. Of course, if you're painting on a block, no support is necessary.

It is best if your board is waterproof so that it doesn't suck the water out of a wet paper from behind, causing the paper to dry sooner. You'll find, as you learn, that the watercolorist's eternal problem is keeping the paper wet enough long enough.

Plexiglas, Lucite, Formica, or any smooth plastic surface works well. One-quarter-inch plywood, sealed with waterproof spar varnish on both sides will do. You must coat both sides, or the board will dry warped. A fair substitute is Masonite, which is slightly porous. This surface can also be improved by sealing both sides with spar varnish.

I use Formica, Masonite, and plywood.

MISCELLANEOUS

You'll find an old towel or rag useful for spills and so on. You'll need a sponge and facial tissue to dry brushes and blot areas of the painting. Artificial sponges are available at hardware stores, but be sure you get one made of *cellulose.* Anything else artificial is not absorbent enough. A small, elephant-ear-shaped natural sponge is useful for lifting out light areas in a wet painting.

Two tin cans, such as coffee cans, are good for holding water. I use one for clean water and the other to wash brushes between color selections. Plastic canisters like those used for refrigerator food storage are also good.

Metal clamps from an office supply store are ideal for clamping the paper to the board—you'll need at least four. If you tape the paper, use brown "butcher" gummed paper tape.

Any tool that will scrape or otherwise make a mark on wet pigment on the paper is part of every watercolorist's personal gear; all painters have their favorites. I use a pocket knife, the end of the brush handle, or a razor blade. You'll find these and others useful as you learn.

An ordinary #2 "office" pencil is fine for sketching in your sketchbook and on the paper. Don't use #3 or "H" series art pencils as they are too hard and can damage watercolor paper. A wide "carpenter's" pencil makes filling in large dark areas in your sketchbook sketches faster and easier.

The best eraser is a soft one like the new plastic eraser or the old art gum. The plastic erasers leave less debris.

You'll need a sketchbook for recording ideas, notes, and sketches. Mine is an 8½-by-11 bound book of bond paper.

Although I've settled upon these materials after considerable time painting, this is not to say you must use exactly the same to succeed. In fact, the unfailing mark of fledgling painters is a preoccupation with equipment; they often buy too many brushes, too many hues of paint, and so on. I suspect this is because they secretly hope good paintings are merely a matter of proper (or enough) tools. Of course we know better; if this were true, anyone with an art supply catalogue and a steamer trunk would be hanging paintings in the Louvre.

What *does* make the work beautiful is what you do with the tools. And that requires *your* heart, *your* mind, *your* determination, and *your* time—none of which are available in anyone's art supply catalogue. This equipment resides within you right now and with time and practice will make *any* brush produce beautiful paintings upon *any* paper!

Read on. Let's find out what to do with these "supplies" you've been hiding within yourself all this time.

Controlling Paint
Make It Behave on Wet Paper

I have sometimes heard watercolor described as "the master's medium" (whatever that is). I have also heard others say "painting with watercolor is much more difficult than painting in oil."

What frightens these sages, no doubt, is the fact that, while oil paint will remain just where you daub it on canvas, watercolor takes off in all directions as if it had a mind of its own . . . and who can control that?!

You can control that—as can anyone—with just this little bit of information.

There are only four ways to apply paint to paper:
1. Dry on dry
2. Wet on dry
3. Dry on wet
4. Wet on wet

Dry on dry is a procedure in which a dry brush is used to spread pigment on dry paper. Safe as it is, this method is a trap. We have none of the advantages of transparent watercolor; we may as well be painting in oil. As with oil painting, the paint goes onto the surface and dies there—it moves not a hair. (There will be times we'll find this

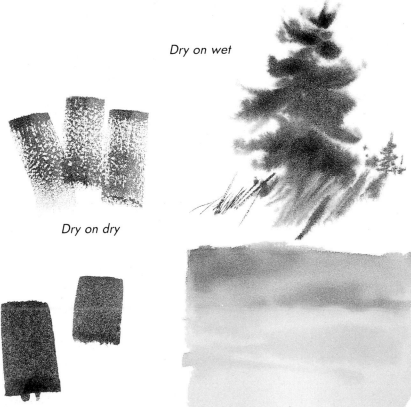

Dry on wet

Dry on dry

Wet on dry

Wet on wet

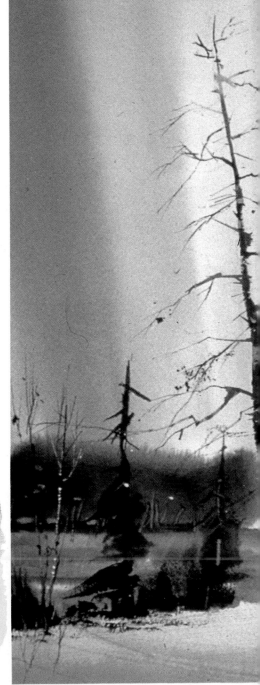

Powder,
15"x22"

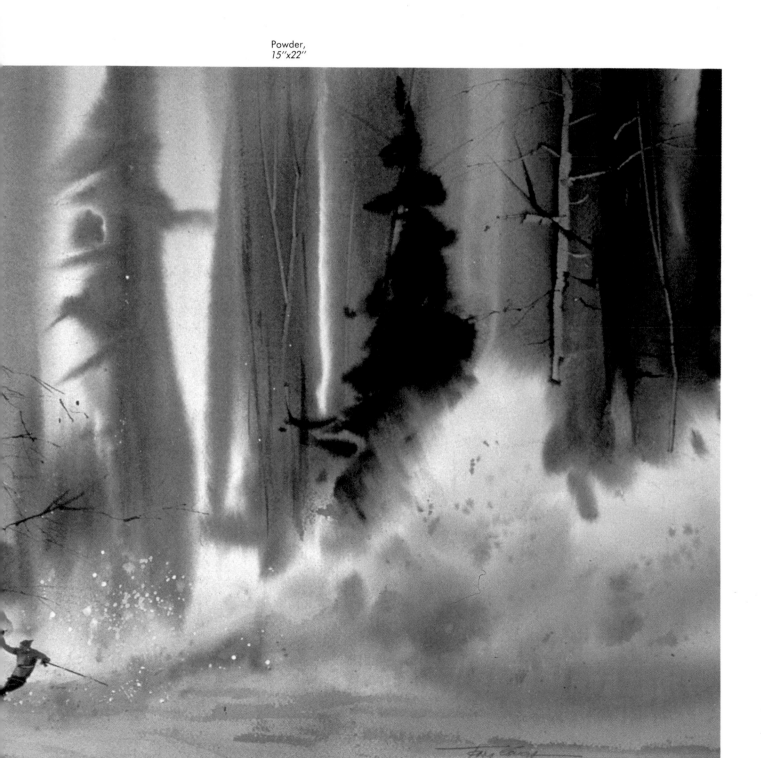

useful. It is also called "rough brush" or "dry brush.")

Wet on dry is similar. The paper is dry, as before, but now we have paint in a wet brush. Like dry on dry, once the paint is on the paper it moves not at all, but we can vary the value (lightness or darkness) of the mark by varying the ratio of water to pigment in the brush. It will produce a sharp, knife-edged shape. We'll use this procedure often.

Dry on wet is painting upon wet paper with a brush loaded with pigment and very little water. It produces the glorious diffusions of color and value that are characteristic of watercolor, yet it allows precise control of a shape. We'll use this most often.

Wet on wet is the same as dry on wet, except here the brush—as well as the paper—is very wet. It's used when soft diffusions are required, but when retaining a particular shape is not, such as when painting a soft sky or a high-key (light) underpainting.

Most novice painters have no trouble at all controlling shapes when painting dry on dry or wet on dry; the paint goes right where they direct it and stays there. But few of the advantages of transparent watercolor are available with these two techniques. On the other hand, all of the control problems occur when painting on wet paper, back runs and lost shapes paramount among them. Yet dry on wet and wet on wet produces all the glorious, soft diffusions that make watercolor beautiful!

So our task is clear: we must learn to *control* the pigment on wet paper!

To this end, it is helpful to review the characteristics of the sponge:

1. A *bone-dry* sponge will pick up no water.

2. A *saturated* sponge can pick up no water (it's already full).

3. A *damp* sponge does pick up water.

Also, all the sponge has to do is touch the water, and the water will travel up into it!

That much you knew—now here's a bit of news: damp paper and damp brushes act exactly like sponges! Why shouldn't they? Paper has the same texture as sponge—as far as water is concerned—and this is also true for a brush. Any time the brush touches the paper, water is going to move either from the brush to the paper or from the paper to the brush—it'll move into the drier of the two. However, pigment on the brush will be deposited onto the paper no matter which way the water flows.

One other thing: the term "dry," when applied to a brush, is misleading. The brush is never bone-dry, since we always wet it before picking up paint from the palette. When we then take all the water out of it that we can, the brush is called "dry," but it is really damp. Not so with paper, however. "Dry" paper means the paper is bone-dry.

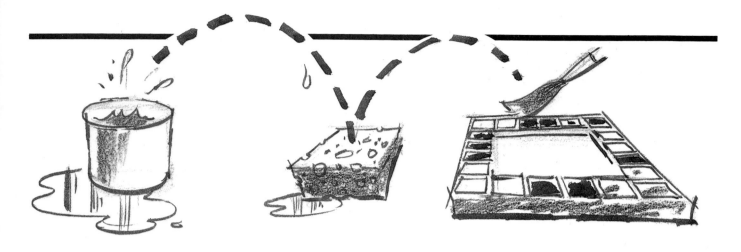

DRY ON WET

Armed with this knowledge, let's wet a sheet of paper and see what happens when we paint "dry on wet." Wet the paper thoroughly with a sponge or brush or even soak it in a bathtub. If you wet both sides of the paper, it'll stay wet longer.

We want to paint with a "dry" (damp) brush, so jab the brush into the water can. What we have now is a dripping wet brush. No one can control anyting with that much water. So keep a sponge—natural or cellulose—or a rolled wad of facial tissue next to the water cans and always lay the brush onto this before dipping into the palette. Leave it there long enough to see some of the glisten leave the brush as the water is transferred into the sponge. Now we have a controllable wet brush. We need only this much water in the brush to get paint out of the palette.

Scoop the paint out onto *one* side of the brush, only. Now roll the brush over and lay the clean side onto the sponge again to remove the rest of the water, but none of the pigment. The pigment stays on the brush because that side of the brush doesn't touch the sponge. It may take a few seconds for enough additional water to transfer from the brush to the sponge. Now we have a "dry" (damp) brush, loaded with pigment.

Paint a stroke onto the wet paper. In this case, the brush is drier than the paper (it has to be: we took most of the water out of the brush, making it a damp sponge, and the

The brush goes from water to sponge, from sponge to palette, from palette back to sponge, resulting in a "dry" (damp) brush loaded with pigment.

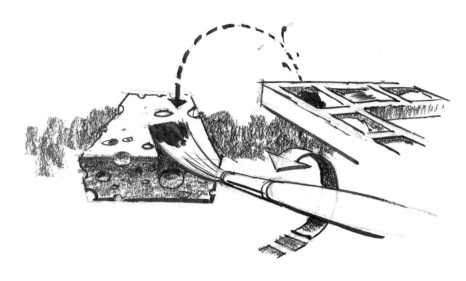

Water goes into the brush while pigment goes onto the paper.

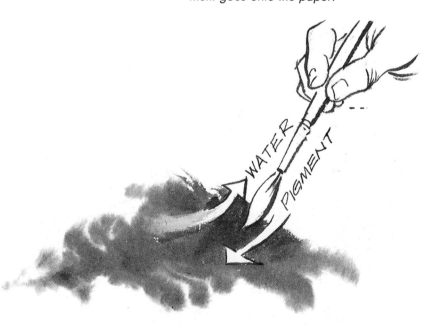

paper is wet, not damp). So water goes into the brush while pigment goes onto the paper. Because the paper is wet, the deposited pigment will "swim" in the water before it settles into the fibers of the paper, forming a shape with diffused (soft) edges. The paint, being relatively dry, won't diffuse so much that it changes the shape we intended.

Remember, the only way diffusion is possible is with wet paper. And anytime the paper is wet, you'll get diffusion.

WET ON WET

Next let's wet the paper thoroughly again and carry more water in the brush. When the brush touches the paper, roughly the same amount of water will be in the brush as is in the paper. Since now neither brush nor paper is a very efficient sponge, there is no transfer of water between the two—only pigment—and

you're painting wet on wet! The pigment, flooding into all this water, expands uncontrolled in all directions.

Here is where the watercolorist is in his glory. There is no chance of retaining a predetermined shape, but maximum chance of creating beautiful diffusions and accidents that you could never equal if you planned them—particularly when you put one color on one side of the brush and another color on the other side and twist the brush on the wet surface—mixing the color on the paper—as you paint. It's the

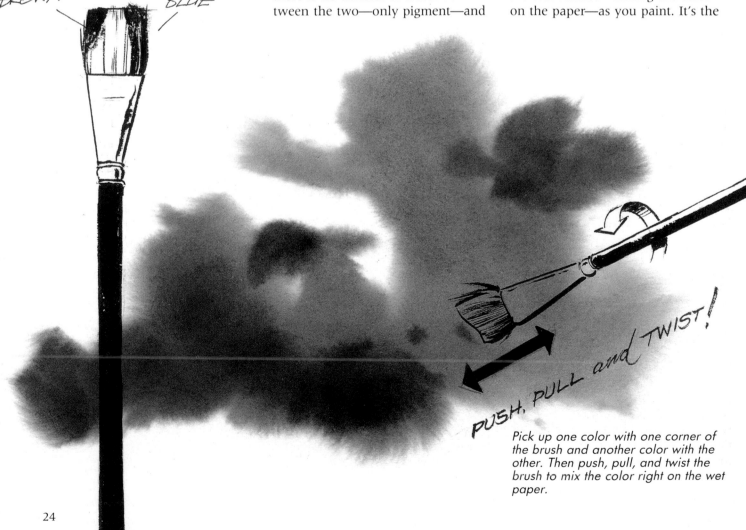

BROWN BLUE

PUSH, PULL and TWIST!

Pick up one color with one corner of the brush and another color with the other. Then push, pull, and twist the brush to mix the color right on the wet paper.

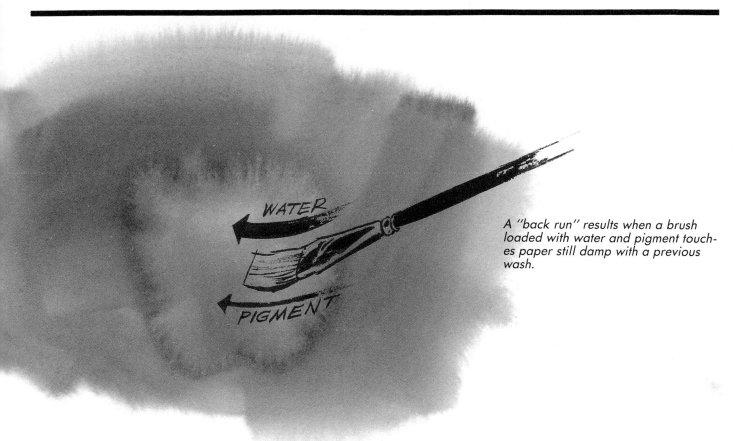

A "back run" results when a brush loaded with water and pigment touches paper still damp with a previous wash.

medium obeying its own laws.

This technique is tailor-made for painting skies, the interior of medium-to-large shapes, underpainting . . . and more uses you'll find yourself. Use it in every painting; it's taking the maximum advantage of the medium, and it's what keeps oil painters awake at night wondering how you do it!

THE "BACK RUN"

Let's repeat the operation, but this time the paper is only half wet—or damp—with a previous wash. An ideal sponge, wouldn't you say? Comes now the water-laden brush with pigment. Pigment is deposited on the paper. With it comes a flood of water from the brush . . . sucked out just as surely as if you had laid it on the other sponge—the forgotten one next to the water can. The paint mixes with the water and runs out onto the damp paper. If we're lucky, the best we'll get is a flat shape with hard edges. That's if the amount of water in the brush wasn't so great that the pigment

couldn't contain it.

If the brush had more water than that, it would mix with the pigment, run onto the paper, and start spreading in all directions. Since the paper is still damp, all the pigment from the previous wash has not yet settled into the fibers of the paper and is picked up by the flood of water and runs with it, "backing up" at the leading edge. Eventually (sometimes after four or five minutes) the water is thin enough to stop. Where it stops, the backed up pigment also stops, forming a hard, dark line. This "back run" is usually a circular shape, resembling a flower, hence its alias "flower" or "blossom." If it happens in a place where you need flowers, fine. But you'll find it almost always occurs in an otherwise beautiful passage— such as a sky!

The same thing happens (for the same reasons) if you sprinkle drops of clean water onto a new, half-dry wash. Keep your water cans and sponge on the same side of your painting as the palette so you don't cross your painting with a wet brush en route from the water can

to the sponge or palette.

By the way, this back run can't occur while you're painting the first wash on clean, white paper. There's no previous wash of loose pigment for the running water to pick up and back into a hard line.

So you get a back run. Can you correct it? Sure, provided you catch it as it is forming. But first evaluate it—see if it isn't something you'd like to keep. Still don't like it? OK, you know the problem, so the cure is simple: there is too much water

on this spot, pushing loose pigment back. Or, looking at it another way, there's not enough paint there to absorb the water that's pushing the loose paint. So could you use a lighter or darker spot there? If it could be lighter, quickly wipe away the excess water with an elephant-ear-shaped natural sponge and form a lighter, soft-edged shape there. For instance, a light cloud if it is in a sky. It's risky trying this with facial tissue; often a light, *hard*-edged shape results.

If it can be darker, paint a darker shape over it with a good bit of pigment and very little water in the brush. The water in the back-run paper should net us a soft-edged shape.

Sometimes a long, linear back run will form along one or more edges of the paper. This is because water has been brushed onto the supporting board at the edge of your paper. As your paper dries to the damp ''sponge'' stage, it is butted against the water standing on

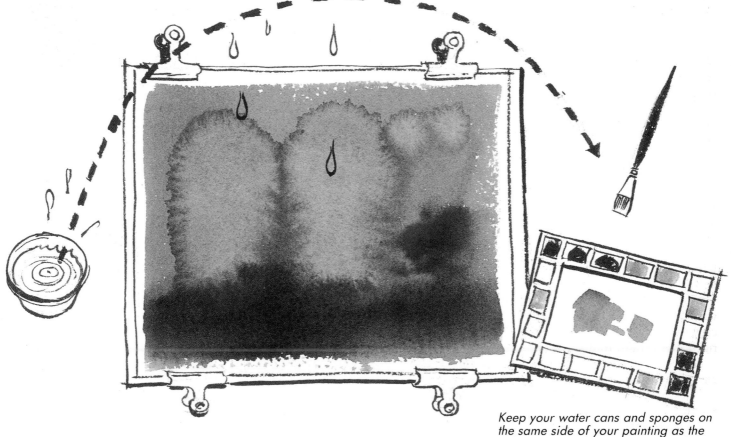

Keep your water cans and sponges on the same side of your painting as the palette so you don't cross your painting with a wet brush en route from the water can to the sponge or palette.

the waterproof board, which is then sucked into the paper. If you catch it as it forms, just wipe over it with a sponge or clean, damp brush—and dry the board so it doesn't happen again. If you missed it, there's no cause for panic. Mat over it when you frame the painting.

Now we know when the back runs occur: only when we paint on paper that is damp with a previous wash and with a brush that has more water than the paper.

In general, if the paper is soaking wet, you can do anything to it with impunity. The same is true if the paper is dry. It's when it's at the *half dry, half wet* stage that the mischief occurs. If you're not sure how wet the paper is, either let it dry completely and wet it again with clear water, or go into it with a brush that's as dry as you can get it. You can't get hurt either way.

Above all, *don't shy away from wet paper.* Learn to control it as I've outlined. Think "dry on wet" as you paint, unless shapes are not important, in which case think "wet on wet." The advantage of watercolor lies in the soft diffusions, obtained only by painting on wet paper!

Of course you will be clumsy in your first attempts and might be inclined to think "the oil painters are right: this is hard to do!"

Let me describe "hard to do": It's *anything* you haven't done much of.

Now here's "easy to do": It's *everything* you've done a lot of!

It's really that simple; of course *you* can do it.

Sometimes a long, linear back run will form along one or more edges of the paper. This is because water has been brushed onto the supporting board at the edge of your paper.

Detail of Blue Mountain, White
Flowers *15"x22"*

The Artist's Role
Shape Maker, Symbol Collector, Entertainer

Edgar A. Whitney, ANA—often called the "Dean of Aquarellists"—exhorts his students, "We are shape makers, symbol collectors, and entertainers!" That's an accurate description of what the watercolorist is about as he paints.

SHAPE MAKER

Upon reflection, you can see that a painting is a collection of shapes. This is true whether it be realistic, abstract, or nonobjective art. Since a painter, then, is in the shape making business it would be a good idea to examine shapes.

There are "good" ones and "bad" ones; let's look at the bad first. There are only three, and they should be avoided like the plague: anything that is—or will fit into—a square, a circle, or a triangle with any two sides of equal length.

The reason these are to be

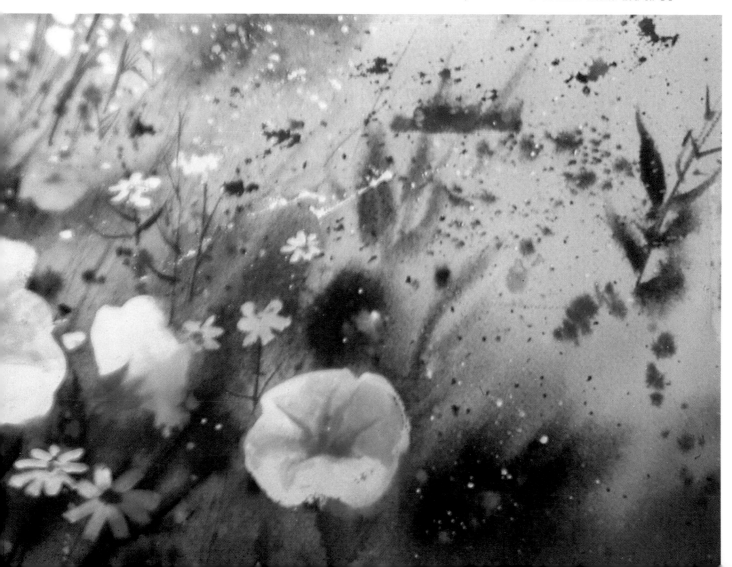

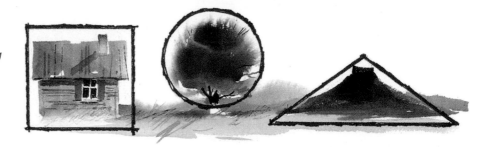

Not many artists consciously paint round, square, or equilateral triangular shapes; rather they fail by painting objects that will fit into these dimensions, as shown.

avoided is that they have no variety of dimension and hence are boring. For example, the square has four sides of identical length and four identical angles. The offending triangle has at least two sides of identical length with two identical angles, and the poor circle has the same diameter no matter where it is measured and the same degree of curve all over!

When you review the principles of design in chapter 5, you'll see this is a violation of the principle of repetition with variation. In these three shapes, we have repetition, but without variation. A better shape—that is, more entertaining— is one with variety to its dimensions.

This is not to say these shapes should not appear in a painting. There are times when the subject depicted may be square, for instance, such as a sign. You're better off, however, keeping these shapes a minor part of the painting or changing the shape by changing the angle from which it is viewed.

Please note that the triangle shapes of which I write are only those with two or more sides of *equal* length. This does *not* include all the other possible triangles with three sides of *unequal* dimension.

Now let's look at the good shapes. A good shape is one that is entertaining or interesting to see, and the more fascinating we can make it the better off we are. It is best described as a bulky, "hunk" of a shape—as opposed to a long string, or "worm" shape. And it is one that

1. has two different dimensions,

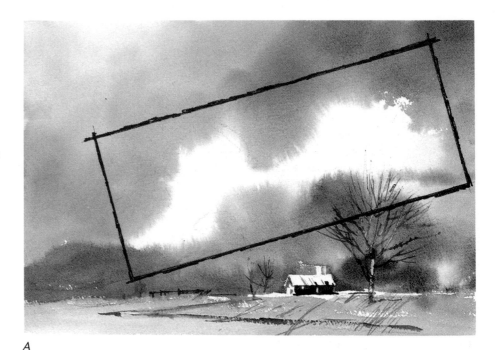

A

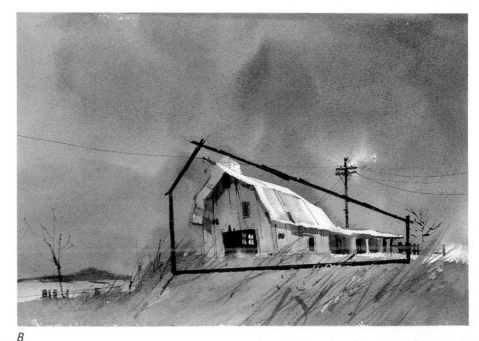

B

The shape outlined in A is oblique. The shape outlined in B has an oblique thrust.

2. is an oblique or has an oblique thrust, and

3. has incidents and/or interlocks at the edges.

Two different dimensions means that the shape's height is greater than its width or vice versa.

Being oblique or having an oblique thrust means the shape is either at an angle or appears to be at an angle. This angular appearance can be effected by making one end larger, smaller, higher, or lower than the other. The wisdom of making the shape oblique lies in the fact that horizontal or vertical lines or shapes are static, while those oblique are dynamic, thus more interesting.

Incidents at the edges are things protruding *from* the shape, or space protruding *into* it, or both. Care should be taken to vary the height, depth, and width of these protrusions, and the spaces between them—as in C, top right—and to avoid the monotonous "sawtooth" edge shown in D.

Interlock is a particular type of incident at the edge. This protrusion comes out of the shape at an angle and forms a hook that causes the shape to interlock with the space behind it.

These incidents and interlocks are the opposite of a smooth, uneventful edge of the shape, and should occur around the entire perimeter. To a lesser degree, attaching things to the interior of the shape so they appear to come forward is important; it adds a third dimension to the shape.

It is impossible to exaggerate the importance of good shapes as

C

D

Interlock is a type of incident at the edge. An interlock comes out of the shape at an angle and forms a hook that causes the shape to interlock with the space behind it.

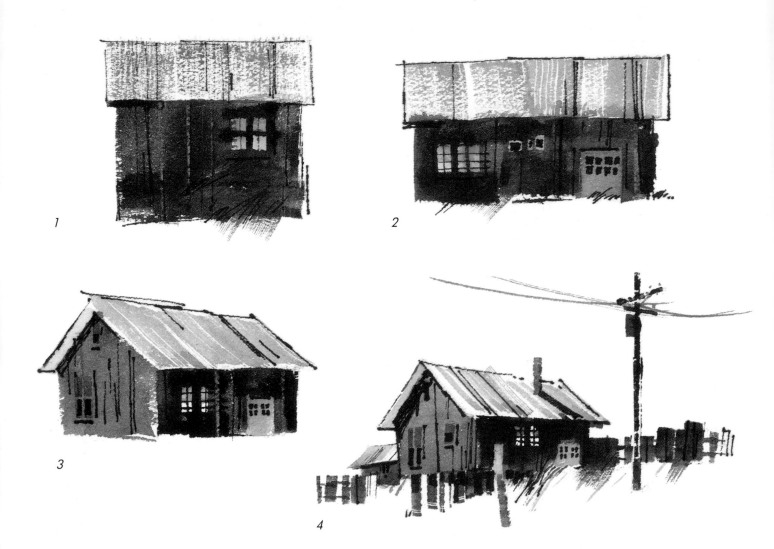

1

2

3

4

Here are four house shapes. Why is #4 more interesting than the rest? Because it has two different dimensions, an oblique thrust, and incidents along its edges. #1 is least interesting because it has none of these attributes. #2 is a little better since it has at least two different dimensions. #3 is better still as it has that, plus an oblique thrust. Look at the vast difference between 1, 2, and 3 as a group and 4. That's how important the use of "incidents at the edges" is.

described here, particularly the incidents and interlocks at the edges. It's the difference between interesting shapes and those that are boring that distinguishes the work of competent painters, and award winners, from the "also rans."

Not all subject matter comes complete with interesting shapes. So your job is to take liberties with it: add, subtract, or do whatever is necessary to make it a better shape, but still recognizable as whatever it is. This is an advantage the artist has over the photographer, who is stuck with whatever is in the lens.

I have, however, seen the work of photographers who are fine designers and know well what constitutes an interesting shape. They will move their position up, down, front, or rear and shoot rolls of film

looking for the angles that produce the best shapes.

Notice that these items that produce an interesting shape have to do with the *edge,* or *silhouette.* This is because we identify shapes first by their silhouettes.

For example, military pilots identify the enemy in a flash by the *silhouette* of their aircraft. Pilots practice on the ground for hours with the silhouettes flashed on a screen for split seconds. When you're exceeding the speed limit at night, you need only see the *silhouette* of a "gum drop" on the roof of a car to change your mind.

Since we see and identify shapes first by the silhouette, it follows that what we put at the edge of a shape is vital. What goes into the interior, although important, is secondary.

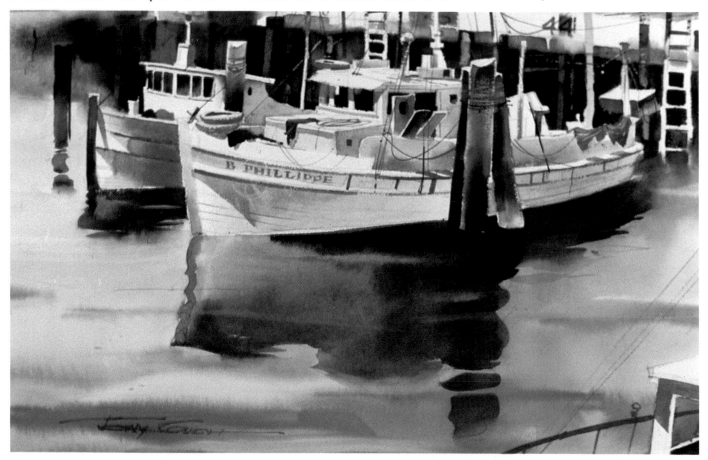

5 6

We identify shapes by silhouette. If I get the correct silhouette, as in the flower on the left, you will still see it as a flower. If I miss the silhouette, no one will recognize it, as in the flower on the right.

If I draw a flower with the correct silhouette, but get the interior all wrong, as in 5, you will still see a flower. But if I render the interior perfectly and miss the silhouette, as in 6, no one will recognize it! This is something to keep in mind when drawing as well as painting.

SYMBOL COLLECTOR

There is something about transparent watercolor that produces a fresh, spontaneous piece of art that no other medium can equal. On the other hand, this medium is not the best for detailed, labored paintings. This latter type of work is better and more easily done with an opaque paint, such as tempera, gouache, or casein.

Since transparent watercolor best produces fresh, spontaneous work, it makes sense to paint that way when using this medium. That means painting in an impressionistic manner, that is, rendering the first fast impression of the subject, without all the minute detail. To accomplish this, we must do two things as we paint: simplify and symbolize.

To simplify means we select one thing to ''say'' in the painting, then select a very few other things in support of this. For instance, the painting *Phillippe,* below, was done at a busy wharf in San Francisco. Here, I said ''boat.'' Then, incidentally, there is another boat alongside her and a hint of one in the foreground to tell the story of a crowded mooring. There is some water

Phillippe,
15''x22''

7

In A Little Help, *below, I've said "barn with tree." Then I put an outbuilding in the foreground and added a farm figure to support the illusion of a rural scene. All other matter was ruthlessly eliminated.*

A Little Help,
15"x22"

and a minimum of pilings to give the illusion of a dock. *And that's all*—even though there were many other docks, boats, buildings, and so on at this cluttered site.

In *A Little Help,* below, I've said "barn with tree." Then I put an outbuilding in the foreground and added a farmer figure to support the illusion of a rural scene. All other matter was ruthlessly eliminated, even though many details surely surrounded the subject in real life.

I try to speak clearly and simply in my work. That quality is appreciated in painters as well as in speakers.

To symbolize means we don't report each object in all its detail as would a camera; rather, we invent *symbols* for them. The painting has a language different from the real land- or seascape, so a translation job must be done. The painting is a lie: it's only paint and paper, but we must convince all that they are looking at a landscape.

Beyond that, the superior artist can show the viewer beauty in subject matter that isn't readily apparent to the layman. Hence, we *lie, cheat,* and *steal* to effect this translation from reality to paper.

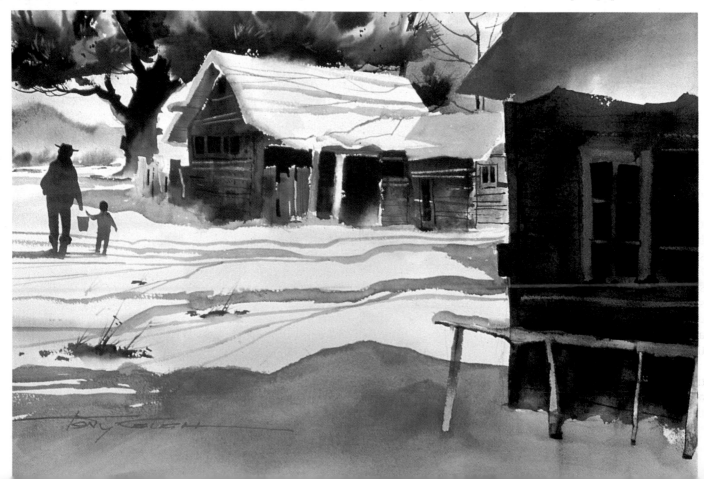

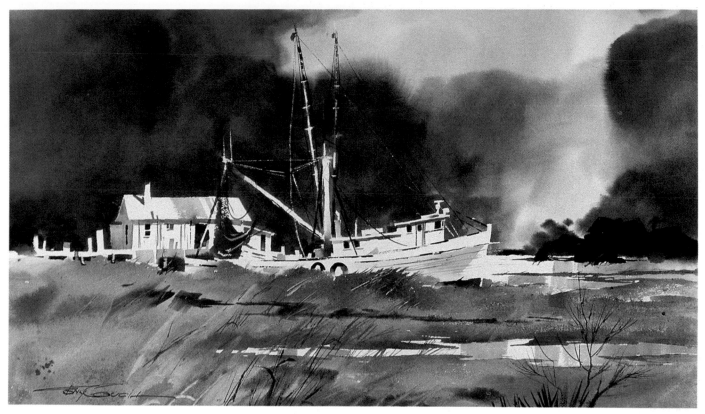

When painting a tree, for example, it is more effective to paint the silhouette of the foliage rather than every leaf (see 7). Rough brushing the edges suggests the leaves, and soft diffusions in the interior give the illusion of clumps of leaves. Breaks in the foliage with branches running through say, "this is a tree." The result is not a tree, rather the symbol for it, and much more beautiful than anything laboriously reported in every detail.

Similarly, rather than paint every tree in a distant stand of trees, it is better to paint only the overall shape of the foliage, then indicate a few individual trees by lifting out or scratching or painting in the tree symbol. The result is not the stand of trees we saw in the distance, but a symbol for it. But it looks for all the world to be the real thing!

If you instead try to report every tree and each bit of detail you see—as would the camera—you'll find that's the wrong language and it re-sults in a dull, overworked blotch. By varying the color and value of the interior and the texture at the edge of the overall shape, you can make the piece appear detailed enough.

ENTERTAINER

Every painter is in "show biz" just as surely as any orchestra conductor or stage play director—each plies the same craft and in much the same manner.

The same people who watch plays or listen to music stop and examine your paintings. And, as in music and the theater, either the work entertains them or they pass it by.

Entertainment means the same in painting as in the performing arts: variety and change. Either we vary and change, or we are bores.

This is why variation, for instance, is used over and over in the course of producing a painting. Our shapes must be varied in size, fami-ly, color, and value—as well as the interval between them—just as the notes of a musical passage are varied in pitch, duration, and interval.

We can avoid boredom in painting by eliminating those large expanses of paper with no variety of color, value, or texture. In general, don't allow more than three inches of a line or shape without changing either the color, value, or texture—or all three. This applies to any size painting, all the way up to a full sheet. This rule also applies to white paper: Bear in mind only a "whisper" of gray or color will do the trick in an area which needs entertainment, but still must appear to be white. Anyone can do this; it's only a matter of knowing enough to do it.

Elements of Design
The Seven Parts of a Painting

If this were a book on anatomy, the parts of the body would first be identified and given names, such as hands, feet, legs, torso, and so on. This would be so that the body could be discussed in whole or in part, and all would be "speaking the same language."

Similarly, before discussing design as it applies to painting, it helps to first separate the painting into simple parts and give each a name.

There are seven parts, called the "Elements of Design," and they are the basic material from which all designs are built:

Shape

Size

Line

Direction

Texture

Color

Value

You'll see that you already know what these parts of a painting are; you've seen them often enough. They exist in every painting anyone has ever done or will do, whether we like it or not. Since they can't be ignored, then, let's examine them one at a time.

SHAPE
Anything that has height and width is a shape and may be placed into one of three categories: curved, an-gular, or rectangular shapes. Shapes in all three categories may be in a painting, but one type should be dominant—that is, some of one type should be larger, appear more often, or both.

The shapes in *Dominguez*, right, are outlined for you in diagram A, below. Note there are negative (shaded) and positive shapes. The positive shapes are those deliberately put into a painting, and the negative shapes are those formed by the space that is left. Care should be taken to make all shapes, negative and positive, two different dimensions, with an oblique thrust and with incidents along the edges, as described in chapter 3.

A

Dominguez,
15"x22"

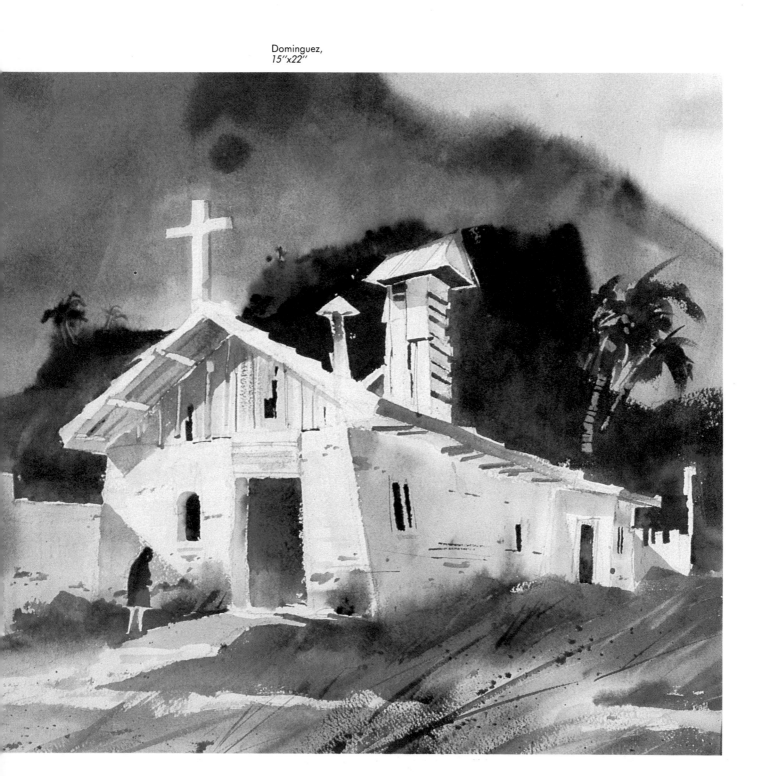

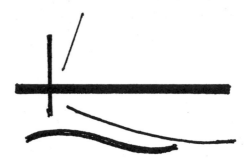

Both curved and straight lines may be in a painting, but only one type should be dominant.

SIZE

This is simple; shapes are of various sizes in relation to one another: larger, smaller, or the same size.

LINE

Another easy one: a line in a painting is the same as a line anywhere else, but you should know they fit into two categories, straight and curved. They may both be in a painting, but only one type should be dominant.

Look at the painting *Chicken à la King*, below. See if you can pick out the lines; then check yourself with diagram B, next to it.

DIRECTION

A well-designed painting will have a directional dominance that is horizontal, vertical, or oblique. This dominant direction is determined by the lines, linear shapes, and the shape of the paper in the case of horizontal and vertical dominance. An oblique dominance is determined by the lines, the linear shapes, and the angular shapes.

For example, in *Through a Window*, top right, page 39, the painting has a horizontal dominance because even though there are lines and shapes that are vertical (the window) and oblique (the weeds),

those that are horizontal are larger, appear more frequently, or are more easily seen because of value contrast around them. The horizontal shape of the paper is also a powerful horizontal force.

Similarly, the painting *Crew's Liberty*, center right, page 39, has a vertical dominance because the dominant lines and linear shapes are now vertical, although there are some horizontals (the hull and dock) and obliques (the gaff and rigging). The horizontal paper on which it was painted counts as a powerful horizontal, so more vertical lines and shapes were necessary

B

Pick out the lines in the painting on the right. Check yourself in diagram B above.

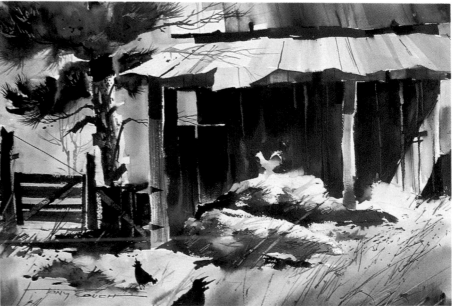

*Chicken à la King,
15"x22"*

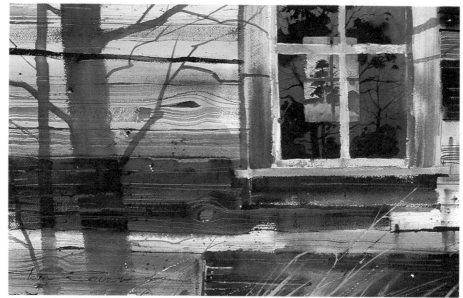

Through a Window, 15"x22"

to achieve a vertical dominance than would have been the case if the paper were vertical.

A dominance of oblique lines and angular shapes gives the painting *Red Ripper*, bottom right, an oblique dominance.

Students often ask if they should paint on paper that is wider than long (horizontal) or longer than wide (vertical). If you're shooting for an oblique dominance, it makes no difference what the shape of the paper is, as long as it isn't square. A square sheet is as bad as a square shape, and for the same reason: the lack of variation of dimension is boring. If you're after a vertical dominance, it can be done whether the paper is vertical or horizontal, although it's certainly easier to do on a vertical paper. But if you're after a horizontal dominance, you're miles ahead painting on horizontal paper, as it's very difficult to overcome the powerful thrust of the vertical paper.

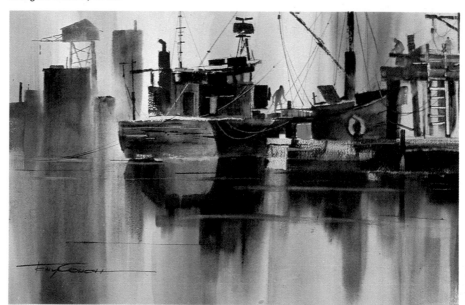

Crew's Liberty, 15"x22"

Red Ripper, 22"x30"

TEXTURE

Texture is defined as the surface quality of objects and is detected by touch or sight. It's also a means by which we identify these objects. The same is true in painting, except that since paintings are seen and not touched, the texture must be produced so that it can readily be detected by sight alone.

Many textures exist in nature, but all are only variations of the three with which the painter deals: soft, rough, and smooth, as seen in C.

In chapter 2 (Controlling Paint), we learned how to produce these three textures. In chapter 3 (The Artist's Role), we learned how important the edges of a shape are, since we recognize a shape first by its silhouette. This is particularly true in the case of texture, as it is a prime tool for identifying or "labeling" shapes. For instance, if we give a rock a rough or smooth texture at its edge, it'll look like a rock. Can you imagine how hard it would be to identify if the edge were painted soft? Similarly, snow, ocean spray, and clouds are best painted with soft edges and a little rough edge here and there. It takes a mighty clever artist to convincingly paint these with smooth edges instead. Shapes can have any texture in the interior, but that texture that identifies them *must* be at the edge!

COLOR

No mystery here: color in painting is the same as color anywhere else. Reds, blues, yellows, browns, and other colors we see in nature ap-pear also in paintings—but we need to understand a few things about color in order to use it. We'll see that in chapter 6.

VALUE

Value is the lightness or darkness of colors. Although listed as a separate element of design, it is really one of the three properties of color, along with hue and chroma, and occurs simultaneously with them. Value is of great importance—more so than hue or chroma—hence, its separate listing. Critical to any graphic art, it is difficult to explain unless in conjunction with its parent, color. I'll discuss value in chapter 7.

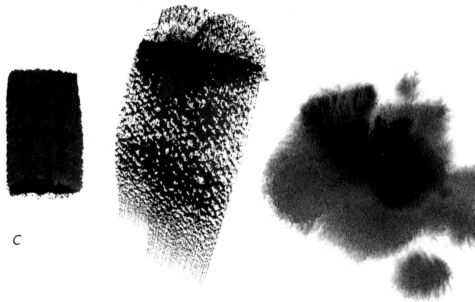

C

Many textures exist in nature, but all are only variations of the three with which the painter deals: soft, rough, and smooth.

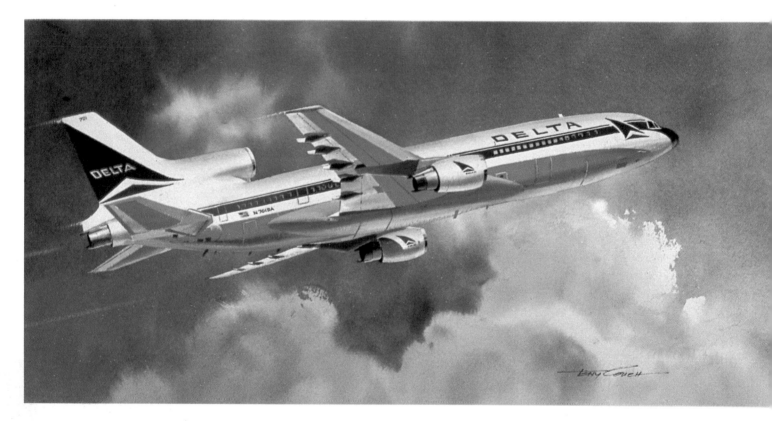

In the painting Medallion Service, the clouds are curved shapes. The edges are dominantly soft, with a whisper of rough texture in two places, for contrast. The illusion of clouds would be destroyed if hard texture were used. On the other hand, the hard, sleek aircraft shape is best stated with dominantly hard texture at the edges.

Can you imagine how effective this painting would be if the textures were reversed so we had a soft-edged aircraft and hard-edged clouds?

Medallion Service
6"x13"
Delta Airlines, Inc., Atlanta, GA

Principles of Design

Eight Principles for Building a Painting

Now that we've reviewed the Elements of Design, or the parts of a painting, let's see how they are used to build a design. There are eight things that we can do with each of the seven elements, and these eight are called the Principles of Design. Here they are listed:

Balance	Alternation
Harmony	Contrast
Gradation	Dominance
Variation	Unity

Each of these principles applies to each of the elements. That is, each of the seven parts of a painting we saw earlier can be *balanced, harmonized, graded, repeated, alternated,* made to *contrast* with like elements, made to *dominate* like elements, and used to make the design a *unit.*

BALANCE

Although balance is applied to each of the seven elements, it is most noticeable with shapes. Just as a seesaw is out of balance if a larger child is on one side, as in A, a painting will appear out of balance if larger shapes are all on one side of it.

If the larger child moves toward the center of the seesaw, as in B, it is balanced. For the same reason, your painting is balanced if the large shapes are moved toward the center, balanced by smaller shapes away from the center. This is called informal balance.

Just as a see-saw is out of balance if a larger child is on one side, as in A, so will a painting appear out of balance if larger shapes are all on one side of it. If the larger child moves toward the center of the see-saw, as in B, it is balanced.

A

B

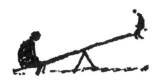

North of the Border,
22"x30"

C

D

It's true the painting (and the seesaw) could be balanced by putting equal shapes on either side, or moving the shapes to the middle of the painting, as in the two small pictures in C. But this formal balance results in a boring design, because it ignores the principle of variation, as we'll see shortly.

When balancing shapes in a painting, it helps to know that a dark shape appears heavier than a light one, so that a small dark shape will balance a larger light shape. Also, a shape can be balanced by a dark area rather than by another shape, as in D where the dark sky on the right balances the shapes on the left.

HARMONY

You probably won't use harmony as much as the other principles as you paint, but it's easy to understand and worth knowing about: harmonious elements are simply those elements that are similar.

For instance, harmonious colors are adjacent colors on the color wheel. So, harmonies of red are orange and red-purple, since these are on either side of red on the color wheel. Harmonies of green are yellow-green and blue-green, for the same reason. The harmonic of a straight line is one slightly curved. Harmonious sizes are those sizes close together. An example is identical shapes slightly different in size.

A shape harmonious to a circle is an oval. The harmonic of a dark value is another value slightly darker or lighter than the first. Similar logic can be applied to the elements of texture and direction.

A painting could be balanced by putting equal shapes on either side or moving them to the middle, as in the two small pictures in C above, but this ignores the principle of variation. Because dark shapes appear heavier, they can be used to balance the lighter shape. In D above, the dark sky on the right counterbalances the shapes on the left.

Dust Storm,
19" × 30"

GRADATION

Like the other principles, gradation can be applied to all seven elements, but as a practical matter, I use it almost exclusively with color and value.

Gradation means a *gradual* change from one thing to something else. In color, it's a gradual change from warm to cool or vice versa. A sky graded blue (cool) at the top to yellow (warm) at the bottom is a typical use of this. Another is the side of a barn that might be brown on the left, becoming gradually red, then graded to a cool purple on the right.

In value, it's the gradual change from light to dark or from dark to light. Notice the change in value in the sky in *Dust Storm*, above. It's dark on the left and gradually lighter on the right. Also, the dark foreground is graded to a lighter value in the distance.

Although gradation is a principle of design, I see it as a technique to be used as often as possible. It easily transforms a flat, dull area into something alive and interesting. Often the novice painter faces a large area, particularly foregrounds, without the foggiest notion of what to put in it. The first thought should be *gradation*! Often, this is enough by itself—particularly gradation of value. If more is needed, splatter or weeds and other shapes can easily be painted into it.

Gradation need not be limited to large areas such as skies and foregrounds. Sides of buildings and tree trunks in reality are darker at the top and gradually lighter and warmer at the bottom, because of sunlight bouncing off the ground. It's a very subtle change, but if exaggerated in your painting, the result is a far more interesting piece.

E

ALTERNATION AND VARIATION

Although alternation and variation are listed as separate principles, they are easier to understand if we see them both as forms of *repetition*. Repetition in art is the same as anywhere else: it's the act of repeating, and we may repeat with variation, or we may repeat with alternation. For instance, when painting a forest, I have to repeat the tree shape over and over again. If I repeat it with variation, I might vary the size, shape, color, value, and texture of the trees, as in E. If I repeat it with alternation, I will create an alternating pattern of trees. Such a pattern is shown in F, where we see one large tree with three small, one large and four small, then back to one and three and so on.

Of course I could repeat the tree shape exactly and make the space between them exactly the same, as in G. But I would have paid a dear price for ignoring those principles of repetition with variation and alternation by producing a boring, uninteresting work.

You might compare it to the speaker who bores you with his steady, unchanging monotone. Wouldn't you rather listen to one who speaks with inflection and dramatic pause?

Alternation is used more frequently in architecture and decorative design, such as in wallpaper and fabric, than in painting. On the other hand, repetition with variation is used more often in painting. So, for simplicity, I'll refer to repeti-

F

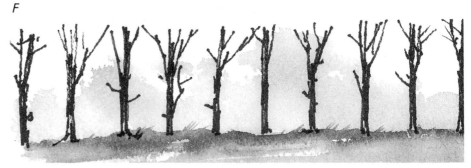

G

When you're painting a forest, the tree shapes can be repeated with variations in size, shape, color, value, and texture as in E, or in an alternating pattern as in F, or repeated exactly as in G. Repetition without variation, however, is boring and should be avoided.

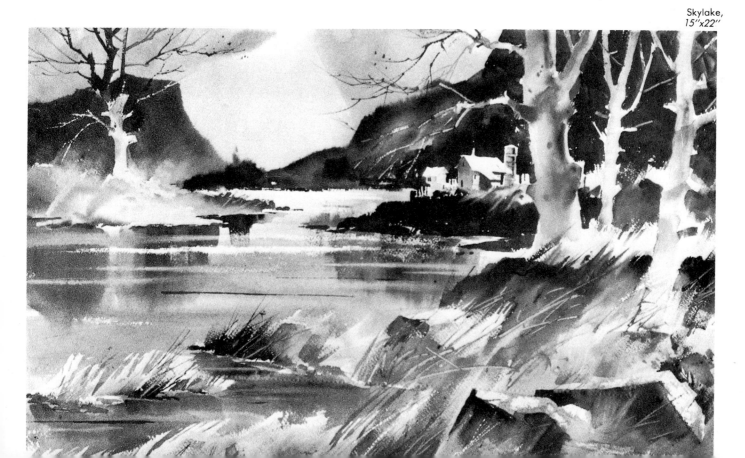

The angular shapes contrast *with the curvilinear shapes.*

H

tion as "repetition with variation" from this point forward and will say little about alternation.

CONTRAST

Sometimes called *conflict*, contrast means "the opposite of." Conflicting or contrasting shapes, for instance, would be a bulky, angular shape and a curvilinear shape, as in H.

Two contrasting directions are the horizontal and the vertical; an example of contrasting texture is rough versus smooth, or soft versus hard. In line it could be curved versus straight; in size, small versus large; in value, dark versus light. Contrasting colors (also called com-

plementary colors) are any two directly opposite each other on the color wheel. An example is blue-purple versus yellow.

In *Skylake*, below, the vertical direction of the trees contrasts with the horizontal lines in the water and the horizontal dimension of the paper. The dark value of the mountains and the spit of land in the mid ground contrasts with the light value of the farm buildings and near trees. The large size of the moun-

tain on the right contrasts with the smaller mountain on the left, and the straight lines in the water contrast with the curved lines of the weeds.

Contrast is an essential part of any design, be it in graphic or performing arts, and is the ingredient that creates *interest* and *excitement*! If contrast is ignored, a dull, boring work is guaranteed.

This same contrast, however, is "chaos under wraps": if used with abandon, it will destroy the unity of the design, resulting in a disturbing work that is difficult to view.

In art as in life, a little contrast is interesting; an overdose creates chaos.

Skylake,
15"x22"

These diagrams demonstrate how dominance is achieved with the element, shape.

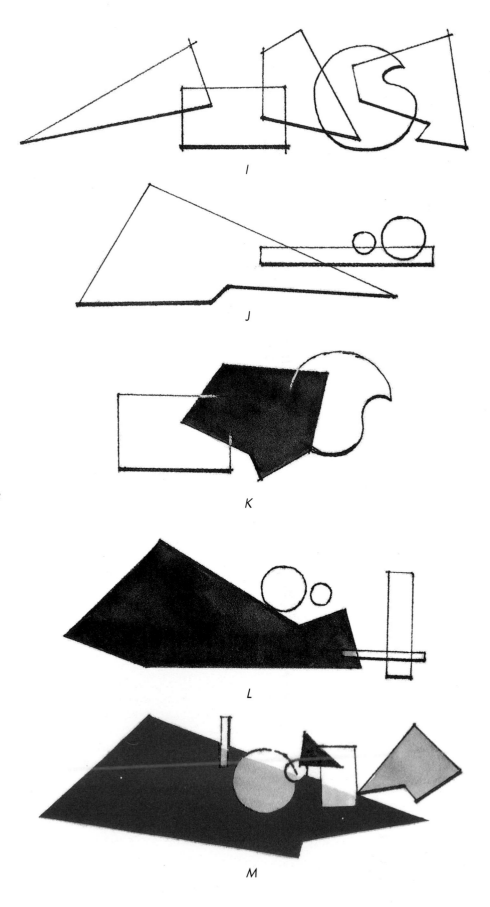

DOMINANCE

If there's one principle of design more important than the rest, it's dominance. No matter how the painting is designed, it must in the end be an orderly, rational unit. To be sure, harmony, balance, and gradation lend some stability, but dominance is the heavy artillery.

Building a design is like staging a three-ring circus: The seven elements are displayed with variation and contrast for entertainment and excitement, but this is a blueprint for chaos. To maintain the order necessary while the show is going on, we must also provide a ringmaster, and *dominance* is it!

How is dominance achieved? First, we should remember that, like the other principles, it can be applied to all seven elements. The problem, then, is to make one of several units of the same element dominant. This is done by making one larger than the rest, by repeating it more often than the others, by providing more value contrast around it, by putting the strongest chroma (brightest color) there, or by all or a combination of these techniques.

Let's take the element *shape,* for example. If there are two or more shapes in a painting, one should be dominant. That is to say,

1. One family of shapes (curved, angular, or rectangular) should occur more often than the others, or
2. One shape should be larger than the others, or
3. One should have more value contrast in or around it, or
4. One should have the strongest

Lavender Green,
15"x22"

chroma (brightest colors) in or around it, or

5. One should have any combination of these.

In the design in I (opposite page), although all the shapes are the same size, the angular shapes are dominant, because there are more of them than rectangular or curved shapes.

In J, the angular shape is dominant (even though there is only one), because it is larger than the other two.

In K, the angular shape is again dominant; this time because there is greater value contrast there.

In L, the dominance of the angular shape is more easily seen, because it is larger *and* has more value contrast.

It's even easier to see the angular shape dominance in M, where there are more angular shapes than in any other family: one of the shapes is the largest shape, and there is more value contrast there. If the brightest color also occurred at this shape, we would have a combination of *all* the devices for creating a dominant shape.

A dominance of the other six elements can be achieved in the same manner as the shape dominance described above. We might make a special note of color, however. While a better design will have a dominance of one hue, blue for instance, it is enough to provide only a dominance of color *temperature*. That is, the painting need only have a dominance of *cool* or *warm* colors. See chapter 6 for a description of warm and cool color.

To review, dominance is applied to the seven elements as follows:

Shape: There are three categories of shape—angular, curved, and rectangular—but only one category should be dominant.

Size: There might be several sizes, but only one should be dominant.

Line: There are two types of line—curved and straight—but only one type should be dominant.

Direction: There are three directions—vertical, horizontal, and oblique—but only one should be dominant.

Color: There are ten hues (Munsell system), but only one hue or warms or cools should be dominant.

Value: We work in three value ranges—light, dark, and mid—but only one (the mid) should be dominant.

Texture: There are three textures—hard (smooth), soft, and rough—but only one should be dominant.

Although a successful design does not necessarily have a dominance of all seven elements, a greater number increases the chances of success.

Let's examine the painting *Lavender Green,* top left, to find the dominant elements there:

The dominant shape is that of a tree, thanks to the large foreground tree, the repetition of tree shapes, and the maximum value contrast around this large tree.

The dominant size is also found in the foreground tree. The dominant line is straight; dominant direction is vertical; dominant value is mid value (see value patterns in chapter 7); dominant texture is soft.

The dominant color is warm. In fact, it is dominantly yellow-green.

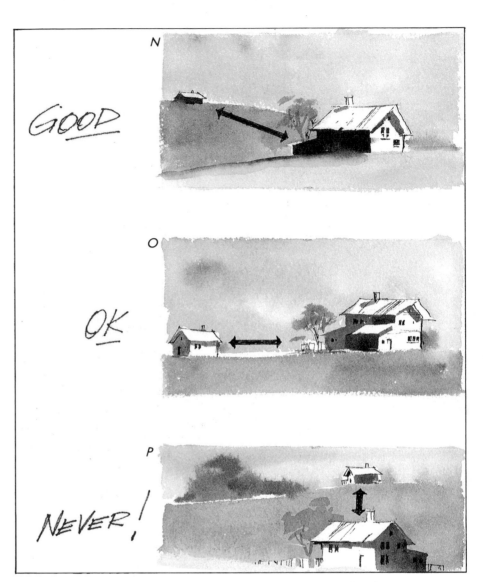

UNITY

In the end, any design must be a complete unit, rather than a collection of several. If an element (size, shape, line, direction, color, value, or texture) appears in one section of the painting, it should be echoed in another part, so that all sections are related.

Ed Whitney explains it best: "If you tear your painting into four equal parts and mix them into a pile of other paintings also torn into fourths—and can then *instantly* pick out your four parts, your painting was a unit!"

This echoing of elements is called "relating." When relating one element with another, be sure it is done *obliquely* (see N). This oblique is dynamic, which is more entertaining than a horizontal relationship, which is static.

If, because of the construction of the design, two elements cannot be related obliquely, it's better to relate them horizontally (see O) than not at all. *Never*, however, relate two elements vertically, that is, one directly over the other, as in P. Better not to relate at all in that case.

Bear in mind that when relating or echoing elements, we are repeating them, so the principle of repetition with variation applies. *Don't make these repeats the same size!* Think "echo," and you'll do the correct thing.

If a green hue is to be related in another part of the painting, for instance, it should be done obliquely if possible, horizontally if not—but never vertically. One area of green should also be larger than the other.

When relating shapes to increase unity, think of "echoing" the elements. However, avoid relating two elements vertically.

Whenever we design, it is not enough to be technically correct; the design must be obviously correct, that is, easily identified at a glance as correct. We don't measure the elements and the degree of principle applied with a ruler or caliper; we measure with the eye, which is approximate. A design that can be appreciated at a glance from twenty feet away is far superior to one that requires a five-minute study by a committee at close range to discover it exists.

SUMMARY

We have just looked at the eight principles, reduced them to seven, and learned how they are applied to the seven elements of design. Seven times seven equals forty-nine things we must think about as we design; what a headache!

Why not forget these mental gymnastics and just enjoy painting? The best answer lies in another question: Do you enjoy painting for hours, only to produce a work you know is bad, for reasons you can-

Lonesome Pine,
15"x22"

The "lonesome pine" (foreground) is echoed obliquely by the group of trees in the lower left distance, again obliquely on the right by the smaller trees atop the near mountain, and yet again obliquely in the upper right atop the distant mountain. The two distant peaks are related obliquely left and right, and both are related obliquely to the foreground peak. Notice that no two peaks or trees are directly underneath one another.

not fathom? Or, when an occasional success results, do you enjoy knowing that the chances of repeating the success are slim because you don't know why it's good?

I can't think of anything more depressing, or a better formula for "hating art." It's probably a major reason many dabble in art, but few persist.

On the other hand, there's nothing like being able to prop a newly created "disaster" against a wall, methodically analyze it, and discover why it failed and therefore what not to do next time! What is more enjoyable than turning disasters into profitable learning experiences so that the failures are as helpful as the successes?

Launching into a painting without knowledge of the principles of design is like a student pilot attempting to fly to a distant airport without a chart. He may make it, but he'd best have plenty of fuel and luck. More often than not, we'll read about him in the news the next day.

Leonardo da Vinci would have counsel for both the pilot and the artist: "Those who are enamoured of practice without science are like a pilot [sailor] who goes into a ship without rudder or compass and never has any certainty where he is going."

Do these principles really work? Judge for yourself.

Each of us possesses something called "human nature." That is, although we are distinctly individual—with our own peculiar likes and dislikes—in many ways we are exactly the same, by nature. You may prefer restaurant A, while I like restaurant B, yet few of us can resist the appeal of a fuzzy puppy, and a passing beautiful young lady will attract most male glances. And who wouldn't retreat before a coiled rattlesnake?

Now, what if we were able to bundle up several basic principles of this human nature and infuse them in some way into our paintings? Would not our work then be preferred by all who possess a human nature, regardless of education or understanding of design?

What a marvelous idea! As you might guess, inasmuch as artists have been practicing their craft since the first civilization, this idea has occurred to someone *before*. In fact, a method for doing it in eight different ways has long ago been devised. This method is called— could you guess?—

The Eight Principles of Design

Let me explain: although called "the eight principles of *design*," they are really eight principles of *human nature*, or eight basic ways in which we are exactly the same.

For example, there is the principle of repetition with variation: Do we not like variety; don't we call it the "spice of life"? Aren't we bored with a never-changing daily routine?

Another principle is contrast (conflict): Almost everyone, at some time, has been stalled in traffic for seemingly hours while an accident ahead is cleared. How often have you finally arrived at the accident only to find that it occurred in the lanes going in the opposite direction? You know that's what caused the jam in your lane, because traffic resumes speed as soon as you pass it. Why does everyone slow down to look at the accident? Because that's conflict over there! No one can resist looking at it, even though, in the case of an auto accident, we may be afraid of what we may see. It's *interesting!*

Would you like to see a terrible accident every morning on your way to work? Certainly not. In fact, that sort of thing could affect one's mental stability. So, from this, we learn that conflict is interesting to us, but only in small doses. We design the same way. A painting must have a color dominance, for instance, but it also needs a small amount of conflicting color to provide interest. Not a great deal; too much is disturbing and will destroy the dominance.

How about this important principle of dominance? Can you think of any successful organization, anywhere in the world, at any time in history, that was not led by one dominant figure? Every ship has only one captain. There are several mates, but only one captain oversees the operation of the ship and is responsible for it. Every corporation or company, no matter its size, has only one president. There are several vice presidents and assistant VPs by the score, but all answer to one president, who runs the company.

Do you think *you* don't operate that way? Imagine your car with two steering wheels, each with equal control of the car, and two of you driving at the same time. Either

you decide which of you will drive or there will be an accident.

Why is this? Because *that's the way we are!* We don't function efficiently without one dominant figure at the top. It assures order and unity, which human nature dictates we must have. Order is the opposite of chaos, with which we are uncomfortable.

We paint the same way. In order for the viewer to be comfortable with your painting, it must have one dominant shape, one dominant value, and so on.

You probably realize by now that, as Ed Whitney said, "You can ignore the principles of design, but they won't ignore you!" You can't get away with ignorance of these principles, because the design errors in your paintings will tell the tale. Just as we all *admire* knowledge, we *disdain* ignorance.

Fads in art come and go, but the design principles remain the same—for the same reason that cultures come and go while human nature remains the same. Even those who know nothing of design will be less comfortable with a painting of inferior design, because less of it appeals to that human nature that is inherent in everyone!

If you'd like to examine these principles in greater detail, I recommend the book *The Art of Color and Design* by Maitland Graves (McGraw-Hill, 1951).

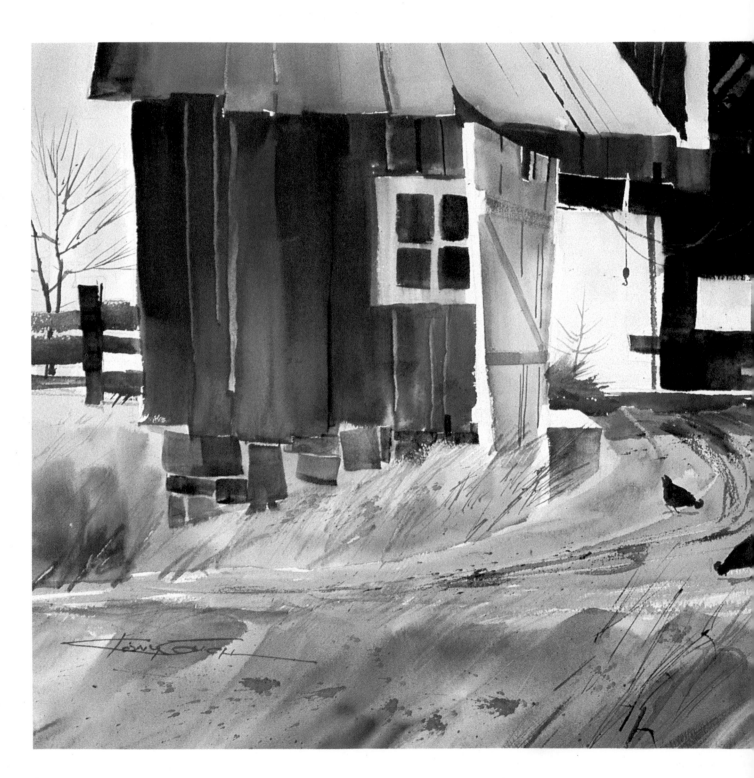

Working with Color

Keep It Simple

There are three dimensions to color: Hue, Chroma, Value.

HUE

Hue is the characteristic by which we distinguish one color from another, and in popular usage is simply "color." Hence, we don't ask, "Which *hue* is your car?" Rather, we would ask, "What *color* is your car?"

Often, during a demonstration, a student will ask "Which color are you using now?" At other times, some ask in advance of the workshop which "palette" the instructor uses, meaning, a list of colors. I've even heard students recommend to others a "newly discovered" color that will surely work wonders.

All of us have daily responsibilities from which we may steal precious little painting time, so we want to learn as rapidly and efficiently as possible. A valuable service of the instructor, then, might be to steer the student from time-wasting pursuits and toward more efficient use of his or her time. This is patently true for students who chase after particular hues in hopes of discovering the secret to beautiful paintings. What these "color sleuths" are missing is a basic understanding of color.

If you're one of this army, I have some good news for you: the subject is far less complicated than you think. And once it's understood, you no longer have to wonder which colors the instructor, or anyone else for that matter, uses.

All the hues in the world fit into ten broad families, shown on the following page, and are simply called red, orange, yellow, green-yellow, green, blue-green, blue, purple-blue, purple, and red-purple.

Every hue you can imagine is either one of these ten or a variation of them. If it's a variation, it was produced by:

1. mixing two or more of the basic ten, and/or
2. adding black to make it darker or thinning it with water to make it lighter (varying the value).

Paint manufacturers, however, have pounced on several of these variations and have made up names for each for identification and marketing purposes (count the racks of colors in the art stores). So we find names like "Thalo green," "Chinese red," "English red," "Powder blue," and so on.

We've grown up with these names and quite naturally have come to believe they are hues unto themselves, but they are not. They

Easy to See Through,
15"x22"

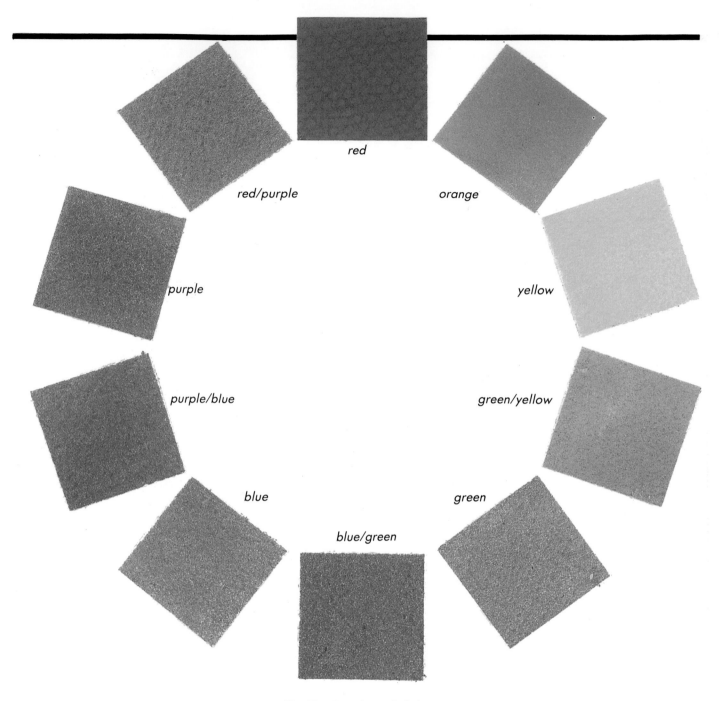

The Ten Families of Color.

are still only variations of the original ten.

Already life is simpler. From this minute on, you can forget all the exotic names the paint manufacturers have concocted and remember only this:

1. There are ten basic hues, plus black.

2. You can lighten any color by thinning it with water and darken it with any darker color or black.

3. You can leave any color as bright as it comes from the tube, or dull it by adding its complement or a small amount of black.

Armed with this knowledge, let's make up a working palette. If you examine the palettes of any ten reputable painters you will probably find no two the same, and you might see everything from a "limited palette" of few hues to one with every well filled with a different color.

On the other hand, I would expect to find the primary colors, or variations thereof, in all the palettes.

How may your palette be made up then? Here's an idea: (1) Use the hues that will allow you to get every imaginable color. That means the primary colors: red, blue, and yellow. (2) Pick any other colors you might use often. Rather than mix primaries to get these hues each time, it will save time to have them already mixed. For many artists, this includes at least raw sienna (yellow ochre), a brown, and black.

Beyond this, you might add as

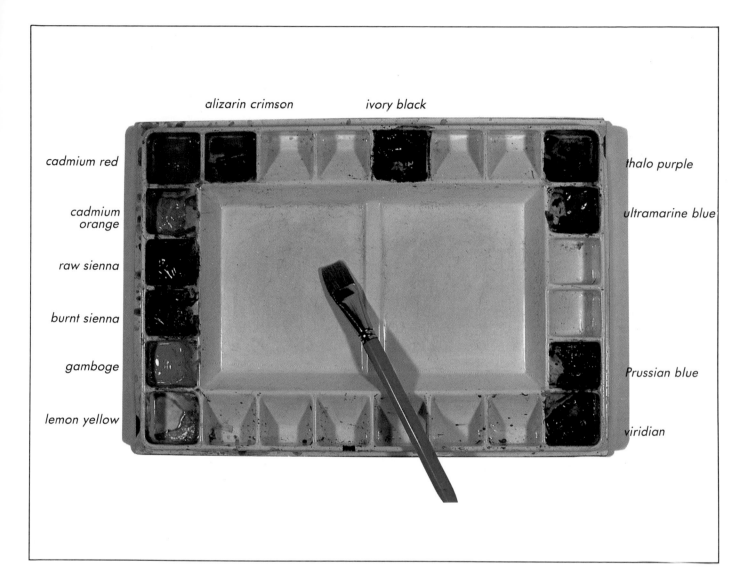

cadmium red
cadmium orange
raw sienna
burnt sienna
gamboge
lemon yellow

alizarin crimson ivory black

thalo purple
ultramarine blue
Prussian blue
viridian

In my palette, I have two of each of the primaries, arranged with the warm hues on one side and the cool hues on the other.

many colors as you like, so as not to have to mix them each time. But bear in mind that, although the paint manufacturers might have a tube of every mixture under the sun (and an exotic name to match), you'll soon run out of palette space and end up with less variety of hue. If I'm painting a red-purple passage, for example, and use a tube of "violent violet" (or whatever name some paint company might give red-purple) for this purpose, I'll net a flat, boring red-purple area.

On the other hand, if I mix red and purple on the wet paper as I paint in the area, I'll get a varied diffusion of red and purple, a much more interesting color.

Depending on the premium you place on this variety, your palette could be anything from "limited" to "loaded."

As for the primary hues, many artists have found advantage in two reds, one on either side of "dead-center" red. One red will have a little purple in it and the other a lit-

orange. Similarly, they may use two blues—one with a little purple in it and the other with a little green—and two yellows—one with a little orange in it and the other with a little green.

In my palette (above), I have two of each of the primaries, just as we discussed above. All that is necessary to arrange your palette similarly is to know what red with some purple in it looks like and what red with orange looks like, and so on, and buy paint accordingly, no mat-

ter what name the manufacturer has given it. This is because these hues parade under several names, and of course, one is no better than another.

In order to judge the color, however, never trust the color printed on the tube or cap; it's only approximate. Don't judge it by unscrewing the cap and looking into the tube; it's too dense. Instead, you must put a little on your finger and smear it on a white surface to thin it.

If you can't judge the hues at first, you might use this guide. I'll give you each "generic" hue in my palette and then as many manufacturers' names as I know for the same thing. But I don't know them all:

The red with a little purple in it that I use is alizarin crimson. But it could be rose madder, Thalo red, Thalo crimson, and others.

My red with a little orange in it is cadmium red medium. But it could be cadmium red deep, cadmium red light, Grumbacher red, vermillion, or Chinese red.

My yellow with a little orange in it is new gamboge. But it could be cadmium yellow.

My yellow with a little green in it is lemon yellow. But it could be Hansa yellow, or cadmium yellow lemon, among others.

My blue with a little green in it is Prussian blue. But it could be Thalo blue, Winsor blue, or Antwerp blue.

My blue with a little purple in it is ultramarine blue. But it might also be French ultramarine.

For the other "extra" hues, I use raw sienna instead of yellow ochre

because it's more transparent, but the hue is the same. I also use burnt sienna. I've recently added an orange and a purple to my palette because even though I can mix two primaries to get those colors, I seldom do. I wanted a middle orange, halfway between red and yellow, and a purple halfway between red and blue. I picked these colors by smearing them on a white surface, ignoring the names. They turned out to be cadmium orange and Thalo purple.

I have viridian (a metal-like blue-green) in my palette because I want more variety in my cool colors toward the green end of the scale. Winsor, Thalo, or Prussian green would do as well. So I have two cool hues in the green camp (Prussian blue and viridian) and two in the purple camp (ultramarine and purple).

I have black in my palette. I know there is a "school" out there that considers this heresy and would never allow a tube to contaminate their paint box, and I have no quarrel with that. Anyone can paint forever without it and suffer

no ill effect. But black is handy for weakening the chroma of any color, or darkening them, or producing a neutral gray.

My only caution is to use ivory black instead of lamp black. Lamp black is made from soot and will give your painting a dirty, sooty appearance if you get too much of it in the painting. Not so with ivory black. Also, a richer black area in a painting is obtained by mixing two dark colors—generally a blue and a brown—rather than by using black.

My palette is arranged with the warm hues on one side and the cool hues on the other. Black, which is neutral, is between them. This is because, when I paint, I think not of particular hues, but only of warm and cool.

My plan is to pit warm against cool whenever possible for contrast, and to vary the warms and cools for variety. That is, if my cool was a blue with a little green in it in one area, then I'll use the blue with a little purple in it nearby, or even purple. Similarly, if the warm I used was a yellow in one passage, I'll use a brown or red or orange near it.

The result is a more interesting (contrast) and entertaining (variety) painting. *And I couldn't care less about, or even remember what the manufacturers named the colors!*

After you set up your palette, spend a little time experimenting. Mix various combinations of color and see what you get. It's not only fun, but you'll learn you can approximate any color in the world by mixing and then darkening or lightening or graying the color with just what's in your palette. You'll never know, or even care what the name of that mixure is, because the next time you mix it, it'll be different—and that's *variety.*

I have only one green in my palette (viridian), and I rarely use it as a green. Rather, I mix it with some other hue to get a third color. And I have no dark browns. It's because I don't need them; the darkest brown I have is burnt sienna, which is not very dark. But it's much more transparent than the heavier dark browns, and I can easily obtain any of them by mixing black with the burnt sienna.

The most brilliant range of greens can be created by mixing your blue-green and orange-yellow. In my case, that's Prussian blue and new gamboge. If I need a warmer green, more yellow than blue goes in it. If it must be cooler, more blue than yellow goes in the mixture. If I want it darker, I add black or burnt sienna. If it should be lighter, I add more yellow or thin it with water. In any case, mix the green again each time you need more pigment; it'll give you a variety of greens.

There is no green on earth (or in the art store) that cannot be produced by this means.

I caution you to use only the blue with green in it and the yellow with orange in it. Using the blue with purple in it or the yellow with green in it will give you a green, but it will be dull.

Alternatively, olive green is more easily obtained by mixing any yellow with black.

So now you no longer need to wonder about the name of a particular color. There is no magic in any color; they're all cousins of the original ten, and you can identify them with just a little comparison practice. If it looks like it's green, that's what it is. Is it a yellow-green, a blue-green, or close to the middle? Is it light or dark? Your eyes will tell you all you need to know to match the color with your palette, if that's important.

Is the blue you want tinged with green or purple? The yellow tinged with orange or green? Does the red lean toward orange, or purple? Are these colors light or dark?

Any color seen in "nature" is either in your palette, or you can get it by mixing what's there. The only requirement is your ability to analyze the hues as discussed here.

COLOR TEMPERATURE

It's important for you to know that there are three "temperatures" of color: *warm, cool,* and *neutral.* Although the neutral colors cover a very small band and are of little consequence, the warms and cools are a different matter.

The warm colors are those we associate with warmth; the colors of

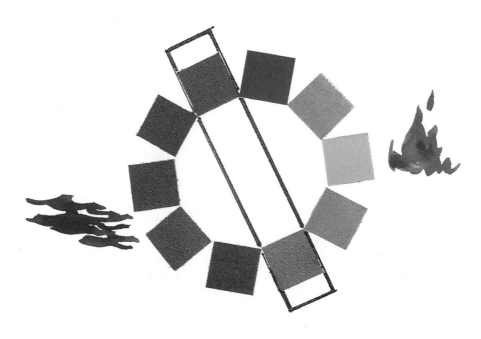

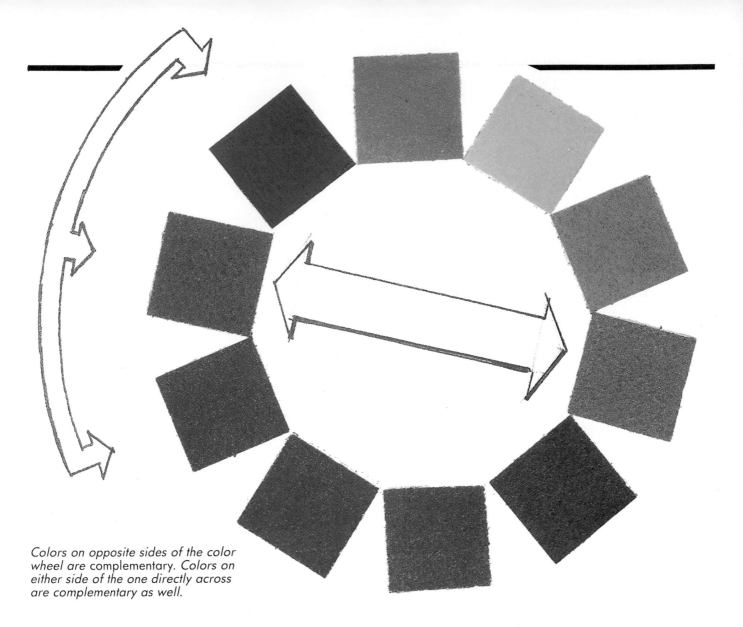

Colors on opposite sides of the color wheel are complementary. Colors on either side of the one directly across are complementary as well.

earth and fire: red, orange, yellow, and brown, and mixtures thereof. The cool colors are blue and purple and anything with blue in it. This is easy to understand; we're used to cool blue skies and large bodies of cool blue water.

That leaves red-purple and green, which are the neutral colors; they are neither warm nor cool. This is of little practical concern, however, as the minute we put a little more red in red-purple it becomes warm, or if we mix in blue instead, it becomes cool. A little yellow in green makes it warm, just as blue will make it a cool green. We rarely deal with a dead-center red-purple or green; rather, they are usually tilted toward warm or cool.

By understanding this, it is easy to remember that while red, yellow, and orange are always warm, and blue and purple are always cool, red-purple and green may be warm or cool, depending on what is mixed with them! It might be simpler to draw a line joining green and red-purple on the color wheel on this page. Now the line joins the neutral temperature colors, and anything on the red side is warm, and anything on the blue side is cool.

COMPLEMENTARY/CONTRASTING COLORS

Any two colors on opposite sides of the color wheel are said to be *complementary*. They are also called *contrasting* colors. In the color wheel above, for example, we see that the complement of green is red-purple. But it could also be red or purple, because the complement is the color

on either side of the one directly across, as well.

Opposite colors are called complementary because each appears brighter when placed close together. When a painting is hung on a blue-purple wall, for instance, the yellows in the painting appear brighter than normal. Experiment for yourself, and you'll see.

Oddly, if you instead mix two complementary colors, just the opposite happens: each becomes more dull, or grayer.

The practical use of complements, then, is mixing them to "gray down" a color or placing them near each other to brighten them. Many painters will determine the dominant color of the sky, then paint the foreground its complement for a brighter painting, as in the painting on page 146.

TINT, SHADE, AND TONE

Here are three terms that are often misused and lead to confusion, so let's straighten them out here. When we *tint* a color, we add water to it (add white when painting with opaque paint, such as oil or gouache) and make it lighter. We *shade* a color with black to gray it, or make it darker, or both. *Tone* is confusion itself. In the United States, when referring to a painting, tone means value. In British art, however, it means value key, and in photography, it means color. For clarity, we won't use "tone" in this book at all; only "value" which is the lightness or darkness of color. But bear in mind "value" might be called "tone" elsewhere.

CHROMA

Chroma is the measure of brightness or strength of a color. A color is said to be at maximum strength when it is brightest, and weak when it is less bright, or grayer. In the painting *Bonnie Jean* on page 150, the red on the stern of the boat is at maximum chroma. It is still red, but a weaker chroma (and incidentally a darker value) on the underside of the boat.

Pigment, as it comes from the tube, is at maximum chroma. That is, it's as strong or bright as that color is ever going to be. With few exceptions, however, nothing in nature is as bright as that pigment. So the painter's constant chore is weakening, or graying down, the color found in the palette.

It is easily done, however. Just mix a little gray, black, or the complement with a color, and the chroma is instantly weakened. If you make it very light by mixing in water, the chroma is also weakened.

If your paintings are too gaudy, then, you now know the problem and the solution. You painted nature with paint as it came from the palette without graying it, or weakening the chroma. Next time, gray the paint down somewhat. For a painting that's finished, lay a thin glaze of the complement or a gray over the gaudy area. That will instantly dull the gaudy spot, too.

The few things in nature that may be painted as bright as the paint in your palette include flowers, fall foliage, and anything manmade (that is painted a bright color).

Simple, isn't it?

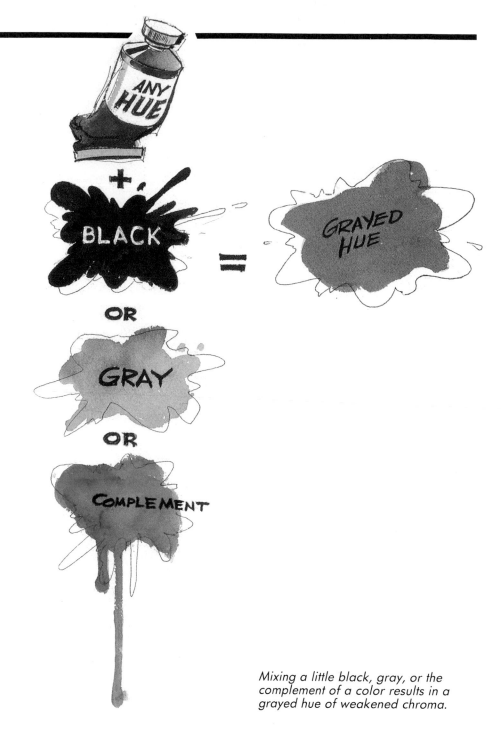

Mixing a little black, gray, or the complement of a color results in a grayed hue of weakened chroma.

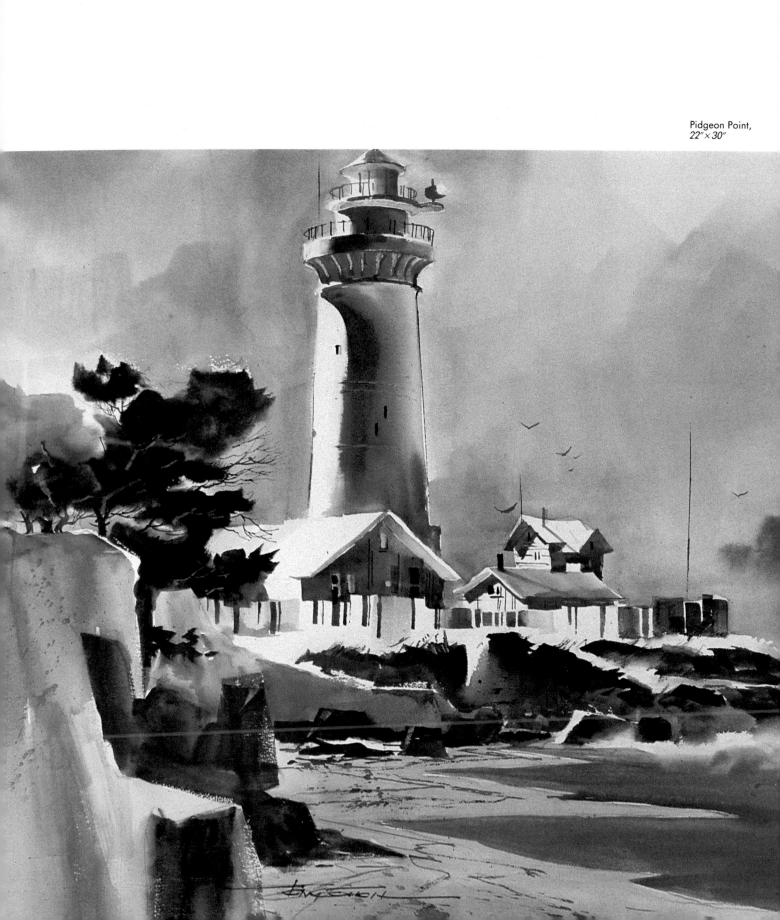

Working with Value
The Basic Patterns

It is important for you to understand that value is the lightness or darkness of any *color*. Color and value occur simultaneously; value is one of the three dimensions of color.

Most value scales in textbooks are without color; rather they are a scale of neutral grays, like the one on the right. Unfortunately, many a novice has interpreted this to mean that value has to do only with grays and nothing to do with color! Value applies to all color *and* the grays. In fact, you can think of gray as color with all the chroma removed.

I imagine the human eye might discern a hundred different values for a given color, from darkest to lightest red, for example. For simplicity, however, we'll cover the range with nine intervals, giving a number to each.

The diagram (right) illustrates this range. The lower numbers are darker, starting with 1, which is black, and ending with 9, which is white.

Just for confusion, you will find the nine-value scale reversed in several publications: the high numbers will be dark, and the low numbers will be light. But don't be misled; the numbers attached to the values aren't important. It's enough to remember that the mid values are in the middle of the scale, and that they become darker in one direction and lighter in the other.

Also, it's interesting to note that most colors in your palette are in the 4-5-6 value range, except for yellow, which is up there at value 8. Your yellow is about as light as it'll ever be; you can only make it darker.

9 (white)

8

7

6

5

4

3

2

1 (black)

Working with nine values while painting is a bit cumbersome. It's much simpler to group them into three groups: lights, darks, and mid values. After all, if we can reduce the 100 or so values the eye can discern to 9, we can further simplify them to 3 groups.

We'll still end up with an infinite number of values in our paintings, because we're thinking in three groups or *ranges:* lights, darks, and mids.

It's easy; for most paintings, we group them as shown below. Note that white is included in the lights and black with the darks. Don't try to be precise; *roughly* use values in the upper part of the scale for the light shapes. *Roughly* those in the lower scale for the dark shapes, and *roughly* the mids for the rest of the painting.

There's nothing sacred about how much of the scale you'll reserve for lights, how much for mids, and how much for darks. Allot them as you will, only be consistent within each painting.

For instance, a high-key (light-value) painting might use values 9 and 8 for the lights; 7 and 6 for the mids; 5 and 4 for the darks; and 3, 2, and 1 would be omitted.

For a low-key (dark) painting, you might omit 9 and 8. The lights would be about the 7 and 6 area, the mids about 5 and 4, and the darks 3, 2, and 1.

Most subjects are done in middle-key, however, using the entire 9 value scale with most of the painting in the mid range.

HOW ARE VALUES USED?

Learn to *place* these light, dark, and mid-value ranges in your painting, regardless of hue. It's not a simple thing if you've never done it before, but it comes easy with practice and is well worth learning. In fact, you cannot become a competent painter or illustrator in *any* medium, without it.

Understanding what values are without knowing how to place them in a painting is like understanding what a car is without knowing how to drive one: learning to drive is difficult at first, but it be-

comes easy with practice, and my, what a difference the car makes when you can drive it!

I recall reading and hearing about "values" for years without understanding how to use them. When one day I discovered they are placed in a *pattern,* it was as if the sun had just risen: my paintings improved 1,000 percent!

Placing these value ranges into a pattern, regardless of hue, organizes your painting according to value. It creates order from chaos.

It also keeps you out of more trouble than I can describe. For openers, it guarantees you won't lose a shape because you painted it over or next to another shape of the same value! How often have you completed a painting only to discover that big tree, done particularly well, disappeared against a sky of the same value? Or your house took French leave because you painted the trees behind it too close to the same value, and so on? Did you notice that painting the house and trees different *hues* didn't separate them one bit?

Think of values grouped in three ranges: lights, darks, and mids.

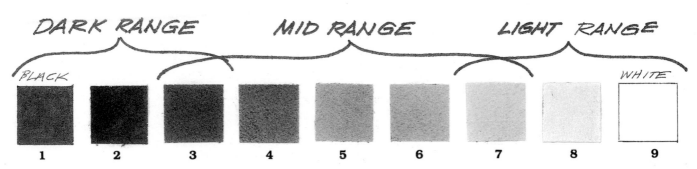

DARK RANGE MID RANGE LIGHT RANGE

BLACK WHITE

| 1 | 2 | 3 | 4 | 5 | 6 | 7 | 8 | 9 |

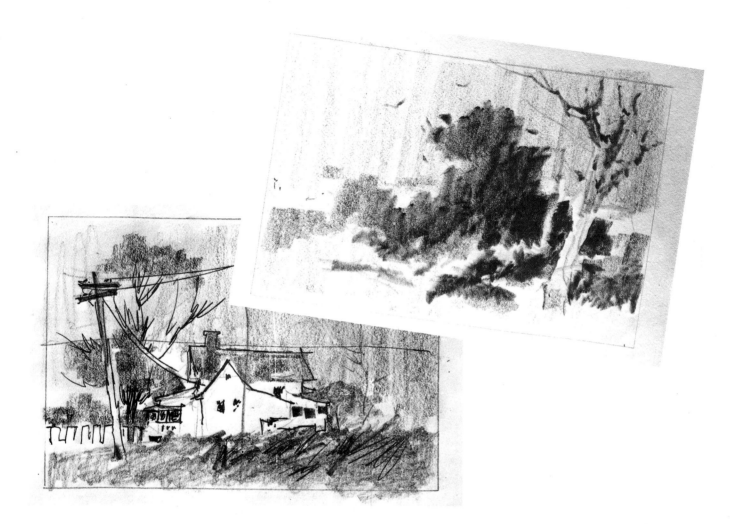

Use small sketches like the ones above to plan effective value patterns for your paintings.

You can forget all that misery and more if you'll just do this:

1. Draw a postcard-sized sketch of the painting you wish to paint and locate the negative and positive shapes. (See "shape" in chapter 4 if these terms are foreign to you.)

2. Decide which of the positive shapes are important to your painting, that is, which must be easily seen in order to tell the story or produce the mood.

3. Now, block in with the broad strokes of a soft carpenter's pencil these important positive shapes either in the light value range or the dark range. Don't leave these light or dark shapes evenly scattered over the painting; rather, group them together into larger shapes of various size and vary the space between them.

4. Block in the rest of the sketch—the negative shapes and the unimportant positive shapes—in the mid-value range.

VALUE PATTERNS

If you understand what I have written in (1) and (2) above—and if you can do it—you understand value patterns and need not read the rest of this chapter.

If, on the other hand, it's as clear as mud, I have some help for you: I'll show you how to fit the three value ranges into an arrangement called a "value pattern."

First, let me explain what a value pattern is: It's a "crutch" to force you into organizing your values in the manner described in these same steps (1) and (2).

There are, in fact, *twelve* value patterns that I know of, *all* of which do the same thing. For simplicity, I'll divide them into two groups: Group I and Group II.

Make a postcard-sized sketch of your painting-to-be with lines only—no values yet.

GROUP I VALUE PATTERNS

Make a postcard-sized sketch of your painting-to-be with lines only; no values, yet.

Once you have the sketch you want, decide which part will be the mid ground. Everything in front of that is the foreground; everything behind it is the background (see sketch at right).

From here on the job is simple. We have three "grounds": fore, mid, and back. Happily, we also have three value ranges with which to work: light, dark, and mid. So we merely assign the three value ranges to the three grounds, and it doesn't matter which you assign to what, as long as you use all three values and cover all three "grounds."

In the sketch above I've assigned the dark values to the mid ground, the mid values to the background, and the lights to the foreground.

On page 156 is *White Pine,* a painting done from this value sketch.

I could have assigned the values in *White Pine* differently; in fact, there are six possible combinations, as shown, at right.

The subject matter or the hues used make no difference; any painting can be painted using any of these patterns. In fact, if you'll do the same painting six times, each time with a different value pattern shown here, you will learn much more than I can show you in this book.

Perhaps you can see how dramatically the mood of a painting is

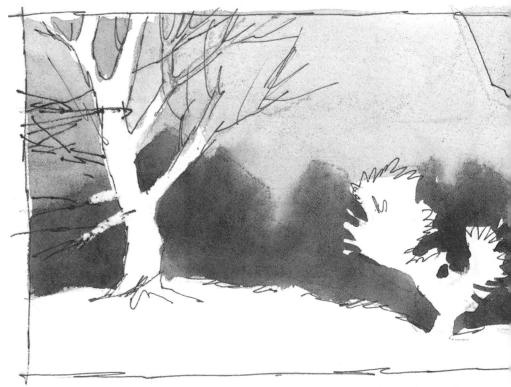

Once you have the sketch you want, decide which part will be the midground. Everything in front of that is foreground; everything behind it is background.

changed with a change in the value pattern.

It's important to remember that the value sketch is a simplification of the values that will appear in the painting. So, although the sketch shows a single-value dark foreground, for instance, it doesn't mean the foreground is painted a single dark value. It's the dark value *range,* so several values will be in there, but largely at the dark end of the scale. Moreover, there will be some mid values—and even light areas in this dark foreground—but they are only incidental. Over all, the area is dark.

It's also important to put these

values into the value sketch before you paint. It isn't a *value* sketch until the values are in it. The temptation is to do a sketch only, and either ignore the values until painting or write the values in with words like light, dark, and so on. *Don't do it! Put* the light, dark, and mid values in the sketch. You cannot judge the relationships between them until you do. And don't move on to the painting until you have a value sketch you like. These decisions will have to be made sometime, and it's much easier on a sketch pad than later when the pigment is flowing on the wet paper and you have only one chance!

We have three "grounds": fore, mid, and back; and we have three value ranges: light, dark, and mid. Assigning the three value ranges to the three "grounds" results in the six possible combinations shown below.

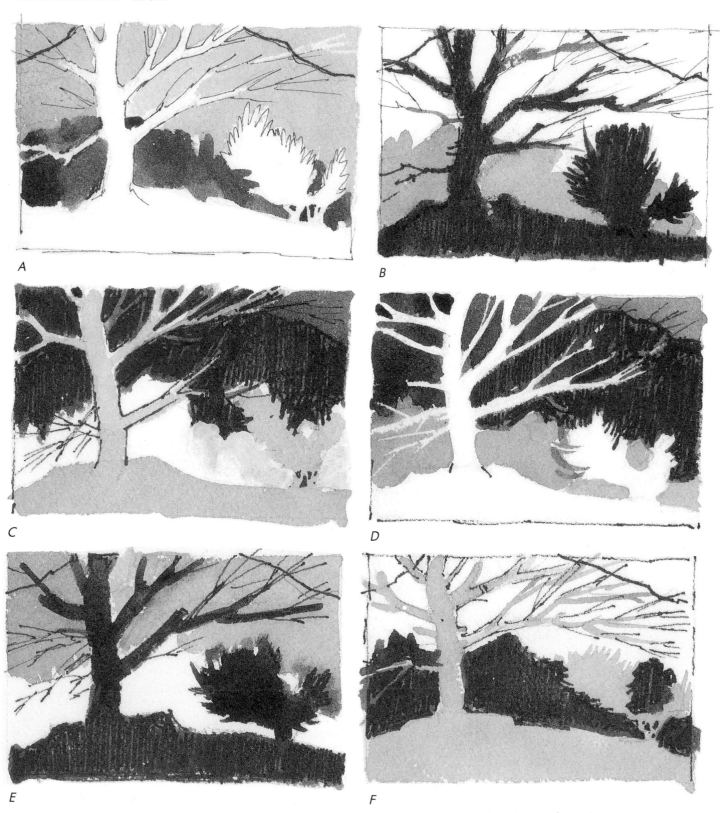

A

B

C

D

E

F

This second group of value patterns applies to any painting. Using patterns for either Group I or II will help you design better paintings by forcing you to organize the values.

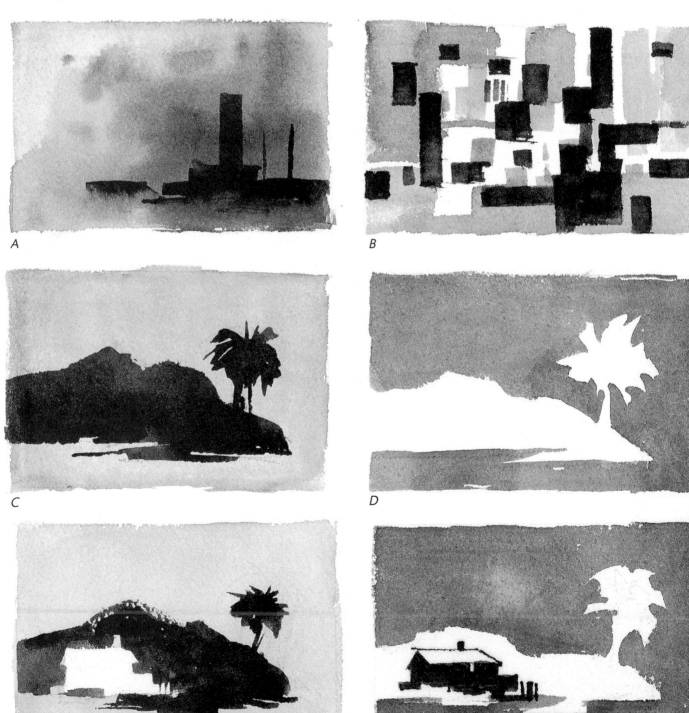

A

B

C

D

E

F

GROUP II VALUE PATTERNS

A few years back, Edgar Whitney analyzed a hundred or so paintings by the masters and prominent American painters. He found all grouped their values into roughly three value ranges: light, dark, and mid values. He also discovered that all the paintings would fit into one of six value patterns using these three ranges. Diagrams of the six are shown, left.

This second group of value patterns has an advantage over the first: while the first group will work only for landscapes and seascapes, the second applies to any painting, including still life paintings and portraits. This is because the second group doesn't depend on a foreground, mid ground, and background.

Patterns A and B are comparatively rare; in A, all three value ranges are blended across the painting using gradation. You can see

Reflections,
22"x30",
by Paul Grant, MWS

Pittsburgh's Market Square,
22"x30",
by Frank Webb, AWS

this value·pattern in the painting
done by Paul Grant on the previous
page.

Pattern B is used for a type of
painting associated with the "Cali-
fornia School," producing a bright,
exciting work. Light, dark, and mid-
value shapes are contrasted by over-
lapping or by placing them adja-
cent: light against dark, against mid,
against dark and so on. Incidentally,
warm and cool colors are simulta-
neously alternated in the same
manner, creating an even pattern of
contrasting value and hue across
the paper—as we see in the paint-
ing by Frank Webb, above.

Most paintings we see or
produce, however, fall into value
patterns C, D, E, or F. You can see

that these four have something in
common: in each there is a large
mid-value field on which light and/
or dark shapes are placed.

In pattern C, the large mid-value
field has a dark shape on it. This is
identical to D, except the dark
shape is now light.

E is only a variation of C: the
same large mid-value field is there;
the same dark shape is there, but
now a small light shape has been
attached to the dark!

Pattern F is very much like D: the
large mid-value field is still there,
the light is there, but now a small
dark shape has been attached to the
light shape.

We'll see how these value pat-
terns build a painting, but first there

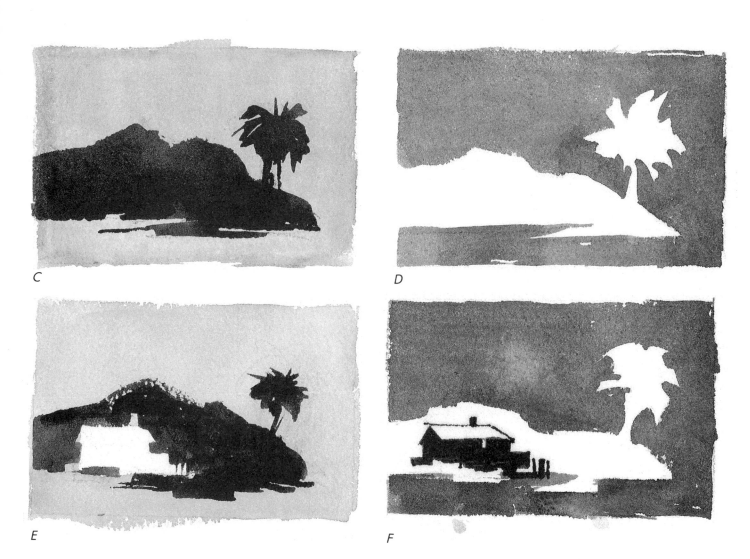

C

D

E

F

In each of these four patterns, we have a large mid-value field on which a large light or dark shape is placed. In E and F, the large shape contains a smaller one of the opposite value.

are a few things about them we should review:

VALUE RANGE

As we saw with the Group I patterns, when we speak of light, dark, and mid values, we are talking about value *ranges*, not just the single value shown in the simplified diagrams on the right. Also, the dark range includes black, and the light range includes white.

The painting should have a "fast-reading" value pattern. This means the darks, lights, and mid values should be easily seen from twenty feet away. If you have difficulty picking them out, squint your eyes until the painting almost disappears. This will cause color to be reduced to value and the minor values to merge with larger areas of like value, bringing the value pattern, if there is one, "out of hiding."

SIZE

The mid values, darks, and lights should be different sizes. The mid value is always the largest and is a field on which resides the smaller light or dark shapes. Either the dark shape should be next in size with the light shape smallest as in pattern E, or the light and dark sizes are reversed as in pattern F.

Think "mama-papa-baby," and you'll do the right thing. Just remember to make papa the mid value and the other two are interchangeable.

The light and dark shapes should be attached in some way, either overlapping or touching, to provide an area of maximum value contrast.

SHAPE

Bear in mind that while the mid value is a large field, the darks and lights are *shapes* and must be well designed. That means two different dimensions, an oblique thrust, and incidents at the edges, as described in chapter 3.

Upon reflection, you might see that planning a painting according to one of these value patterns can trap you into designing the values in spite of yourself.

1. It forces you to apply the principle of repetition with *variation* to the size of your value areas (mama-papa-baby).

2. It forces you to provide a *dominant* value (mid value is always the "papa").

3. Patterns E and F force you to put the sharpest value *contrast* in one spot, creating an interesting area, which is a dandy place for the center of interest!

In reviewing the Group I value patterns, we learned that the light, dark, and mid-value ranges can be imposed upon any of the three grounds, fore-, mid, or background.

Just as there is no sacred value for the "grounds," there is nothing sacred about the shapes in Group II patterns. The sketches at right illustrate how the same painting can be done using patterns C, D, E, or F.

Which value pattern should you use? It doesn't matter. Use whichever pattern best fits the subject matter, the way you want it presented, or both.

Whether you use Group I or II patterns is also unimportant. Use whichever group is easiest for you to understand. The other group will come in time, with practice. You may notice that patterns from Group I can be made to coincide with some from Group II, anyway. That is because they all force you into the same thing: *organizing the values!*

You could select just one of these twelve patterns and paint for the rest of your life with it. Most painters do the body of their work with only one or two favorites. I use Group II patterns E and F for almost everything: it's like shooting fish in a barrel!

In chapter 15, starting on page 147, are several paintings in color with the value sketch from which each was painted. Seeing the value pattern with the painting will help you understand more—and once you understand it, you can do it!

The sketches below show how the same painting can be done using patterns C, D, and F of Group II. Use whichever pattern fits best.

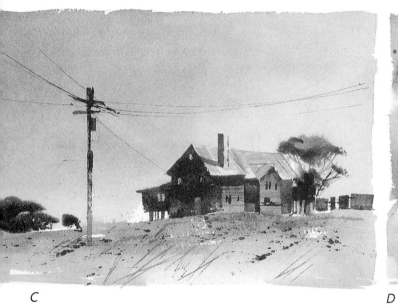

C

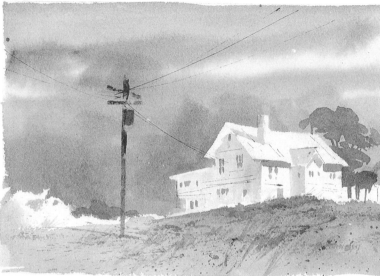

D

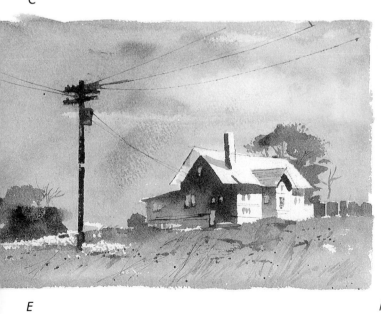

E

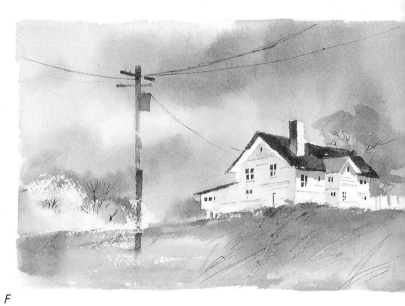

F

Composition
Putting It All Together

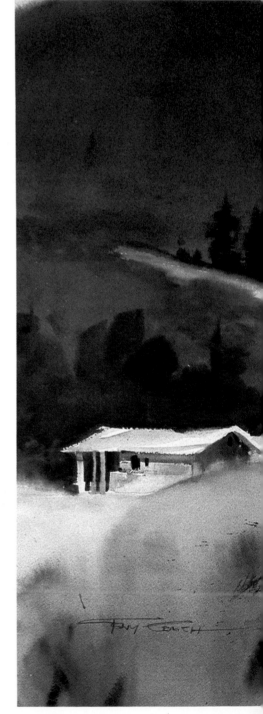

Using the eight principles of design will surely aid us in building a pleasing visual unit; however, there are additional considerations necessary for producing an effective painting. I'll tell you what I know of them here.

CENTER OF INTEREST

Your painting should have a center of interest: a small area more attractive than the rest of the painting to serve as a focal point, or "headquarters" for the eye. It's a resting place from which round trip excursions are made to other parts of the painting.

Without it, the painting lacks a degree of order; the viewer has no clue where to look and must continually search the entire painting—a tiring process.

Your center of interest should avoid the center of the paper, the middle of the top or bottom areas, and the middle areas of either side of the paper, as shown in A.

To do otherwise would be to violate the principle of variation, since this is repeating the distance to two or more edges without varying it. More importantly, this lack of variation will be boring to the audience.

When I consider what will be the center of interest, I ask myself, "What do I want to say in this painting?" and then, "What is the best way to say it?" The best way to

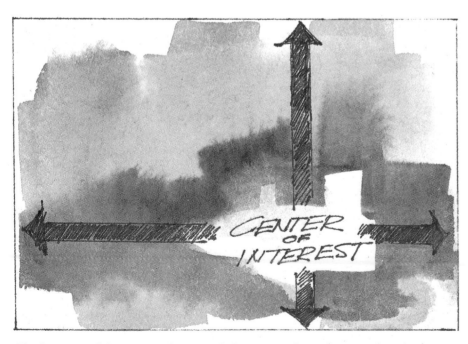

The location of the center of interest is important. It can be any place in the painting as long as the distance from it to the edge of the paper is different for all four edges.

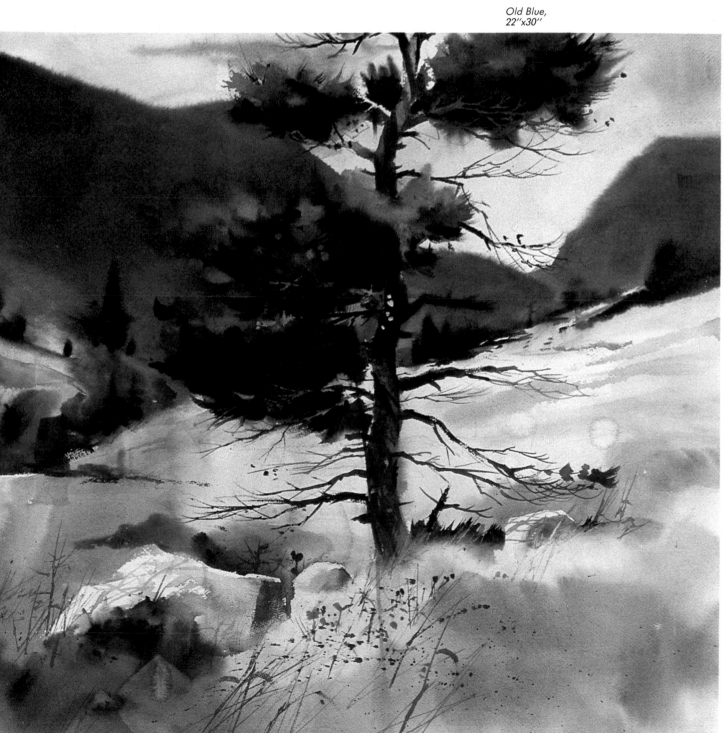

Old Blue,
22"x30"

Another device to create a center of interest is to cross the longest shapes or lines in a painting, as in this detail from Blue Mountain, White Flowers.

A

say it involves several things, but paramount at this stage is to put the "What I want to say" where you can "hear" it: at the center of interest.

"The best way" also dictates, among other things, that I keep it simple by picking one thing to say and then eliminating everything else except for three or four other things to support it.

For example, if I want to say, "Here is a particular tree in the forest," I would paint the particular tree at the center of interest, then support it with a background of trees to tell you the tree is in the forest. I might also, in a break in the forest, indicate a distant field with a small farmhouse or barn to show you this is a *large forest,* not just a group of trees in a city park. I could also support this with tall weeds.

I would also put more detail at the center of interest and less in the rest of the painting. I would put maximum value contrast there. If feasible, I might make the center of interest a shape (in this case, a tree) larger than other like shapes in the painting.

Precisely the same technique is practiced in staging: only one character or group of characters are lit by the spotlight; they're the center of interest at that moment. The rest become the supporting cast by remaining in the shadows and singing or talking at a lower volume than those in the spotlight.

While the theater does the job with *light* and *sound,* we may create a center of interest with the compositional devices mentioned above.

Examine the painting *Lavender Green* on page 148. Is there any doubt which tree is the center of interest?

If I'm worried that the center of interest might be lost, I could also paint with maximum chroma there and make the rest of the painting duller—even gray.

Another device is to design the two longest shapes or lines in the painting so they cross at the center of interest, as in A.

Yet another is to put the "hottest hot" color against the "coldest cold" there.

Of these several devices, maximum value contrast is by far the strongest; for this reason I use it for every center of interest.

There is one thing more I consider when deciding on a center of interest: if I am going to make you look at one place on my painting, I had better have something *interesting* there.

In our travels, we don't point and direct others to look unless we see something more interesting where we point than in the surroundings. We are *pointing* when we direct the viewers' eyes to the center of interest in a painting.

Anything man-made, such as a boat or a house, is more interesting than those things routinely part of the landscape such as trees, bushes, and sky. So I usually make one of these man-made objects the center of interest. If the center of interest is not going to be man-made, then I either have no houses, boats, and so on in the painting or they are very small and in the distance.

If the man-made object must be in the painting and also must be large, it can still be played down enough by running most of it off the painting and putting very little detail and value contrast there, as is done with the building on the right in *Sun in the Rain.*

On the other hand, a common error among novice painters is to create a center of interest through one or several of the devices mentioned earlier, and then provide nothing interesting there!

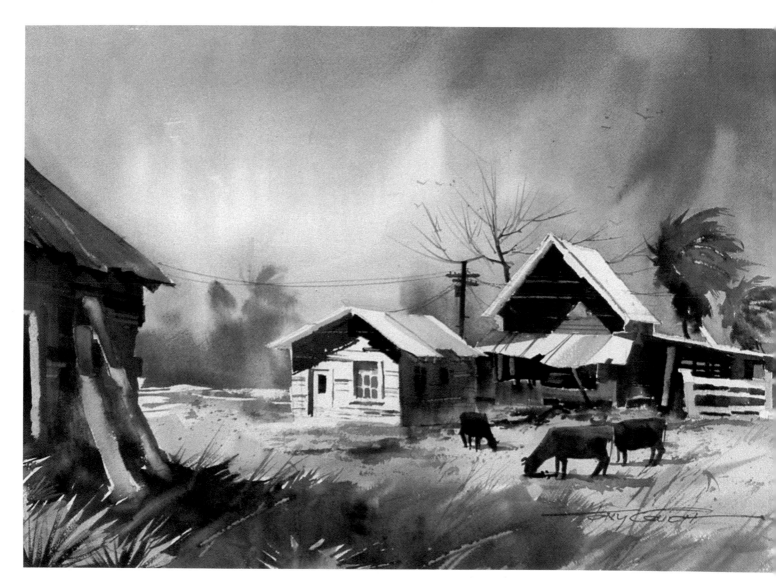

Sun in the Rain,
15"x22"

B

C

In B above, *the converging lines all lead the eye to one spot. In* C above, *the eye is led into the picture by curving lines.*

LEADS AND TRAPS

Once a center of interest is established, it is useful to provide a lead to trap the eye into that area. There are several; among them are

1. Converging lines and shapes or radiation, as demonstrated in B, left: here the road, mountain, power lines, and trees all lead the eye to one spot. These are powerful directors; not all are needed to do the job. The diagram would be effective if only two or three of these converging lines and shapes were used.

2. Curved lines and shapes that lead to one point (a variation of the converging lines, and more pleasing): it might be a single curve or a zigzag as shown in C, left. The usual device is a winding road or stream, or a similar cloud pattern in the sky.

If the shapes/lines are in a zigzag, the twists and turns are more varied—thus more entertaining—if they occur in a rhythm. The runs should be of various length, and no two angles between them should be the same. In D, top, page 79, lines AB, BC, and CD have different lengths, while angles 1 and 2 are varied.

Any object with a point, such as a boat, acts as an arrow and helps direct the eye to the center of interest if it points either toward it or toward something else that in turn points toward it. It should not, however, point to the edge of the painting, leading the eye out.

The same is true for any other moving thing, such as an auto or airplane. Even though they may not be shaped in an arrow, they should face into the painting and preferably

Lines leading the eye into the picture should be varied in length and direction, and no two angles should be the same, as in the sketch below.

D

toward the center of interest. We are used to seeing these things move forward, and if these objects are placed facing the edge of the painting, we get the feeling they're going to move right off the paper.

This is also true for people in a painting. If they are near the edge, have them facing in. There is a powerful urge in all of us to look where someone else is staring. The story about anyone being able to stand on a busy street corner, stare skyward, and cause those passing to look up is true. Again, here is a de-

vice used in the theater: when one actor speaks, all the others turn to face him, so the audience will, too.

THE FOREGROUND

Be careful with the foreground; *keep it simple*. If it is made too interesting, it can easily take over the painting and provide unwanted competition for the center of interest. I see the foreground only as an entrance to the painting.

THE HORIZON

If the horizon will be easily seen in

a painting, its placement is important; the last place it should be is through the center of the paper, as in E, top left, next page, because this divides the paper into two equal parts. This is repetition without variation, hence, boring.

When placing the horizon low, I am careful that the dark area (mountains, trees, and so on) that goes on top of it doesn't extend so high that I have a dark belt also dividing the paper into two equal parts (see F).

As a practical matter, then, I

E

F

G

H

place the horizon high or very low (see G and H).

DEPTH

We are in the business of producing illusions; among them is the illusion of depth, which adds a third dimension to the two with which the paper comes.

We have several tools for the job, but it isn't often necessary to use them all in the same painting. I'll review a few here:

Size of Shapes

Placing the large shapes in the foreground, the mid size in the mid ground, and the small ones in the distance is one of the more powerful devices producing the depth illusion. In fact, to place them in any other sequence is to flirt with a disturbing, "push-pull" effect (so called because we mentally try to push the small shapes behind the larger and pull the larger forward, since that is what we're used to seeing in real life).

This device isn't always a simple matter of similar objects; it may involve the relative size of dissimilar things:

In the painting in I, the depth illusion is compromised, and an uncomfortable "push-pull" sensation is produced by placing the smaller house at the left in front of the larger boat in dry dock. We know their relative size instantly, even if only intuitively, by comparing the windows of the two shapes. Boats and houses are not necessarily the same size, but windows *are*, and the shape with the smaller windows is in front of the one with larger windows!

Subconsciously we want to pull the boat forward and push the house back where it belongs. Some of the comments I overheard when showing this painting were, "I wonder how fast that boat was going when he ran it ashore?" and "How would you like to look out of the window of the shack and see *that* coming at you?"

Seeing my error, I corrected the painting. Which do you like best?

Shape and Line
Making shapes progressively smaller and lines converge in the distance, discussed earlier as a means of drawing the eye to a center of interest, also produces a powerful illusion of depth (see J next page).

Color
Painting distant objects cooler (by adding blue) and those nearer the foreground warmer produces the depth illusion, because this is how objects usually appear in real life.

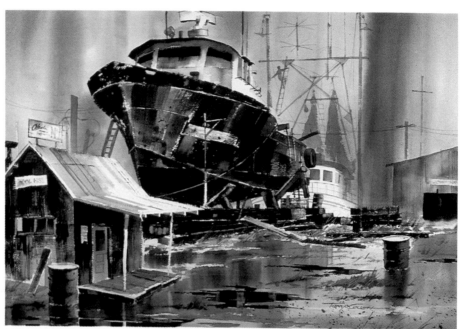

I The first version

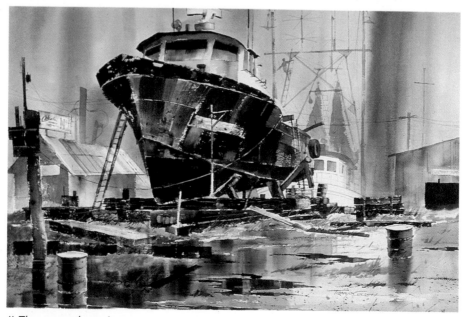

II The second version

Making shapes progressively smaller and lines converge in the distance produces a powerful illusion of depth.

J

There exists everywhere in the atmosphere a haze that is blue most of the time. This thin haze is invisible to us at a two- to three-mile range on an average day, but as we look at objects beyond that range, the blue veil becomes thick enough that objects are influenced by the blue color just as if we had mixed a little blue paint with them.

So a mountain brown with fall leaves would be just that color at close range; it would become duller and purple at mid range (brown + blue = dull purple), and blue in the distance.

But the distant haze isn't always blue. Looking *into* a low sun on a hazy day often produces a light yellow-brown haze, and distant shapes are affected accordingly. Also, a heavy industrial haze has the same effect at *any* time of day.

Value

In general, objects are darker in the foreground, becoming lighter as they go into the distance, thanks to the same haze just discussed. This has merit in producing the depth illusion, but it's not the only way to handle values.

As we saw when reviewing the value patterns in chapter 7, the darks, lights, and mid values may occupy any of the grounds; fore, mid, or back.

Texture

Rough texture gives the illusion of detail; hard (smooth) texture is neutral, and soft texture says there is no detail. Since we can see the detail of near objects and less as they recede until there is no detail in the distance, rough texture in the foreground, hard in the mid ground, and soft in the distance gives the illusion of depth.

Clouds are an exception to this rule, however: cumulus clouds closest to us are large and soft, while those in the distance are smaller and harder edged.

THEMES

In music, a theme is a melody recurring throughout a composition, giving it a measure of unity.

The same may be applied to painting, for the same purpose. Rather than notes, the recurring theme might be a combination of colors or other elements. It could be a combination of similar lines and shapes: curved lines with curved shapes; straight lines with rectangular shapes; angular lines with angular shapes (see K, below). Anything recognizable that recurs throughout a painting creates a theme.

A theme can be used to create a mood: angular shapes and lines lend a feeling of movement, or action, and greatly enhance the mood of an action painting, such as an athletic event or a construction site. Horizontal straight lines with hori-

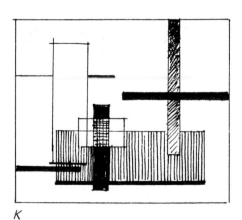

K

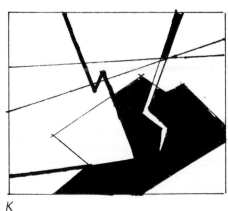

K

K

L

zontal rectangular shapes fit a quiet mood, such as one might choose for a painting of a wake. A theme of curved shapes with curved lines would fit a scene depicting slow movement, such as a sailboat plowing through a rolling sea.

BEWARE THE OBLIQUE!

An oblique line is neither horizontal nor vertical; it's a slanted line. An oblique shape is one that is either slanted or has a good portion of one or more edges slanted.

I am careful to *avoid* running long, steep oblique lines or shapes off the edge of a painting, as in L. Just as a ball will roll down an incline, there is a tendency for the eye to travel along these obliques, right out of the painting! Like the ball, velocity increases with an increase in length or angle.

The problem is easily solved by breaking a long run with a shape or turning it to leave the edge of the paper at nearly a right angle, illustrated in M. Another method is "hiding" the oblique line or shape by keeping the values of it and its surrounding background very close.

I suspect, to the novice painter, these additions to the list of things one must consider while painting make the task appear too cumbersome to attempt. But the reverse is true: if it seems complicated, it's only because you're seeing all of it at once, for the first time. As you gain experience, however, more and more of it becomes second nature. Then, instead of an impediment, each item becomes yet another tool that makes the job easier and more certain!

M

Do you remember how complicated driving a car seemed when you first thought of learning to drive? How complicated is it now?

Absolutely, with practice, you will assimilate these eight principles and additional items so they become your best friends. Absolutely, *you can do it,* and I don't care who you are or how new all this is to you.

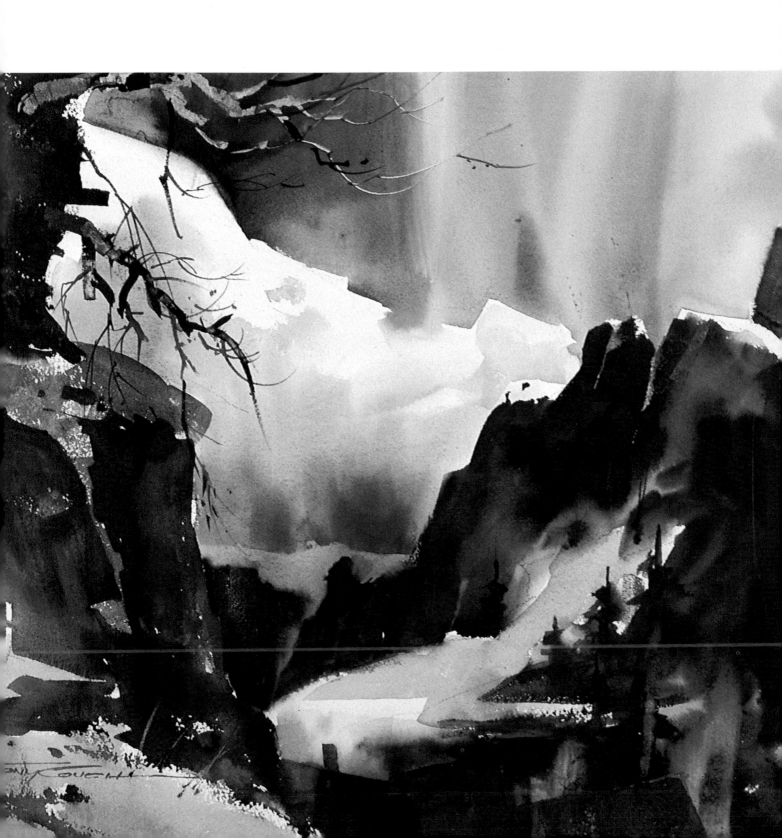

Technique
Ways to Handle Watercolor

Peak of Snow,
15"x22"

So far, we've covered the "mechanics" of painting: equipment, control, and design, including color and value patterns. Let's move now to the "firing line" and put this information to work in a few paintings.

First, in this chapter, we'll look at general painting techniques. Then, in the following chapters, I'll show you a few symbols for painting the components of a painting: trees, skies, fields, rocks, water, and so on. Next, we'll see why, where, and what I paint, then how I do it, with three step-by-step demonstration paintings.

Finally, in the last chapter, we'll review some of my past work with the value sketches from which they were painted, and examine the work of a few other artists, too!

GRADATION

We saw in chapter 5 that gradation is the gradual change from something to something else and is one of the eight principles of design. This change makes an area more interesting, or entertaining, and may be applied to all seven elements of design: size, shape, line, direction, color, value, and texture. As a practical matter, however, I seldom use it on anything but color and value.

My usual procedure is to gradually change the hue, value, or both in a soft blend across a space or within a shape. Although it is particularly useful for creating interest in large, otherwise uneventful areas, such as a sky, field, or body of water. I use it at every opportunity regardless of area size. Even a one-half-inch square window pane, for example, is more attractive when graded in value from top to bottom.

In the painting on the left, you can see gradation in value in the sky where I graded it from dark at the left to lighter at the right. It is also cool on the right graded to warm on the left. The snow-covered slope in the mid distance is light at the top where it faces the sky, graded to a darker value as it turns out of the light.

Gradation is a valuable tool, but requires some practice to master, so it's best to go through a few drills before trying it on a painting.

Starting with a piece of dry paper, wet a box about 5-by-7 inches with clear water until it glistens. With a one-inch flat brush, select any dark color or combination of colors from your palette, being careful to get out the excess water. Now stroke the dark pigment horizontally across the top of the box. With slightly overlapping strokes, continue down the box. The value of the color should become slightly lighter with each stroke as less and less pigment is left in the brush.

85

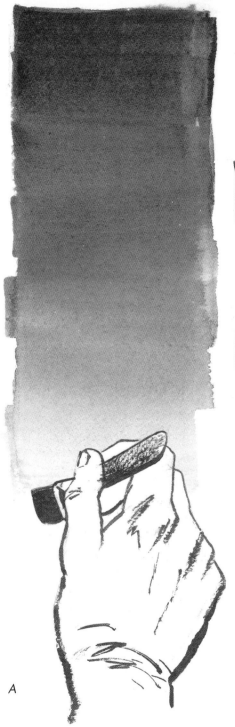

Practice making graded washes so you achieve a gradual uniform change in value from dark to light as in A, left, and around shapes as in B, below.

B

A

If it isn't getting lighter, dip the brush into the water can, striking the bottom. Get the excess water out, then continue as before. More pigment will have left the brush via the water can trip, so the box should gradually be getting lighter with each horizontal stroke. Continue to the bottom, and you should have a gradual, uniform change in value from very dark at the top to very light at the bottom, as in A.

If the gradual change isn't smooth enough, some adjustments must be made, which is simple enough if the entire box is still soaking wet. Suppose the bottom is too dark: rinse the brush in clean water, striking the bottom inside the can a few times to get the pigment out. Now dry the brush on a wad of facial tissue to get the maximum amount of water out.

Stroke the bottom of the box with the same horizontal stroke as before, but slowly to allow the thirsty brush to pick up the wet pigment as you go. Work up the box now, and the brush will pick up

less and less pigment as it becomes saturated. Not light enough yet? Repeat the process.

Too abrupt a change from dark to light? With a clean, half wet brush, stroke the dark area back and forth, moving down into the light area. The brush will "borrow" some of the dark and transfer it to the lighter area. Again, all this must be done rapidly, while the entire box is still soaking wet.

Area not dark enough? Go into it with a brush with more pigment than water and stroke this area again, working down to the lighter area, as before. If the paper is still soaking wet, there is no danger of a back run.

When you have this technique down, draw a shape in the middle of a box and repeat the drill, this time painting around the shape, as in B. This exercise is helpful, because often, while using gradation in a painting, you'll also have to paint around a shape.

Practice these drills until you can do them instinctively; then you'll

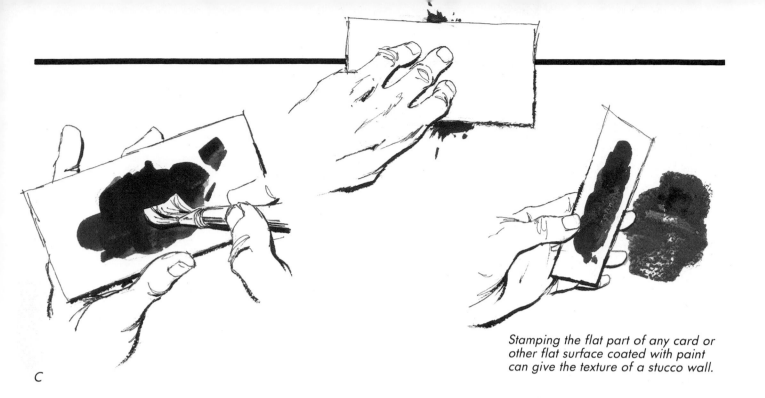

C

Stamping the flat part of any card or other flat surface coated with paint can give the texture of a stucco wall.

have no qualms about using them often in your painting. It only takes a few minutes to do each drill, and it's an excellent exercise when you don't have enough time to do a whole painting.

COOL AGAINST WARM

In impressionistic painting, we have plenty of "color latitude," that is, discretion in deciding which hue to paint a given shape. In many cases, the object we are painting can be a variety of colors, so we can take our pick. While we should maintain a color dominance, placing a warm against a cool color whenever possible creates an exciting but subtle contrast all over the painting, making it more interesting.

Another cool/warm contrast technique is to start a painting with a wash of very light-value warm shapes over the entire paper, overpainted with very light-value cool shapes—leaving gaps for a little warm to peep through. This provides an underpainting with a subtle glow, over which the rest of the work may be painted.

A third method is to gradually change a shape or large area from warm to cool, using gradation. This is especially effective in a sky, for instance, which can be graded from

left to right, top to bottom, or the reverse.

STAMPING

Here's a useful technique made popular by the "California School" of watercolorists. Merely cut out of cardboard, plastic, or other rigid material a shape you want reproduced. Then coat it with paint and stamp it upon the paper!

Similarly, the edge of a credit card or razor blade can be used to

produce a thin straight line. For a thicker line, use something thicker, such as mat board, or drag the credit card perpendicular to the direction of the line (see C).

Stamping the flat part of any card or other flat surface coated with paint can give the texture of a stucco wall, as in D. Alternately, pressing a card coated with clear water onto a wet painting often produces the same result.

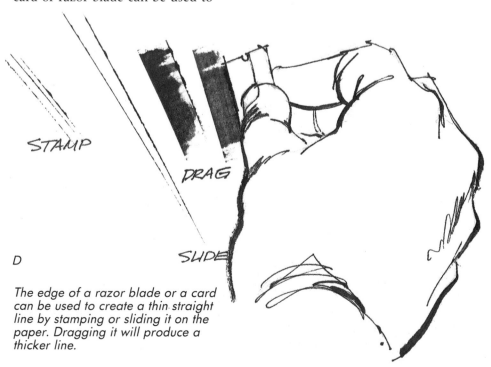

STAMP

DRAG

SLIDE

D

The edge of a razor blade or a card can be used to create a thin straight line by stamping or sliding it on the paper. Dragging it will produce a thicker line.

Cut a stencil from thin plastic and use water and facial tissue to lift a lighter shape from a darker one.

E

If you're painting tropical vegetation, cutting a palmetto stencil out of thin plastic (film) or other material is ideal for lifting a light palmetto leaf shape out of a darker background. Starting with a dry area, put the stencil in place, and rewet the spot with clean water. Then wipe out a lighter area with facial tissue (see E).

SPLATTER

Here's a technique easy to employ, used by everyone, and as old as the hills, yet that never seems tiresome. A splatter of darker pigment on a lighter area gives the illusion of several things: clumps of dirt on a field or wall, burrs and assorted growth in a patch of weeds, the few remaining leaves on a bare winter tree, stains on weathered boards—the list is endless; you'll invent your own uses.

It's simple to do, using any brush from a #8 round to a one-inch flat loaded with pigment and plenty of water. Hold the brush horizontal to the paper and just high enough to allow four fingers of your other hand under it, as in F. Now lift the brush and bring the ferrule down smartly on your fingers (it won't hurt) and—splat! There's a splatter pattern.

If you didn't get anything, the brush wasn't wet enough or you didn't hit your hand hard enough.

If it's too light, you didn't have enough pigment in the mixture. If the paper is dry, the splatter pattern will dry just as you see it, and will be most effective. If the paper was wet when you splattered, the pattern will diffuse into something else.

To keep the splatter from going where you don't want it, be sure to keep the brush low to the paper, or lay a piece of paper over the "no splatter" area before you fire.

An allied splatter tool is the toothbrush. Simply make a puddle in your palette and soak it up into a toothbrush. Then hold it close to the paper and run a thumb over it. Result is a very fine pattern, seen in G. It's too fine for most uses, but

F

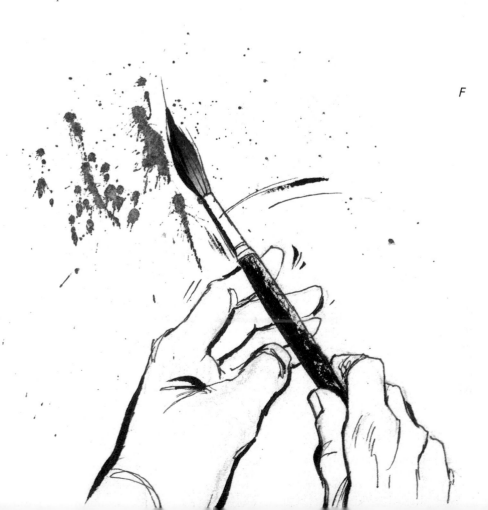

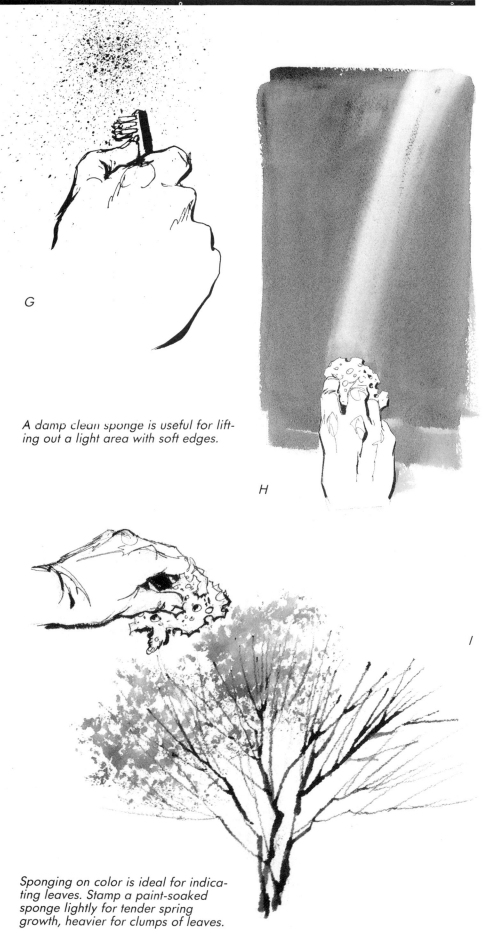

Running your thumb over a toothbrush soaked in paint makes a very fine splatter pattern.

G

ideal for fine buds at the ends of branches on a bare tree in spring.

SPONGING COLOR ON AND OFF

Working wet on wet, any area inadvertently covered with a wash can be wiped clean with a barely damp, clean sponge. It's particularly useful in lifting out a light area in the sky where a soft edge is mandatory, and the operation must be completed while the paper is still very wet, as in H. It *can* be done with facial tissue, but the edges often dry in a hard line.

Sponging on color is ideal for indicating tender new leaf growth on a spring tree or full clumps of leaves. I make a puddle in my palette of whatever colors the leaves will be and pick it up with a clean, damp/dry sponge and stamp it onto the paper. Lightly for tender spring growth, heavier for clumps of leaves (see I).

This same technique also produces a stucco effect when stamped onto a wall, and a clean damp/dry sponge, pressed into a freshly painted rock shape will lift off some of the color in a "sponge pattern" and give the illusion of moss on the rock. Your imagination will direct you to other uses.

A damp clean sponge is useful for lifting out a light area with soft edges.

H

I

Sponging on color is ideal for indicating leaves. Stamp a paint-soaked sponge lightly for tender spring growth, heavier for clumps of leaves.

LIFTS

"Lift" is the technique of lightening a portion of a dark area by lifting out pigment with a clean, "thirsty" brush.

It's typically used to show the sunlit side of a shape or to lighten the lower part of a wall, the underside of a rock, and so on. It must be done immediately after the initial dark wash is laid on white paper, while it is still wet. I quickly rinse the brush in clear water and squeeze all the water out with my fingers or facial tissue, creating a thirsty brush. I put several strokes into the desired area, and if it's still wet, the dark pigment will be sucked up into the brush, leaving a lighter version of the original hue.

If nothing happens, you either waited too long (the paint is too dry) or the initial wash was put over a darker underpainting so that the lift cannot be seen. It must be on white paper!

If you got a lift, but it closed back up, you were too fast; the dark wash was still too wet. Wait a few seconds and try it again, or next time, don't make the wash quite so wet.

Caution: You cannot rewet a dry passage and hope for a lift; it won't work. It must be the initial wash on white paper.

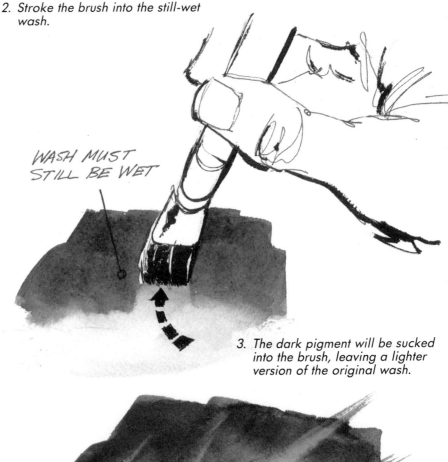

1. Squeeze all the water out, creating a thirsty brush.

2. Stroke the brush into the still-wet wash.

WASH MUST STILL BE WET

3. The dark pigment will be sucked into the brush, leaving a lighter version of the original wash.

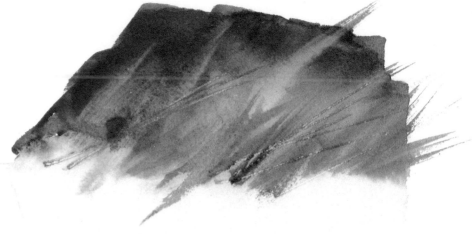

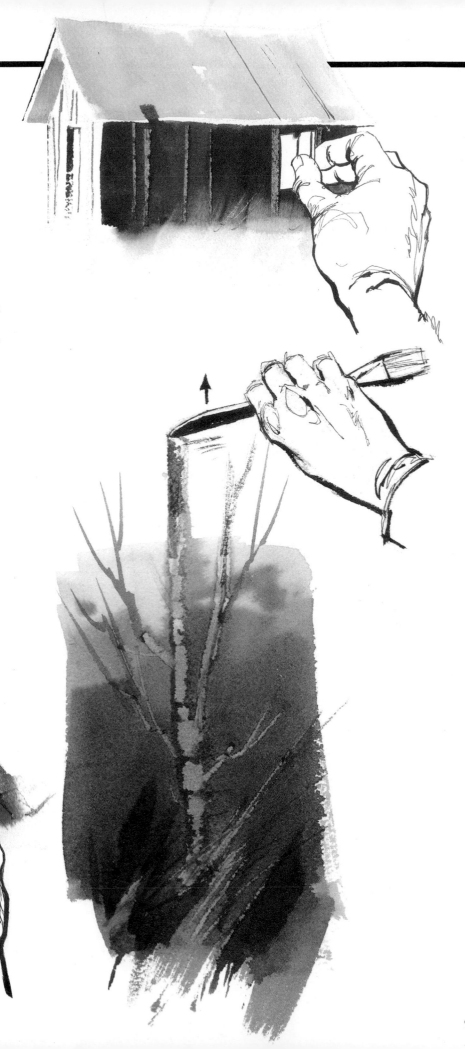

A "scrape" can be made with any sharp, flat tool such as a razor blade or brush handle.

SCRAPES

The brush lifts just discussed result in a lighter area with soft edges. If a sharp-edged light area is required, a sharp, flat tool like a single-edge razor blade is an excellent device. It's a "scrape" instead of a "lift," but the results are the same.

An advantage of the scrape over the lift is that you have more time to make the mark. That is, the dark wash is less likely to creep back in when you scrape too early, and you can still scrape in a light area when it's too late for a lift.

When a light line in a dark area is needed, it can be scraped in with any sharp tool: a pocket knife, end of the brush, and so on. These are ideal for scraping out tree symbols and weed marks from a dark, wet shape. Again, if the paper is too wet, the light mark will fill back in, this time leaving a mark darker than the background. If it is too dry, there will be no mark.

ERASER LINES

Upon occasion you may need a light, soft-edged straight line over a darker background. For example, light wave marks on a still body of water, or a thin shaft of sunlight.

The easiest, most attractive way to accomplish this is to lift it out with the sharp edge of a flat thirsty brush, while the paper is still wet. Failing this, however, it can be done with an ordinary office pencil eraser and a straight edge after the paper dries. *The paper must be bone-dry*, or damage to the paper may result. I lay the straightedge along the desired line and rub the edge of the eraser back and forth with medium pressure until the line is as light as I want it.

Rewel to loosen the pigment.

Wipe out with tissue.

Burnish with an eraser.

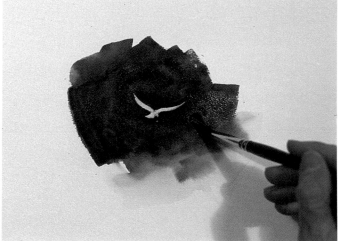

Paint around the new light shape.

REGAINING A SMALL, LIGHT SHAPE

I normally execute a small, light shape by painting a dark shape around it. However, if I accidentally paint over this small, light shape, all is not lost; it can be easily regained.

The illustrations above show you how it might be done, in steps.

After the dark background has dried, I rewet the area where the missing light shape should be. After giving the water a minute to work some pigment loose, I wipe it out with a dry facial tissue and repeat this operation until the area is as light as I can get it. When it is bone-dry, I burnish it with a plastic or art gum eraser, regaining still lighter paper.

Now I draw in the missing light shape. I rewet the dark area around it and paint around the light shape with pigment approximately the same hue and value as the background.

The light shape will hold up because I left the paper dry there, and I "lose" the edge as it goes into the dark area because I rewet the paper. Net result is exactly the same as if I had originally painted around the light shape while painting the dark.

THE PLANE-CHANGE ACCENT

Look at the illustration below. When painting a building with one side facing the light source (A) and the other out of the light (B to C), it will look more realistic if you'll make the dark side darkest right at the edge where it turns out of the light (B). This is called the "plane-change accent" because of the dark accent where the plane changes from one facing the light to one not facing it.

Here's what is happening: side A is lightest because it faces the sun. On the shaded side, C is lighter than B because light from the sun is reflected off the ground and lights this side from the opposite direction. Since it only receives reflected light, which is weaker than the source, C isn't as light as A. Since B is farther from this reflected light source than C, it's the darkest part of the shaded side.

Also, the reflected light (C) from the ground is always warm, so the C areas of a white wall will always have a pale warm glow, graded to darker and cooler away from the reflected light source. This phenomenon exists in real life, but it's very subtle, and I exaggerate it.

The technique for achieving this is simple gradation, as explained earlier in this chapter. In this case, it's grading from dark to light and cool to warm at the same time.

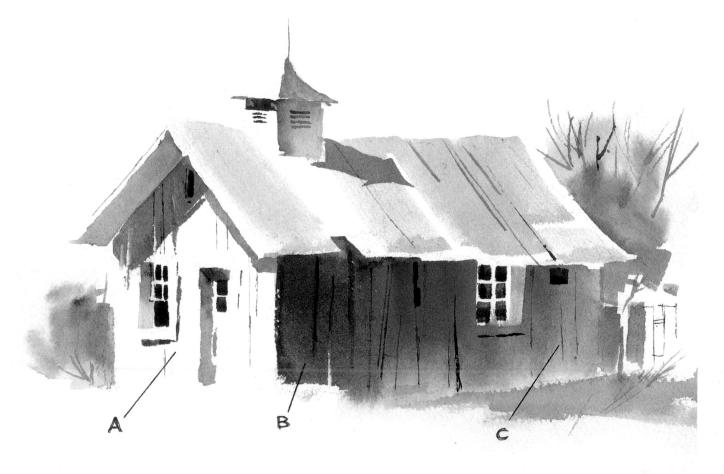

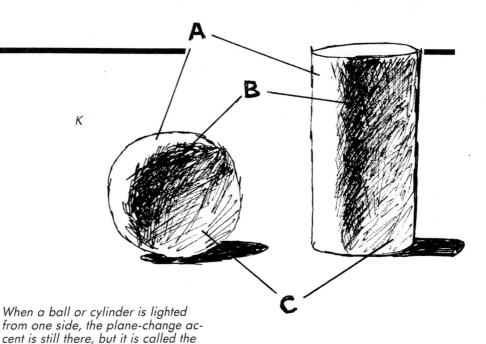

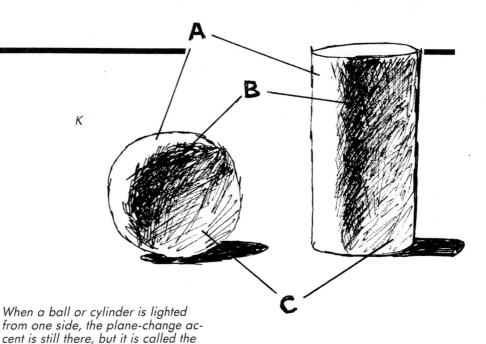

When a ball or cylinder is lighted from one side, the plane-change accent is still there, but it is called the "core" of the shadow.

THE CORE OF THE SHADOW

Exactly the same thing happens to any cylinder or ball shape that is lighted from one side. The same plane-change accent is there, but since the shape is round and has no planes now, it is called the "core" of the shadow (see K). Also notice that the core has soft edges; soft texture is necessary to give the illusion of roundness. A soft edge says the shape is round; a sharp edge says "angular."

There are several techniques for producing a core on a cylinder such as a silo; L illustrates a simple one:

1. I wet the entire cylinder with clean water, then, using a round brush (#8 or so), I stroke on a dark core. It should be closer to the right or left edge of the silo, anyplace but the center. A core lying in the center divides the shape into two identical halves, which violates the principle of repetition with variation and is boring space division.

I think "dry on wet" (chapter 2) when painting the core. I need a lot of pigment and little water in the brush for the core to be dark enough and hold its shape. I know the paper is wet, so the core will dry a lighter value.

2. Quickly, while the whole cylinder is still wet, I fill in the shaded side with a wet brush, remembering to make it slightly lighter and warmer at the base (light bounce).

3. While it's still wet, I use a sharp instrument—a knife, the brush handle, and so on—and scrape a few contour lines from the dark side to the light. It will leave a light line in the dark area and drag

pigment into the light area, forming a dark line.

The silo in *Dust Storm* on page 45 was painted in this manner.

Some of these "techniques" are simple to perform, and you might be able to incorporate them into your painting right away. Others require some practice, so don't be discouraged if they don't work out well the first few times you try them. You can, with experience, learn them all. They will be valuable additions to your arsenal of painting skills and a springboard to others that you'll discover as you paint.

L

1

2

3

Trees and Foliage
A Collection of Symbols

As we learned in chapter 3, one of the advantages of transparent watercolor is its fresh, spontaneous appearance. The way to achieve this quality is to paint "symbols" for objects rather than to laboriously "report" them in detail, as would a camera.

The transparent watercolorist is continually inventing symbols for those things he wants to paint. To get you started, let's look at symbols for something often found in landscapes: trees—with and without foliage.

TREE WITH NO FOLIAGE

I think of trees as being in three families: pine, palm, and hardwood. The type you'll probably paint most often is the hardwood group, which is any tree that loses its leaves in the winter, or "would if it could" (most of these trees retain their leaves in the winter in tropical climates). In this group, I include oak, maple, gum, walnut, hickory, and so forth.

Seldom is it necessary to paint a tree identifiable as a particular species within these families, so for the hardwoods, I use a standard tree that looks like them all. The particular species, when you must paint them, are only variations of this same standard.

The symbol is a model tree, as it would look if it grew by itself in the open, with unrestricted sun from all directions and no diseases to cause it to lose limbs—as shown on the right. Not all hardwoods look like this, but most do, and if the rest had a choice, they would, too!

The tree has four sections, each with its own thickness:
1. Trunk—thick
2. Limbs—less thick
3. Branches—thin
4. Twigs—thinnest

White Wash Fence,
15"x22"

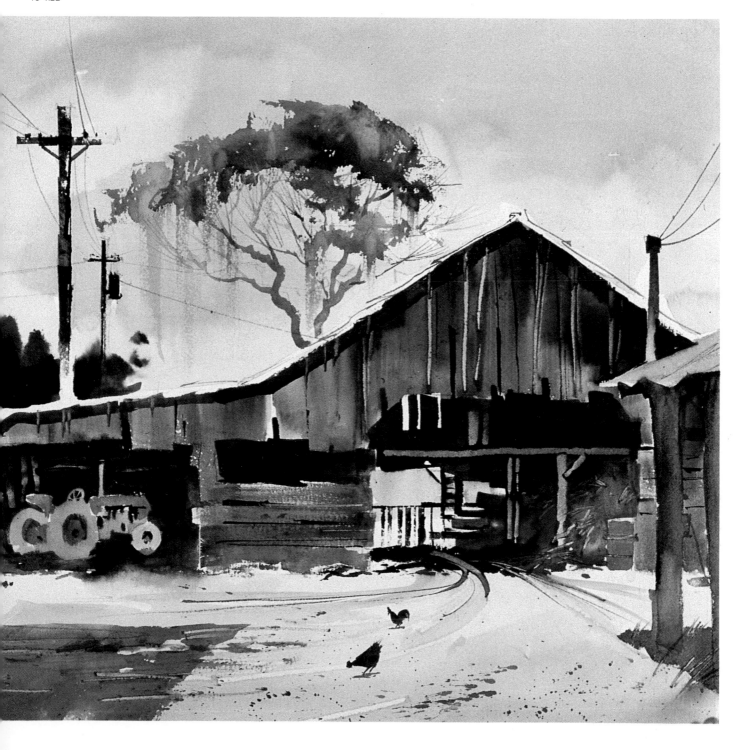

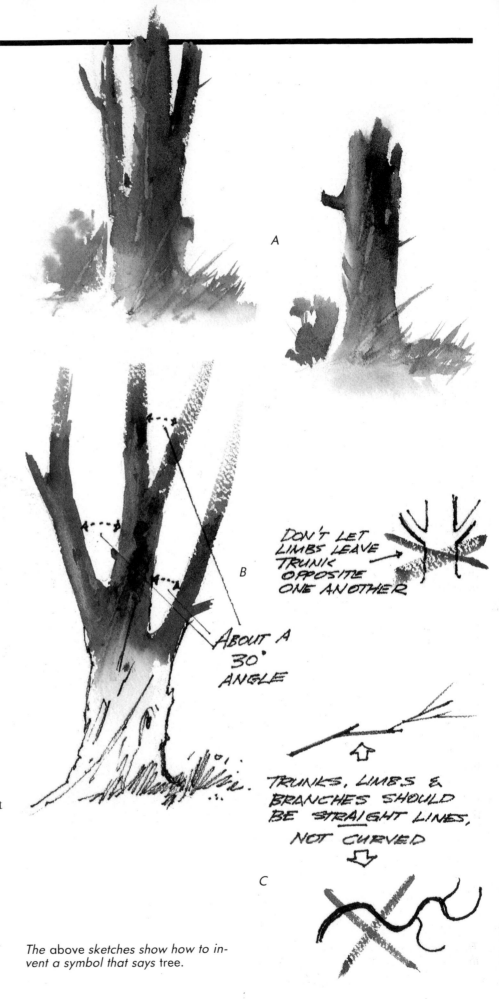

The trunk usually grows out of the ground as one piece, but could occur in a cluster of two or more trunks. In any case, they are the thickest part of the tree and are vertical or near vertical (see A).

From the trunks grow the limbs. They're not as thick as the trunk, but thicker than anything else on the tree. Think of them as extensions of the trunk that have split into several limbs. These limbs leave the trunk at roughly a thirty-degree angle, as shown in illustration B.

There are two things to watch here: (1) I don't let two limbs leave the trunk directly opposite one another, and (2) I don't let any two limbs leave the trunk at the same angle. Instead, I stagger the position and angle slightly. Remember, it's *roughly* a thirty-degree angle; about five degrees either side still looks like thirty. The design principle involved here is the same old repetition with variation.

The trunk and limbs should be straight or angular shapes or lines, as opposed to the curved trunks and limbs you may see in real life. When they change direction, I give them an angular change. *Curved* is not the symbol for a tree; *straight* and *angular* is (see C).

I should reemphasize at this point that I am not painting a tree, but *inventing a symbol* for one.

The trunk retains its same thickness along its run until a limb comes off it: after this point, the trunk is less thick than it was. The same process is repeated as each limb leaves the trunk until there is no trunk at all; only a split into the last two limbs.

A

B

DON'T LET LIMBS LEAVE TRUNK OPPOSITE ONE ANOTHER

ABOUT A 30° ANGLE

TRUNKS, LIMBS & BRANCHES SHOULD BE STRAIGHT LINES, NOT CURVED

C

The above *sketches show how to invent a symbol that says* tree.

Once a limb leaves the trunk, it splits into smaller *branches*. The process is identical to the trunk-limb split: the branches are thinner, they should be shown as straight or angular lines, and none should come off the limbs opposite another. The limbs retain their thickness until a branch comes off, then become thinner, eventually disappearing as a split into the last two branches.

Now here's a difference: while the limbs leave the trunk at about a thirty-degree angle, the branches do something else. At the *top* of the tree they leave the limbs at about a thirty-degree angle, but as they descend the tree the angle becomes wider until about two-thirds down, the branches are horizontal. Branches below this point are fewer, and slant toward the ground at a progressively more acute angle as they descend the tree (see D).

At the same time, the length of the branches vary. Fairly short at the top, they become gradually longer as they descend the tree. They reach maximum length two-thirds down, or at the horizontal position. Below this, the branches become abruptly short again.

The "leaf" symbol shown in E will remind you of what to do with the branches.

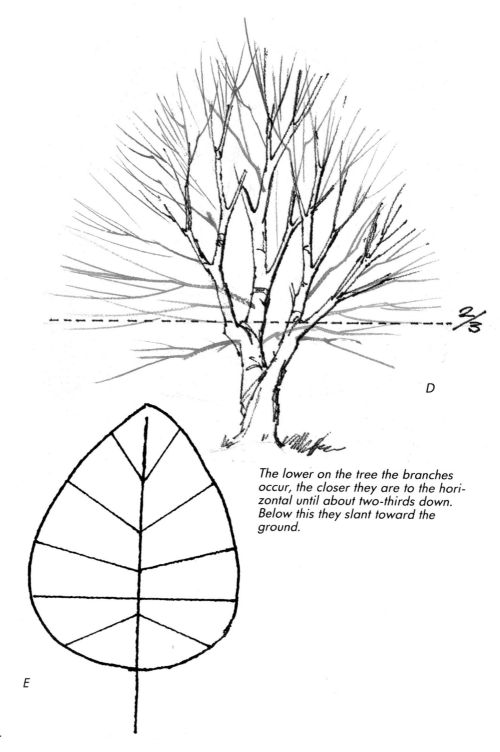

D

The lower on the tree the branches occur, the closer they are to the horizontal until about two-thirds down. Below this they slant toward the ground.

E

This "leaf" symbol will remind you of the directional pattern of the branches.

Last come the twigs, which are thinnest and fan out from the ends of the branches. These are either straight or curve gracefully upward toward the sun. These fine twigs are important, since, without them the tree appears dead rather than one that has merely shed leaves for the winter, as in F.

Painting a particular species of hardwood is simply done by varying this standard tree. For instance, an oak tree is effected by adding a few twists to the trunk and making the limbs and branches twisting shapes and lines instead of straight or angular. Everything else remains the same (see G). A eucalyptus would have gracefully curved limbs branching from a short trunk, but the rest would be the same.

Sometimes a young tree will have no limbs and will go directly from trunk to branches, as seen in H. The same formula for branches applies. Saplings and bushes are done exactly the same way.

By using this standard tree, you'll avoid the odd, awkward-looking trees with which the novice is plagued. I remember well my own frustrations with trees until I discovered this basic symbol. I learned how to do it; *so can you!*

TREE TRUNKS

Limbs, branches, and twigs are usually so thin that they are lines or very thin shapes. So it's a matter of "drawing with the brush" straight, angular, or curved lines, following the standard tree formula.

The trunk needs more attention, however, since it's usually wide

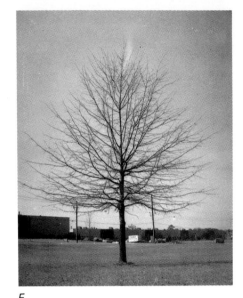

F

Sometimes a young tree will have no limbs and will go directly from trunk to branches.

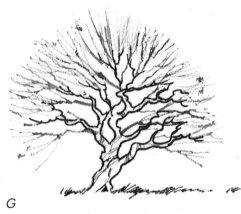

G

To paint a particular species of tree, vary the standard tree. An oak needs a few twists to the trunk and twisting limbs and branches instead of straight or angular ones.

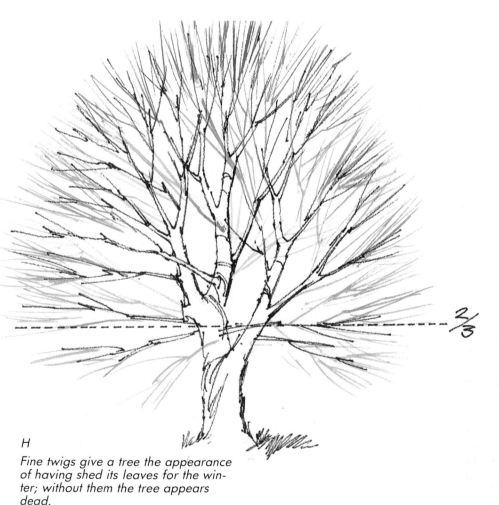

H

Fine twigs give a tree the appearance of having shed its leaves for the winter; without them the tree appears dead.

I usually paint the whole trunk at once with any light value, cool at the top and a warm light such as raw sienna at the bottom. While it is still wet I paint the shaded side a darker value, allowing the two colors to blend where they meet. This soft edge gives the trunk a round appearance.

enough to require some modeling. That is, a light and a shaded side, and even a core of the shadow if the trunk is wide enough.

I put trunks into three size categories—small, medium, and large—and render them accordingly.

If it's small, as on a distant tree, I merely indicate a line for the trunk, as well as for limbs and branches.

A medium sized trunk will need some modeling, else it will appear flat and artificial.

It's enough in these cases to merely decide where the light is coming from and make that side of the trunk lighter than the other.

I usually paint the whole trunk at once with any light value, cool at the top and a warm light such as raw sienna, at the bottom. While it is still wet, I paint the shaded side a darker value, allowing the two colors to blend where they meet. This soft edge gives the trunk a round appearance (see I). I am careful not to allow the trunk to become half light and half shade: one or the other must be dominant.

I am also careful to vary the color and value along the length of the trunk, even though in reality the trunk doesn't have these varieties. Remember, we are *entertainers,* as well as shape makers and symbol collectors. An example of this is making the trunk lighter and warmer at the bottom and darker and cooler higher up to give the illusion of light bounce from the ground and a reflection of blue sky at the top. By the way, this also provides a nice warm-cool color contrast, as well.

Here's another technique for instantly creating light and shaded sides with a soft transition between them that's handy for long, thin trunks: with a flat, very wet brush, pick up some pigment on one corner of the brush only, leaving the other carrying clean water. Starting at the base of the trunk, move upward along it in one slow, continuous stroke, running the charged

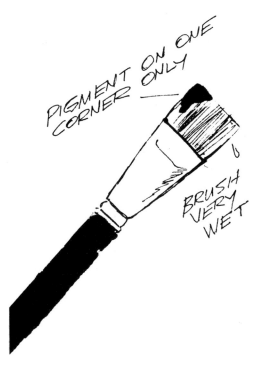

PIGMENT ON ONE CORNER ONLY

BRUSH VERY WET

To paint the light and shaded sides of a tree trunk in one stroke of the brush, pick up some pigment on one corner of a flat, very wet brush, leaving the other corner carrying clean water.

edge of the brush along the dark edge of the tree. Result is a round-looking trunk, as shown, right. A few dark, soft spots might be added while it's still wet to indicate places where branches once were. Scraping some pigment from the dark to light side with a knife, also done while the trunk is still wet, gives the illusion of roundness.

A *large* tree trunk is more dramatic if it has a core as well as light and shaded sides, as you see in the painting *Lavender Green,* below. This is done in exactly the same manner

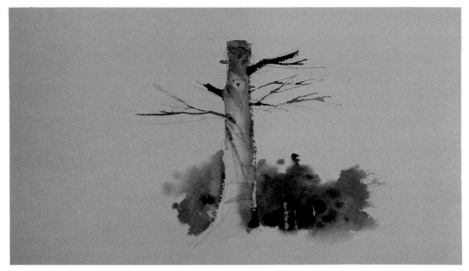

Start at the base of the trunk and move upward, running the charged edge of the brush along the dark edge of the tree. A few dark spots and horizontal scraping complete the illusion.

as the silo earlier on page 95. As usual, the trunk should be lighter and warmer at the bottom because of light bounce. The change to dark

at the top of the trunk is perhaps too dramatic in *Lavender Green,* but even this exaggeration doesn't seem terribly abnormal.

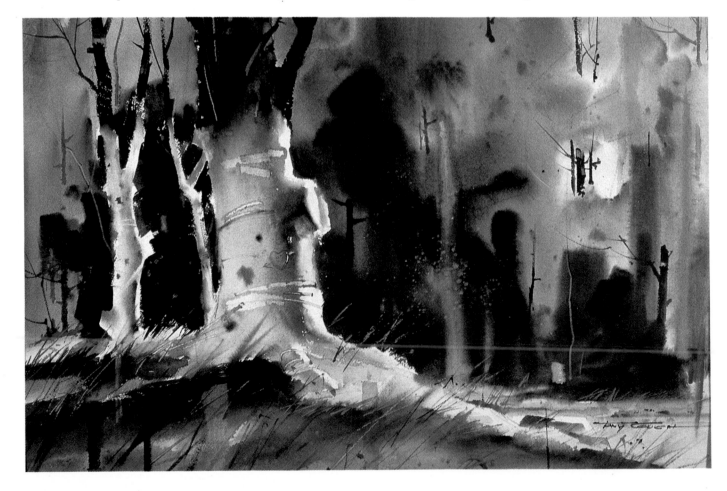

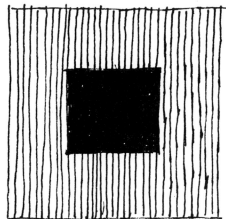

The two squares on the gray background are the same size and the same distance from you. Yet, the light one appears closer.

TREE WITH FOLIAGE

One of the more notorious stumbling blocks for the novice watercolorist is the technique of painting a tree with foliage. There are several ways to do it; here is one. You'll invent others as you gain experience.

First, I fix a pair of objects in my mind:

1. I'm not painting any particular tree; I just use a symbol that will cover all hardwood trees.

2. As always, I want to greatly simplify what I see in real life.

Therefore, I forget all the individual leaves I see on trees; it isn't necessary to paint any of them! Instead, I paint the foliage as big clumps of leaves.

I keep one other bit of information in mind: look at the diagram, top right. The two squares on the gray background are the same size and the same distance from you.

Yet, the light one appears closer! It's an optical illusion, but we're in the illusion business, and we can use it: since light shapes appear closer, and darks recede, I'll paint the clumps of leaves closest to me light and those farthest dark to give the tree an illusion of depth.

I sketch with a light pencil the outline of the clumps of leaves. There might be twenty on an average tree, but I don't want them. A tree full of leaves can be convincingly painted with as few as one clump: the canopy of leaves at the top.

For demonstration purposes, I'll use more this time. Besides the canopy, I'll have a clump on the near side, one on the far side, and one on either side (see J, below).

Remember that we are painting a symbol for a tree; the leaves are considered as a few large clumps.

J

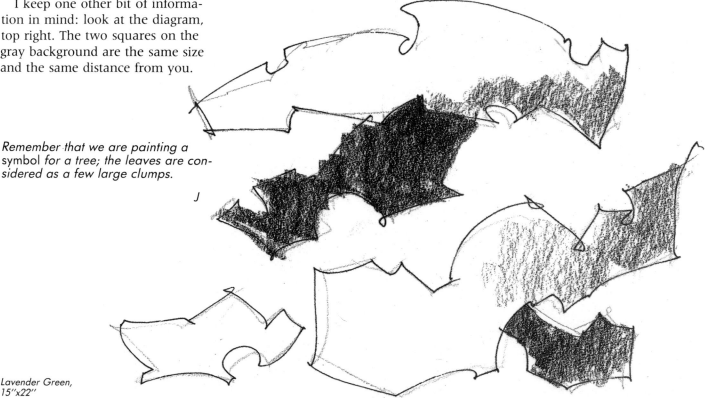

Lavender Green, 15"x22"

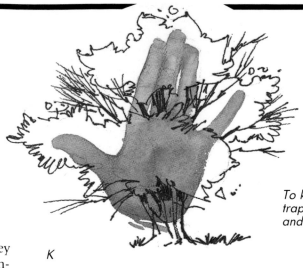

To keep out of the "lollipop-tree" trap, use your hand with the thumb and little finger extended for a model.

K

THE SHAPE:

Since the clumps are shapes, they should have two different dimensions, an oblique thrust and incidents at the edges. They should also be varied in size. Moreover, the entire silhouette of the combined clumps—which is the tree shape—should also be well shaped: no round trees, even though round trees might be seen in real life.

To keep out of this "lollipop-tree" trap, use your hand with the thumb and little finger extended for a model (see K). Or visualize a maple leaf shape with clumps of leaves as the extensions.

I'm careful to leave plenty of open space between these clumps; that's where I'll later run the lacework of limbs and branches, which is the label for "tree."

VALUE:

Now I must decide the direction from which the light will come. In the illustration at the top of the page, I've made it from above and the left.

In this case, the canopy clump should be light since it faces the light. The clump on the right side will be slightly darker than that on the left as it is shaded by the rest of the tree. The far side clump will be most dark, and the near side most light to provide depth and also to give the illusion of a dark interior.

COLOR:

The hue of the foliage can be anything I would like to make it, as long as I keep the greens dominantly warm to give the illu-

Vary the shapes of the clumps for interest.

sion of a live tree. An early spring tree is best described with a blend of yellow and yellow-green. A midsummer tree might be dominantly a black-green (olive) with a blend of yellow-green on the sunlit side and blue-green in the shadows.

The foliage in the fall could be a blend of the strongest chroma yellow, yellow-red, red, brown, and even a little yellow-green.

TEXTURE:

The idea is to merge the various hues in the interior of each clump with soft texture, but give the edge a rough texture, since rough is the

label for "leaves." This rough at the edge makes the whole piece look like a clump of leaves. Hence, I don't try to paint leaves; I let the rough texture at the edge do the work for me.

Here's a procedure I might use: I paint the tree one clump at a time. I wet the interior of the clump shape with clean water, leaving the edges dry. Then with a one-inch or so flat brush, I pick up two or three hues: one on either edge of the brush and perhaps a third on the center edge (for a spring tree, for instance, a good amount of cadmium yellow on one edge, about half that

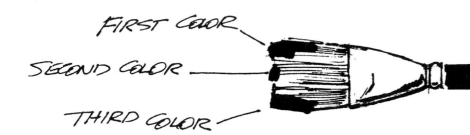

FIRST COLOR

SECOND COLOR

THIRD COLOR

amount of Prussian blue on the other, with a bit of burnt sienna in the center).

I quickly push and twist the brush into the wet interior of the clump, covering the area with as few strokes as possible. This allows the yellow, blue, and brown to merge on the wet paper, forming beautiful diffusions of various greens, dominantly yellow-green. As quickly as possible, I continue out to the edges where the paper is dry which will effect a rough texture; I might have to lay the brush nearly parallel to the paper to get it. I try to keep in mind that I'm painting the leaves while doing this rough brushing.

When painting the dark clump on the far side of the tree, I have to be careful not to get it too dark; I try for nothing darker than value 4. This is so I can later paint dark interior limbs and branches over it in values 2 and 1. If I see I'm painting the clump darker than 4, I'll abandon the idea of painting over it with darker limbs. Instead I can scrape in light limbs and branches with a knife or other sharp tool, while it's still wet.

When all the foliage is painted, I immediately paint in the limbs and branches in the open areas between clumps and over the dark areas. *I do not paint limbs over the light foliage.* Instead I'll run the limbs into the edge and continue them out the other side. If I can get this done while the light foliage is still wet, the merging of the limbs with the edge of the wet foliage gives the illusion of the limbs disappearing into it.

Of course, the dark foliage must be dry before the darker limbs can be painted over it.

The "skeleton" of the tree is painted exactly as shown earlier for the bare tree, only it disappears into the light foliage.

As you gain a little experience, trees will become a pleasure to render and a welcome asset to your paintings. There are other things that make up a typical landscape. Let's look at symbols for them in the next chapter.

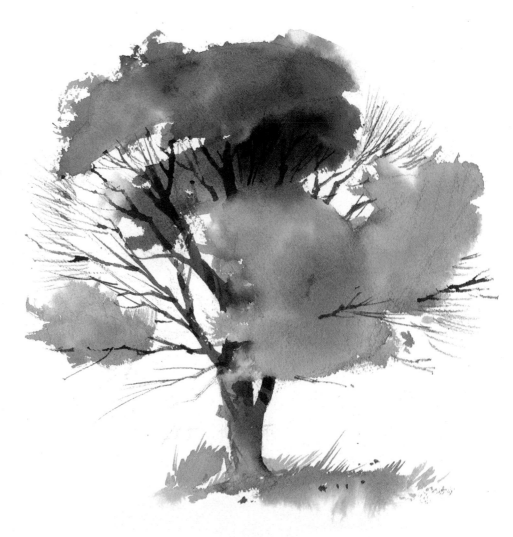

Combine the simplified clumps of leaves with the "skeleton" of the tree in the open areas to create a symbol for tree.

Two Friends
22" × 30"

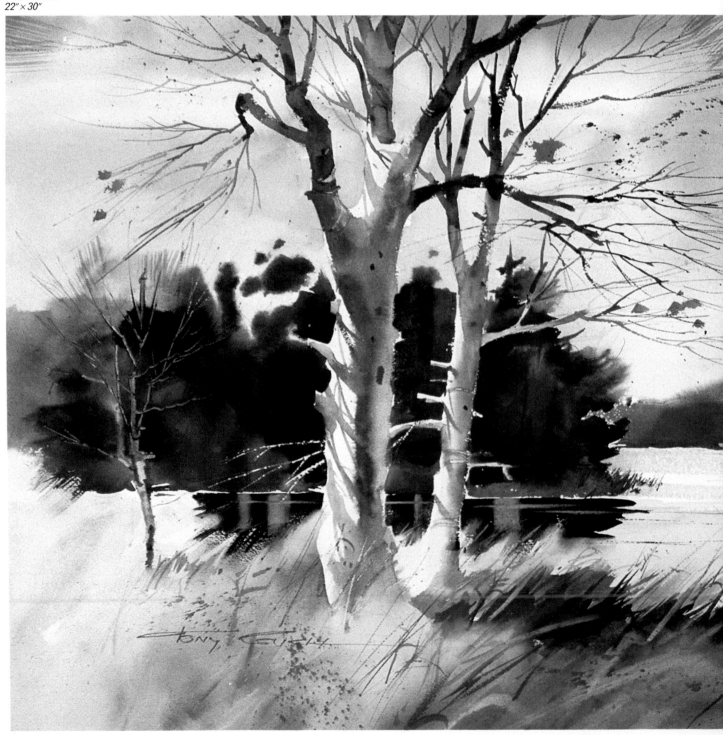

Earth and Sky
A Collection of Symbols

While trees usually appear in landscapes, you will almost always have to put in a sky. So here we'll examine symbols for the sky, as well as other things you'll often need *under* the sky: rocks, weeds, and weathered wood.

SKIES

Of all the parts of a land or seascape, the sky is probably the easiest to paint and is usually one of the more beautiful areas of the painting!

Here are some keys to successful skies:

1. Wet the paper, then go into it with a wet brush, using the wet-in-wet technique discussed in chapter 2.

2. Don't spend more than 60 seconds in the sky.

3. Be happy with what you get at the end of that time; *Don't* go back in to "touch it up"!

If you're still having trouble with your skies, here is a simple formula; use it and you'll be astonished at the improvement:

1. Remember, we are shape makers, *symbol collectors*, and entertainers. This medium works best for us if, instead of painting a particular sky, we invent a *symbol* for "sky" and paint that.

2. The texture for the sky symbol is *soft*.

3. The color of the sky can be anything, but it is usually cool (bluish) at the top and slightly warmer (faint yellow, brown, or red hues) at the horizon. It might be a cool gray at the top and a warm gray at the bottom, for an overcast sky.

4. The best and simplest sky technique is wet-in-wet. Be careful to only work very wet and keep the values fairly light. Bear in mind that the wash will dry slightly lighter than it looks when wet.

5. Don't try for any particular cloud shape; it's not important. Just paint slightly darker in a few areas and let the shapes form themselves; if they're soft edged that's all that matters. One caution: don't let the clouds form into spheres, squares, or equal-sided triangles, and guard against any two shapes of similar size.

6. Work wet and rapidly, covering the whole sky in about 60 seconds. Changing the color slightly each time you take some from the palette will make your sky more entertaining; shoot for cool at the top and warm at the bottom.

7. Soft texture and light value all over is paramount; the color is secondary.

8. Be happy with what you have, whatever it is, after 60 seconds or so. *Get out* and *don't go back*, even if you're not sure you like what you have. Remember, when you stop, the sky isn't finished yet! It'll finish painting itself in the next five minutes or so. It'll dry a little lighter, and the soft shapes will continue to spread and change shape for awhile.

Sometimes you can tilt the paper upright at this stage and cause the

Lightly draw the silhouette; wet the interior with water, but avoid the edges slightly.

1

Wash in the color to get a hard edge at the top and a soft edge on the bottom.

2

wet shapes to run in one direction, giving the illusion of rain. But let it "rain" by itself; you stay out of it except for the tilting. Invariably the sky looks better ten minutes after you stop.

Placing the 60-second (or so) limit on youself while painting wet-in-wet nets the best chance of soft, diffused shapes which say "sky" better than most painters can paint a particular sky. And there is infinite variety here. Every time this operation is repeated a different sky appears.

The single, most often repeated fault of novice or even intermediate painters is an overworked sky. This formula detours that trap.

ROCKS

We have only three of the seven elements (parts of a painting) at our disposal to convince the viewer that what we have painted is a real object; these are shape, texture, and color.

In general, the rock *shape* should be convex, never concave. Concave expresses weakness, and there is nothing weak about a rock!

The *texture* of the rock *silhouette* should be hard (smooth) or rough—but never soft, as there is nothing soft about a rock, either.

The *color* could be any except

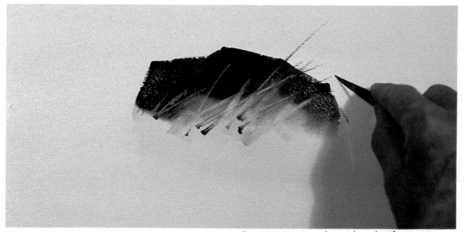

3

Scrape in weeds with a knife, and highlights with a razor blade.

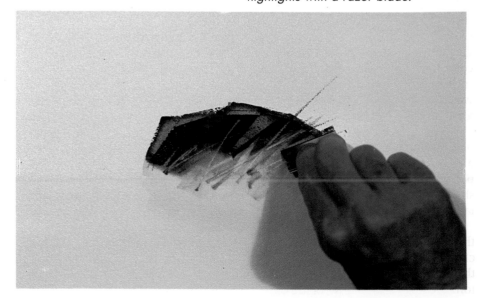

4

For curved rocks, first paint a darker background, leaving white paper for its silhouette (1).

Paint the interior with a lighter value, leaving the white on the top and the side toward the light; the wash should be lighter toward the bottom to give the illusion of "light bounce" from the ground (2).

1

2

green, as green is the color of grass and could easily be confusing, Usually rocks have a gray hue: a warm gray, cool gray, or neutral gray. However, bright sunlight can be dramatized by leaving the top and side facing the sun white paper, and painting the areas out of the light a bright warm color to show light reflecting off the ground.

When painting a group of rocks, as with a group of anything else, the distance between them should be varied as should their size and shape. It is also wise to place the larger rocks in the foreground and most of the smaller in the distance, to build the illusion of depth.

I first lightly draw the rock silhouette with pencil, making sure that none of it is concave and that all its edges are sharp and angular. I generally avoid round edges as they don't express the hard, sharp character of rock.

Next, I wet the interior of the rock with clean water, being careful to avoid the edges by a little margin. This is because I want whatever color I put into the interior of the rock to blend upon the paper, but I want to save dry paper at the edge for hard and rough texture (1).

With a flat brush, I'll mix any blue and any brown together to get a dark puddle in the palette, then paint the rock all at once—getting sharp or rough texture at the angular top and side edges of the rock.

I'll avoid the bottom half with this dark wash, then immediately clean the brush and paint something light and warm into this bottom area, such as yellow ochre or raw sienna. This must be done

while the first wash is still wet, so that the lighter color will blend into it. It gives the effect of "light bounce" from the ground.

While this second (yellow ochre) wash is still wet, I immediately clean the brush again and paint a bead of clear water just below the second wash, then paint the clear water up into it, allowing this second wash to drift down, forming a soft edge. I then promptly clean the brush again, dry it with towel or facial tissue, and use it to dry up the bottom edge of the clean water bead before the yellow ochre wash drifts into it and forms an unwanted hard line (2).

While the whole rock is still wet, I'll scrape in a few weeds or blades of grass along this bottom edge if the rock is in a field (3).

Again, while the dark wash is still wet but not soaking wet, I'll scrape in the highlights with a razor blade or knife. I don't try to scrape in any particular light shape, I only want to make the top of the rock and the side facing the light source light. I may add one or two marks in the interior, also facing the light (4). These scrapes should be done in *one* motion. A series of scrapes for one mark will make the rock appear overworked.

I wrote earlier that soft texture

Cast shadows, scrapings, and splatter give added texture and roundness.

should not be used for rock silhouettes, yet I paint the bottom edge of the rocks soft. This is because the bottom edge is describing the field, not the rock.

Although an angular edge describes "rock" more effectively than a round edge, still many rocks are round—worn smooth by erosion—and you'll need to paint them. I use another technique for these curved rocks.

First, I paint in a darker background for the rock, leaving white paper for its curved silhouette (1). Then, I paint the interior of the rock, using a value lighter than the background, and leaving white paper at the top and side of the rock facing the light. This white paper will serve as the highlight. The value used for the interior of the rock is painted darker at the top, with a soft edge at the highlight and lighter and warmer near the bottom. The edge is soft at the highlight to give the illusion of a round rock, and the color becomes progressively lighter and warmer near the bottom to give the illusion of "light bounce" off the ground on which the rock rests (2).

The result is a core of the shadow effect we saw earlier, which is similar to the plane-change accent.

As before, weeds may be scraped into this wet wash with a knife to give the illusion of a rock in a field. A cast shadow of trees or other objects on the sunlit portion, following the contour of the rock, reinforces the illusion of roundness. If the rock is close or near the center of interest, I'll usually add some texture by splattering color into it or pressing a dirty, wet sponge onto it, or both (3).

WEEDS AND TALL GRASS

Here is a way to paint weeds, reeds, or other tall grass. I usually start by covering the entire area with a midvalue underpainting of the general color I expect the field of weeds to be. For me, this is usually yellow, brown, green, and combinations of those, varying value and chroma. The byword here, as in other areas, is variation in color.

I work the entire area at one time, using a wet-in-wet technique, being careful to grade the area at least in value (light to dark), but sometimes also in color (warm to cool).

This means the underpainting will have a gradual change from light to dark and/or warm to cool across the area—either side to side or top to bottom. In addition, I might paint in a few darker, soft-edged areas, varying their size, shape, and the distance between them (see 1).

While the entire area is still wet, I usually "lift out" soft weed marks in a dark area with the edge of a flat, thirsty brush. As with all the marks that follow, these lean dominantly to the left or right to show the direction of the wind. Care should be taken, however, not to strike these weeds in monotonous parallels. Forming a series of "×s" with these marks is insurance against that.

Next come a few hard-edged, light weeds, to contrast with the soft, light ones. These are scraped into the wet pigment with a knife, brush handle, or other sharp object (2).

While the paper is still wet, I usually paint in a few soft-edged, dark weeds for more variety.

In most cases this is enough, but when the painting is finished, I again look at this area to see if it needs more detail—either for balance or to relate it to another area with like calligraphy. If it does, I'll paint a few more weeds there (3), this time on dry paper, so the weed marks will be either sharp-edged or rough-textured, dark marks. I may also add a little "splatter," which produces more texture and variety.

1
Using a wet-in-wet technique, wash in the underpainting, gradually changing from light to dark or warm to cool.

2
"Lift out" soft weeds with a thirsty brush while the wash is still wet. They should lean in the direction of the wind.

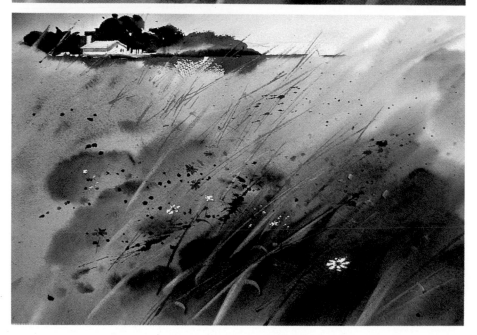

3
Scrape in a few hard-edged light weeds with a knife.
When it's dry, finish with dark weeds and splatter for variety and texture.

WEATHERED WOOD

L

After wetting the entire area with clean water, I flood into it a mid-value gray—mixing any blue and any brown—so that some of the area is a blue-gray, others brown-gray, and others a near neutral gray.

When that is dry, I mix a puddle in the palette of dark, staining color, such as alizarin crimson and viridian or Thalo green. I use this to place a few knotholes on the wood, being careful to vary their size, shape, and the distance between them (see L).

M

Now I dip a flat brush into this same puddle and split the hairs into several groups, so that the brush looks like the brush on the left. With vertical strokes, I paint the wood grain over the first wash, moving around the knotholes as I come upon them (see M).

112

Next, with a rigger, I paint in the dark cracks between the boards, being sure to vary the board widths and the width of the cracks between them.

The illusion of sunlight filtering through a nearby tree onto this shaded surface can be easily effected by painting a pattern of various size oval shapes onto the surface with clean water. Let it soak for a minute, then wipe up the loosened pigment with a facial tissue (N).

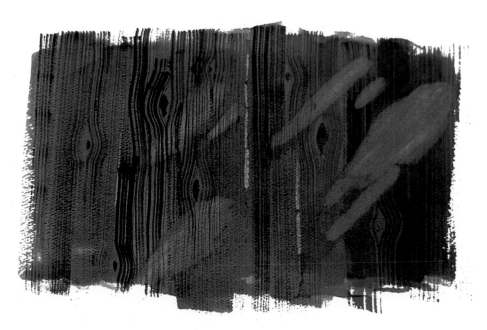

Repeat this operation until the pattern is light enough to be easily seen. Now paint back in the cracks and wood grain that had been lightened (O).

If I think I need more texture, I'll splatter in a few dark spots (P).

P

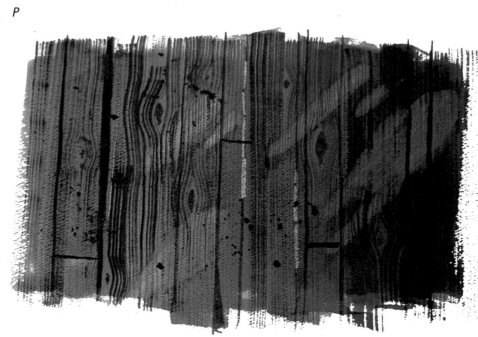

Q

Then, with the corner of a razor blade, I'll pick out a white piece next to a few splatter marks on the side opposite the light source. This gives the appearance of holes in the wood (Q).

Drive Through,
22" × 30"

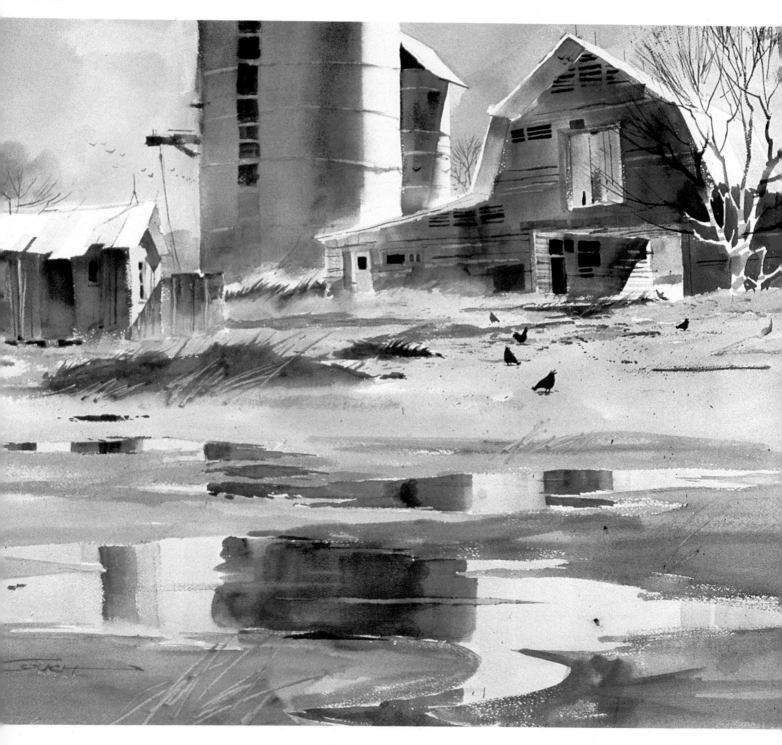

Water and Waves
A Collection of Symbols

Water is one of the things watercolor is ideally suited for. Since watercolor is by its nature liquid and free flowing, it is perfect for creating subtle and dramatic images of water. Because water appears in so many forms, painting it might seem overwhelming to the beginner. However, if we remember to look for ways to create symbols which say "water," our task can be reduced to easy pieces.

I think of water as having three categories of "movement":

1. Motionless, as in a mill pond,
2. Some motion, as in a harbor, and
3. Rough, as in the open sea.

Each has its own peculiarities, requiring different techniques.

MOTIONLESS WATER

Easiest to paint is motionless or calm water. I start by painting a graded wash: the color is the same as the sky, and I grade it light in the distance to dark in the foreground. The water is generally darker in the foreground since we are looking down at that section at an acute angle and see through the surface to the dark bottom.

As we look farther into the distance, the angle of vision becomes less acute, allowing us to see less of the dark bottom and reflecting more of the light sky. For these reasons the water gradually becomes lighter as it goes into the distance.

As the water approaches the distant shore, we aren't looking through any of it; it only reflects

1

Start by painting a graded wash the same color as the sky, lighter in the distance to dark in the foreground.

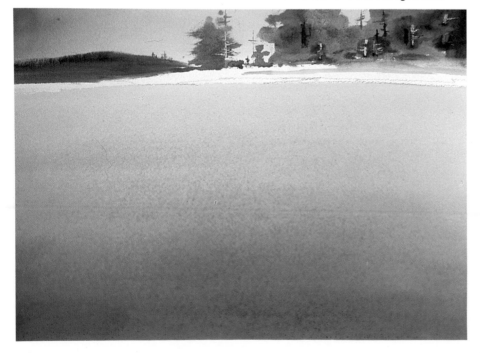

Big Sister,
15" × 22"

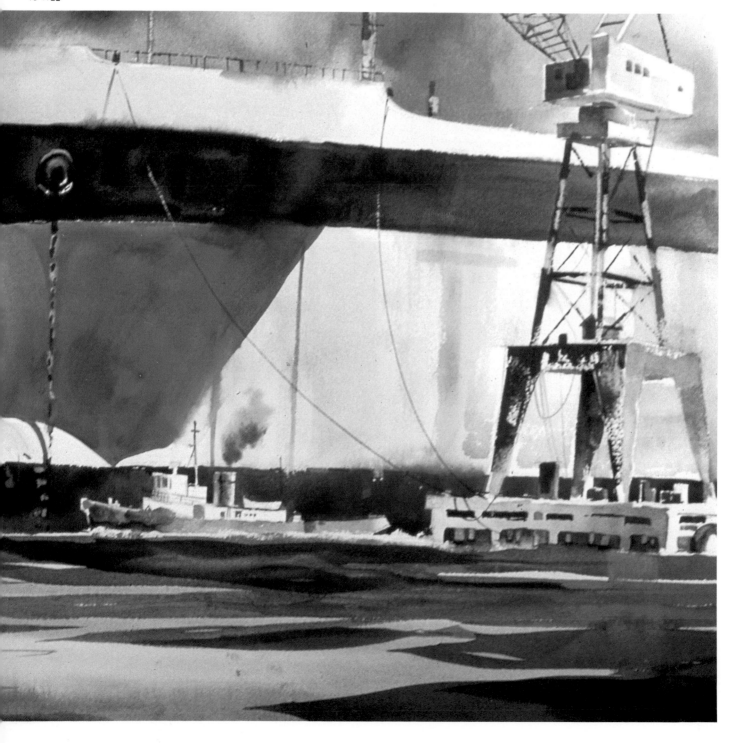

2

While the paper is still wet, paint in a few vertical reflections in the approximate color of whatever they are below on the opposite shore.

the light sky, so this part of the graded wash is the lightest (1).

Next, while the paper is still wet, I'll paint in a few vertical reflections below whatever is on the far shore. There is nothing precise about these reflections; I paint them only the approximate color, and a value lighter or darker than the object casting the reflection. The same value would be too confusing. The length of the reflection can be any, not necessarily the same as the height of the object (2).

Care should be taken to vary the width of these reflections lest they become boring. A common error is painting a series of reflections with single brush strokes so that each reflection is the same width—that of the brush!

Just before the glisten leaves the paper, I lift out a few horizontal lines with the sharp edge of a thirsty, flat brush. These light lines show some slight motion in the water, and indicate a reflection of the light sky on the far side of a very slight swell. They should be perfectly horizontal. They should also be of various lengths, and the space between them should be varied: closer together in the distance and gradually farther apart as they approach the foreground. This latter spacing is to provide an illusion of depth (3).

Just as there is a light reflection of the sky on the far side of the swells, there is a dark area on the near sides where the swell is tilted toward the foreground, reflecting the dark shore behind the viewer. I indicate this with scattered, thin,

3

Just before the glisten leaves the paper, lift out a few horizontal lines with the sharp edge of a thirsty, flat brush to indicate the reflections of the sky on very slight swells.

When the paper is completely dry, stamp in dark reflections with the edge of a credit card or razor blade.

dark lines, varied and spaced in the same manner as the light lines. These are thin, hard-edged lines, so I must wait until the paper is completely dry, then stamp them in with the edge of a credit card, a razor blade, or a piece of mat board (4).

WATER WITH SOME MOTION

I start this type the same way as motionless water: the same graded wash, light in the distance, and gradually darker in the foreground. While this wash is still soaking wet, however, I lift out a few light horizontal streaks with a small natural sponge or a thirsty brush. I also paint in other broad, darker horizontal streaks, then let the whole wash dry. It only takes one or two light and dark streaks to do the job. They're the symbol for smooth swells, and the soft-textured light and dark streaks correspond to the light and dark lines that went into the calm water painting. They are

Start with a graded wash. While this wash is still soaking wet, lift out a few horizontal streaks with a sponge or thirsty brush and paint in broad flat horizontal swells.

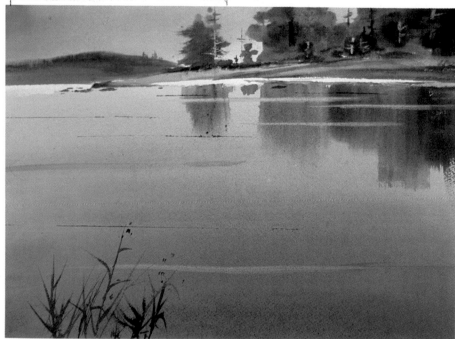

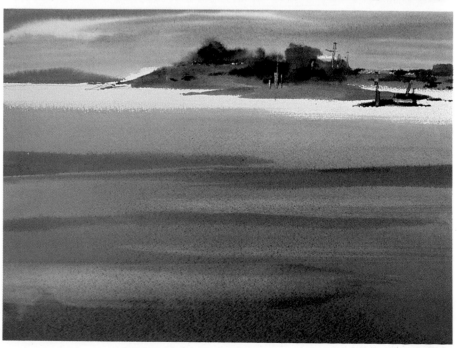

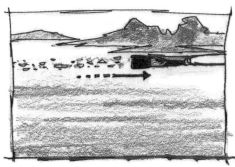

2

Leave the paper dry near the horizon, and give it a fast horizontal streak of rough texture to create the illusion of sunlight reflected in the distance.

3

Next, paint the rest of the painting while the wash dries. The reflections will be mostly hard-edged.

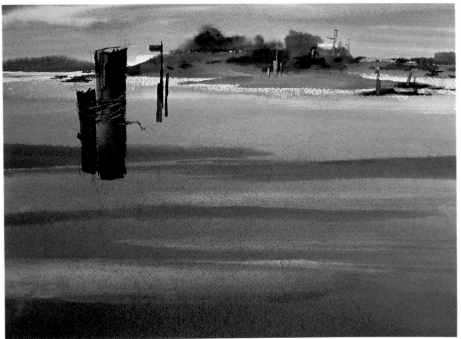

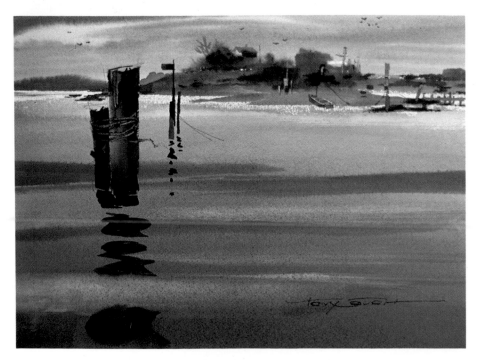

wide streaks instead of lines because the swells are larger (1).

If I want to create the illusion of sunlight dancing off the distant surface, I'll leave the paper dry in that area. When I get to it with the graded wash, I'll give it a fast horizontal stroke, which leaves a streak of rough texture, giving the proper illusion (2).

Next, I usually paint the rest of the painting, including whatever will be casting a reflection, leaving the reflections for later. This is because I need time for the wash to dry, as I want the reflections to be mostly hard edged, and it's easier to paint a reflection of an object if I'm looking at that object (3).

This body of water has some motion to it, and to reinforce this illusion, the reflections also will have motion. The symbol for this is a hard (smooth)-edged reflection that zigzags. The reflection might be all one piece or have breaks with isolated reflection symbols (see 4).

There is nothing precise about the shape, color, or size of the reflections I paint; I am only concerned with roughly the color of the object casting the reflection and very roughly the shape. If a boat, for instance, has a tall superstructure in one section of the hull, I'll make the reflection a little longer under that area (5).

4

To reinforce the illusion of motion, the reflections will be hard-edged zigzags.

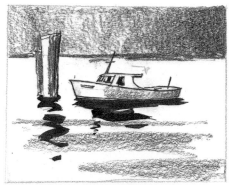

5
There is nothing precise about the color or shape of reflections. Make the reflection a little longer if you want to represent the reflection of a taller object such as a ship's superstructure.

Hauling It In,
22" × 30"

ROUGH WATER (OPEN SEA)

Before describing my method of painting the open sea, I should review three symbols that say "rough sea":

1. A theme appearing all over the rough water section of the painting is the wave symbol (see 1, next page). These symbols should be large in the foreground, mid size in the mid distance, and very small or not at all in the distance, to give the illusion of distance. It's exactly the same thing that is done with shapes in landscapes (weeds, rocks, trees, clouds, and so on) for the same reason.

Again, we have only shape, texture, and color to convince all viewers they are looking at waves: the shape is the wave symbol, the texture should be soft, and the color roughly the color of the sky.

These wave symbols might be independent, or a section of one may overlap a section of another as shown in 2 and in *Hauling in the Canvas* (above).

Care should be taken to make one side of the wave symbol longer than the other, to avoid the monotony of triangles with equal sides.

121

1

2

This also gives the illusion of movement and wind direction. The wave is being driven by the wind, so the side into the wind is the long side.

2. Another characteristic of rough water is foam and spray, both of which occur around the hull of a ship or around anything else floating in the water, around rocks, along the shore, and often at the crest of waves. In particular, they occur at the bow and stern of ships or boats.

The symbol for spray and foam is the same: any good shape (see chapter 3), very soft texture, and a stark white color with very light value in the modeled areas. Alternately, some texture at the edge of the shape should be rough (it looks like flying droplets of water) but the dominant texture is S-O-F-T. It will *not* look like spray or foam if the texture at the edge of the shape is *hard*, unless you are a very clever painter.

The only difference between spray and foam is the area of the painting it covers: in general, spray should be painted against a background of sky, a ship, rocks, or shore, or a distant section of the ocean—or any other background that makes it appear to explode upward out of the water. Foam, although the same symbol, should appear to lie flat upon the water.

3. The final characteristics for rough water are some things called holes and rivulets, shown in the sketch at the right. They occur in a patch of foam in its decaying stage when it becomes riddled with light-value holes that then dissolve into

linear streaks of white foam called rivulets.

The symbol for these holes is an irregular oval shape with rough- or soft-texture edges, although a little hard texture will not destroy the illusion. The hue is that of the rest of the water without foam, but the value is lighter.

All the above symbols are characteristic of, and can occur simultaneously upon, any body of rough water. The sequence in which they appear is this: the wave, then spray as it crashes against an object or crests a major wave, then foam as the spray falls back into the sea, then holes, then rivulets as the foam thins back into dark seawater.

While the spray is thrust up into the air, the foam, holes, and rivulets lie on the surface of the water and follow its contour. In fact, the shape and direction of the holes and rivulets are an effective means of describing the rises and falls of the swells, just as cast shadows describe the contour of the terrain in a landscape.

Holes are the first stage of decay of foam and occur at the edges of the foam shape, becoming larger and more numerous as they spread outward.

Rivulets are in reality the last remnants of holes that have been elongated as the surface is drawn into the peak of the following wave. For this reason, rivulets generally occur only when a major wave approaches and point toward the peak of that wave.

There are a couple other general items to keep in mind when paint-

ing seascapes:

1. Unlike still water or water with a little motion, the rough, open sea can be dark in the distance and light in the foreground. Or it can be the reverse, or there might be a dark streak in the mid distance from the shadow of a passing cloud or a deeper bottom in that area. Think of it as you would a landscape in which the fore-, mid, or background might be the darker area (see value patterns in chapter 7).

These symbols say "rough sea": the wave, foam and spray, and holes and rivulets.

2. I keep the sky very simple. The sea will appear rougher by contrast. More importantly, a busy sea and a busy sky produce a painting that is *too* busy overall. Study the paintings of the marine painters you admire and note how the skies are handled when the sea is rough. However, to achieve unity, clouds or other shapes in the sky should not be vertical or horizontal, but diagonal to echo the angular shapes of the waves.

3. I am careful not to exaggerate the size of the burst of spray against rocks. An oversized burst can easily appear too dramatic for the rest of the painting.

4. On a rough water surface, a ship or other object reflects very little, and then only a little of the color and none of the shape.

There are any number of ways to paint the open sea, and I don't always use the same approach. But as a guide, I'll describe a typical procedure.

I usually paint the sky first, keep-

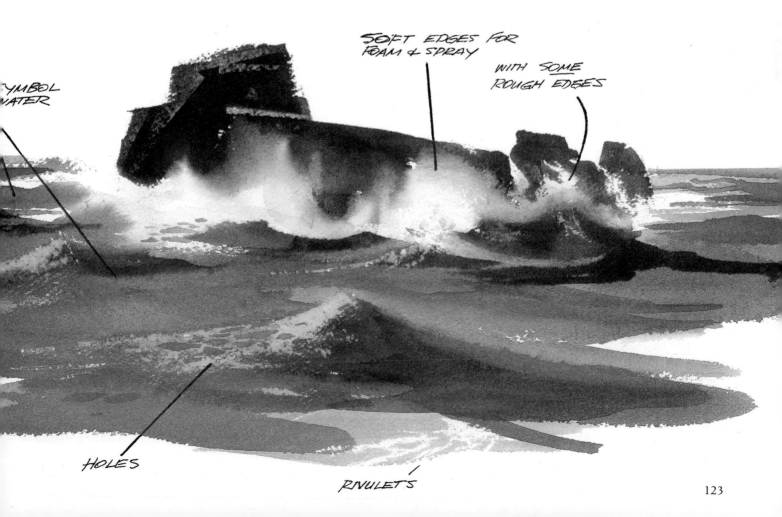

SOFT EDGES FOR FOAM & SPRAY

WITH SOME ROUGH EDGES

SYMBOL WATER

HOLES

RIVULETS

ing it as simple as possible while still giving the illusion of "something going on" up there to cause the wind that kicks up the waves. I do this first so I'll know which colors to paint the water. Since the sea always reflects the sky, my sea will be various values of the sky color.

Next comes the water, starting at the horizon. If I want to portray only a mildly active ocean, I'll paint the horizon a straight horizontal line, sometimes using rough-textured horizontal streaks on dry paper to give the illusion the sun is dancing off distant waves.

If I want a rougher sea, I will instead paint the horizon with small wave symbols, varying their height and depth. The horizon is an important label for the state of the sea since as usual, we judge the shape—in this case the sea—by what we see at its edge.

I usually underpaint the entire water area at one time, laying a graded wash lighter at the horizon and darker in the foreground, but being careful not to get too dark, as I'll paint darker waves on top of it, and the dark waves must be seen. The color of the wash is roughly a repeat of the sky: if the low sky is warm and the high sky cooler, I'll paint the distant sea warm, to gradually cool in the foreground. This underpainting is going to be the valleys between the swells.

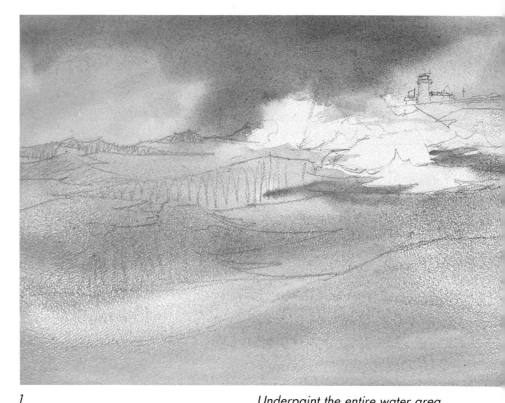

1

Underpaint the entire water area, lighter at the horizon, with white areas left around whatever is in the water.

Next, while the paper is still wet, paint in dark wave shapes.

In the process, I leave white areas around whatever is in the water (rocks, a ship, and so on). This white area is going to be the spray and foam, so I must model it into a good shape, being careful to keep the edges soft, with a little rough edge here and there (1).

I often leave small shapes of white paper in the open sea. Later, I'll either use them for white crests of waves or paint over them, depending on how the waves come out and what I need. It's an option I leave myself that can be easily canceled.

Next come the wave shapes. They must be darker than the wash already laid, and soft. I should have no problem making them dark enough if I kept the first wash just a little darker than the sky. But they must also be soft, so I must proceed rapidly to get them in while the paper is still wet (2).

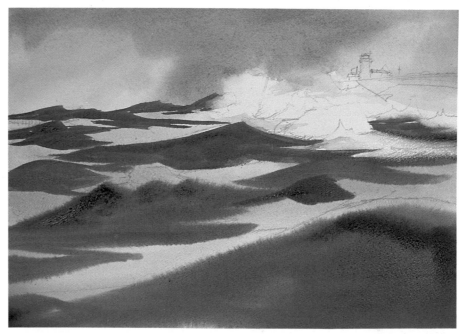

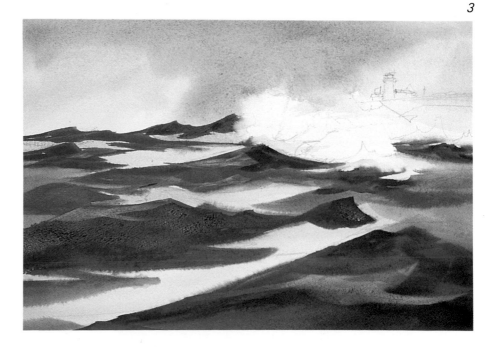

Now I lift lighter wave shapes out of the larger swells and paint in darker wave shapes.

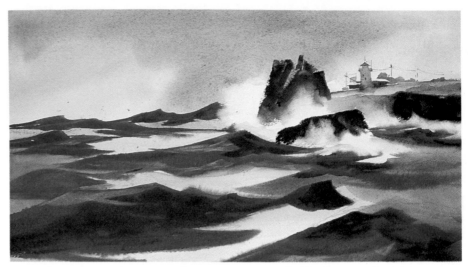

When the paper is dry, paint whatever is surrounded by foam in the white spaces. Wet the paper again so the edges near the water are soft. **4**

The first waves are really large overall swells, within which smaller wave shapes are painted later. These swells are painted using the same wave symbol discussed earlier: some are isolated, others overlap. I must paint them various darker values of whatever is in the sky. Now the first, lighter wash I painted becomes the "valleys" between the darker swells. The valleys are lighter because they face upward and reflect the sky, while the waves are dark because they are tilted toward us, and we're seeing through them into the dark depths of the sea.

Now I lift lighter wave shapes out of the larger swells and paint in darker wave shapes (3).

When the paper is dry, I paint the dark shape (ship, rocks, or whatever is in the water) that the foam and spray surround. When I get to the bottom of this dark shape, where the foam or spray meets it, I am once again painting the foam shape, so the edge must be very soft, with perhaps a bit of rough texture for contrast. So I'll rewet the paper there, leaving a dry spot or two for the rough texture.

If it will be spray bursting against the boat or rock, I will give it a billow shape like a cumulus cloud. If it will be foam, I'll give this edge

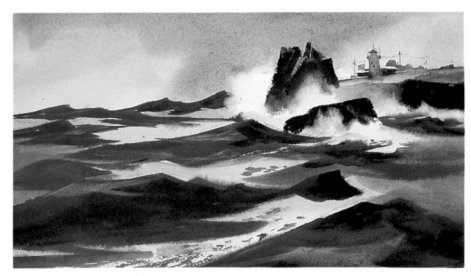

Paint in the "holes" at the edge of the foam areas. **5**

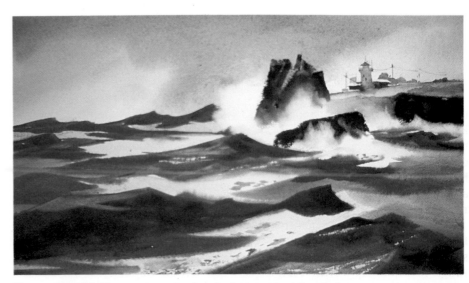

Use a razor blade to scrape in the rivulets against the darker sea. **6**

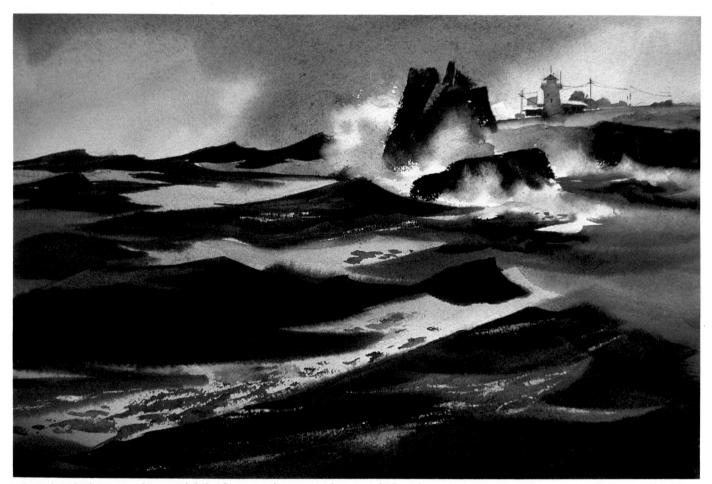

When the "holes" are dry, model the foam and spray with a very light value, cool gray so it does not look flat. *7*

the shape of the wave symbol, keeping it very soft and white. Often this appears as water running off the side of the ship or rock back into the foam, as it might just after a wave has smacked the object and receded (4).

Now I'll go to the edges of the foam area and paint in the "holes," shooting for a dominance of soft- or rough-textured edges with a few of contrasting hard edge. They should

be lighter in value, smaller, and farther apart toward the burst of spray, becoming darker, larger, and closer together as they leave it (5).

Eventually, they dissolve in rivulets into the darker sea, which I scrape in with a razor blade. I keep in mind the contour of the wave or valley they occupy and shape them accordingly (6).

When the holes are dry, I model the foam and spray with a very

light-value, cool gray (7). Modeling is particularly important for the spray, as it gives it "body." Without this, the spray appears to be flat.

Finally, I evaluate the small pieces of white paper I left while laying down the initial wash. If they appear to be or can be made to look like pieces of foam, I'll keep them. Otherwise I'll paint them out with a glaze of the same hue and value as the water.

Choices

Why, Where and What I Paint

To more easily understand why I paint, it is helpful to first review the way I believe most artists grow.

It's my observation that artists develop in three stages:

Stage I

This is the entry level, in which we learn to report what we see.

We see the task as "making pictures." We're all intimately familiar with the camera; in fact, we're part of what I call the "camera society": everything in the movies and on TV was done with a camera. So was everything in the family photo album and most of the art in the printed media. Most of us have grown up with at least one camera in the house. So I'd guess 98 percent of the pictures the beginning artist remembers are photographs. A picture to us, then, is what a camera produces: a precise replica of whatever was in front of the lens when the shutter "clicked."

It's easy to see why the novice artist (and much of the lay audience) thinks the artist's purpose is to copy precisely what he or she sees onto the paper as does the camera. After all, the artist is making (taking) a picture. Therefore, the more "photographic" the reproduction, the higher the art!

Adding to the confusion is the fact that imitation of the camera appears to have been the intention of some respected artists, including some commercial illustrators and artists using trompe l'oeil (trick the eye) technique. There is, of course, more to it than that.

The question, "Where is that?", often asked when landscape paintings are viewed, is prompted by the camera syndrome: implied is that the painting, like a photograph, is a reproduction of a specific place or thing. The answer, "because it was there," when a student is asked why he put something superfluous into a painting is an example of the same condition.

It has occurred to an army of Stage I artists that a photograph can be projected onto the paper or other

Snow Valley,
22"x30"

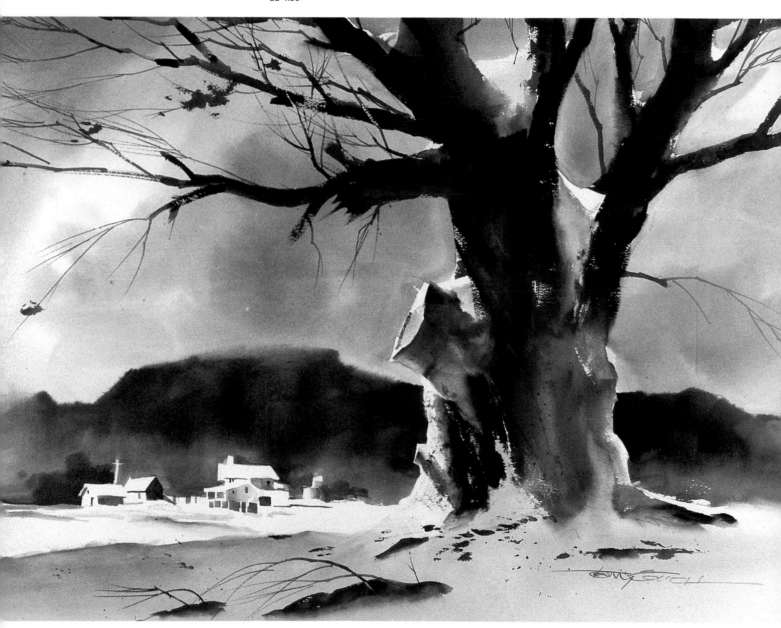

surface using any of a number of copying devices on the market today. Popular among them are opaque projectors, pantographs, "lucies," and even the family slide projector. Then the photograph is traced onto the paper.

Entire photographs have been transferred to paper and canvas in this manner and painted. Moreover, many an unsophisticated sidewalk-show judge has given the top award to these painted photographs.

Although there may be merit in projecting isolated objects onto a surface as part of a larger design, as a timesaving device, copying the entire photograph is at least questionable.

For one thing, I know it would impede my growth as a draftsman because I would be content with my drawing without having drawn!

For another, I am limited to whatever design is in the photograph. If this photograph belongs to someone else, I also have a plagiarism problem. If the photograph is mine, and I copied it because I don't think I can design something better, this tells me I have spent too much time with the camera and not enough time designing. *A superior design is only available from designing,* not copying nature.

Stage I is useful, however, and is the stage through which most of us plod on our way to better things. In it, we learn the mechanics of the trade: how to use equipment, how to make trees look like trees, rocks like rocks, and so on, and it breeds the confidence and curiosity that lead to Stage II.

Stage II

This is the stage in which we learn to design the Stage I "report."

Here we learn to take what is "out there," or subject matter, and fit it into a design. The design is of primary importance; subject matter is only secondary.

It makes no difference to the Stage II artist if the subject matter is a barn, house, or cow. This artist may use some of it, all of it, or substitute something behind him or in a photograph in his hip pocket. If the subject matter fits the design, he'll use it, and if not, he'll use something else.

A key point in producing a creative work is the manner in which subject matter is employed. The Stage II artist knows art is not nature; rather it is *nature infused with*

The Stage II artist knows art is not nature; rather, it is nature infused with the principles of design.

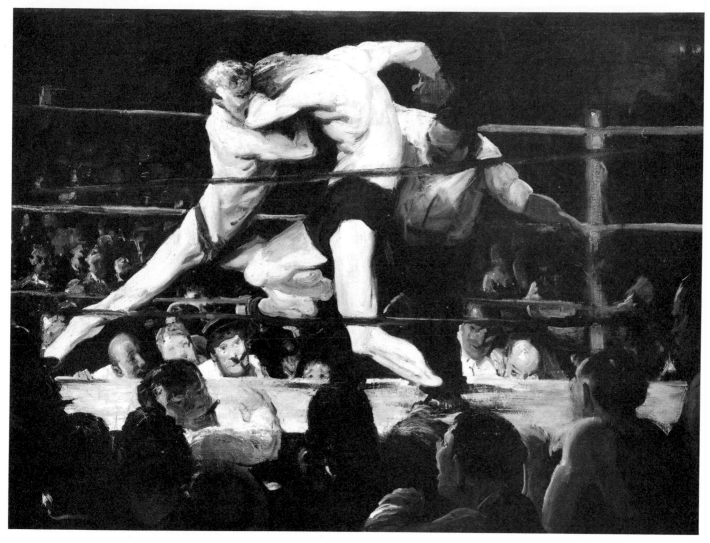

the principles of design. Ed Whitney put it this way: "To which would you rather listen: a tape recording of the buzzing sounds in a bee hive, or Rimsky-Korsakov's "The Flight of the Bumble Bee"?

Stage III

This is the level at which the artist learns to design a report that tells a story, transmits an emotion, or creates a mood. These three are within the realm of illustrators as well as fine artists. It is the stuff that makes art that is cherished for generations. Who can resist the humor and warmth in the illustrations of a Norman Rockwell? Who cannot feel the bitter cold and isolation in Remington's *The Scout: Friends or Enemies*? Or sense the power and excitement of George Bellow's *Stag at Sharkey's*?

The difference between work produced in Stages II and III is the difference between another good painting and the type of work worthy of museums.

I envision myself to be a Stage II artist struggling to produce Stage III paintings. It's a happy struggle; I remember my Stage I and the gradual realization that Stage II exists and the struggle to get there. Now the fight is on for Stage III while increasing my knowledge of Stage II.

Among my first thoughts when deciding to paint is what the subject will be (Stage I). Then, how best to present it? (Stage II). Then, can I tell a story about this, or create a mood with it? (Stage III).

If I'm painting outside, it's a matter of wandering around looking for shapes or a combination of shapes that I might turn into a pleasing design. If it is a studio (indoor) painting, I go through the same process, except the wandering is through my reference material.

When I think I have something, I make a series of fast value sketches in pencil in my sketchbook, changing shapes and moving objects around. When I have a pleasing group of shapes, I'll try a value pattern on them; usually C, D, E, or F from Group II (see page 68). A

131

few are shown on the opposite page.

At this point, if I haven't thought of a mood to create or a story to tell, and I'm pressed for time, as when demonstrating, I'll give up and paint a "Stage II" painting. Otherwise, I will stick to it until I have "something to say."

WHERE I PAINT

I've noticed there are artists who think the only place to paint is outdoors and others who think the only place to paint is indoors.

I think both are wrong; the knowledgeable painter works in both places. A great advantage of outdoor painting is the availability of an abundance of subject matter. As most painters learn early, it's a big help to have something to see from which a painting may be designed. Also, when working from "real life," the outdoor painter can walk up to, around, or behind the subject for another view to help understand it, something impossible when working from a photograph. This is especially helpful in eliminating the confusion presented by complicated subjects, such as the rigging of a group of ships tied alongside a dock.

Plus—the sounds, smells, and background activity at the location often spur the painter toward a more "inspired" work, a more authoritative expression of the subject.

On the other hand, the disadvantages are many: the sun and wind that dry the paper faster than you expected; a bright sun on the paper that causes a misjudgement of values; less than optimum equipment

(you have to carry everything); the changing light; sometimes changing subject matter (I was once painting a sailboat docked in Kennebunkport, and the skipper got in and sailed away!); rain, cold, heat, insects, kids, grownups, dogs, and I imagine you have a list of your own.

Of course, seldom do you have to contend with all these at once, and many can be neutralized to a degree.

Studio (indoor) painting bypasses these distractions, but there is one great disadvantage: no subject matter. This single deficit is effectively overcome, however, by working from photographs clipped from magazines and newspapers, your on-site sketches, or from memory.

I suppose most professional painters do their "serious" work indoors.

A prominent American aquarellist was once asked how many award-winning watercolor paintings are done outdoors. His answer: "About one in fifty."

Generally I sketch outdoors, then paint indoors from the sketch. Occasionally I'll use photographs for reference—either my own or those clipped from magazines and newspapers. Sometimes I work from a combination of sketches and photographs, and nearly always some of the painting is from memory.

If I'm conducting a workshop, I'll paint indoors or out, depending on several factors, such as weather, available subject matter, and facilities.

My sketches are large, on about 18-by-24-inch paper. I use any blunt-point, black felt-tip marker to force myself to draw large. When

necessary for clarity, large areas are filled in with a black or gray marker. Any paper that is hard enough to prevent the marker ink from spreading is good enough for me.

The purpose of the sketch is only to gather information; to remind me of the peculiarities of a farm building, an industrial site, a working boat, a particular species of tree, and so on. It will contain more detail than I will use in a painting, giving me a selection.

I draw large so I can easily see small parts of the sketch when posted on a wall some six feet from me as I paint, an advantage over any photograph. It is exactly the same as being on location—better, in fact: I can see what I need without the clutter at the original site, which I eliminated as I sketched.

Nothing goes into the sketch un-

less I understand what it is and its relationship to the rest of the shapes, an advantage over any photograph. Obviously the sketch forces me to be more creative in my painting since there is no color, and it usually presents only a center of interest around which a painting must be built.

Probably for these and other reasons I've noticed paintings done from these sketches are superior to those done otherwise. In fact, the only time I use my camera now is when a lack of time precludes the sketch.

My photo reference for studio paintings is kept in a ''morgue'': a file drawer of photographs and newspaper and magazine clippings of objects or scenery that might stimulate my mind. A few are in color, but most are black and white. I have them in file folders by subject matter for easy retrieval.

From my travels, I have at least 500 color slides in carousels, also indexed by subject matter. Using these requires some means of pro-

My sketches are large, on about 18x24-inch paper. I use any blunt point, black felt-tip marker to force myself to draw large.

jecting them while still providing enough room light in which to paint. I've solved the problem by cutting a rectangular hole in the bottom of a cardboard box and covering it with opaque acetate; then I project the slide onto it from the outside. When I'm looking into the box, it is dark enough around the screen so that I can paint in daylight or with the lights on in my studio (see next page).

If I'm painting outdoors, I look for a working spot in the shade because sun reflecting off white paper is blinding and will often cause me to paint a passage too dark or too light.

Sometimes I have to get out into the sun after all for a better view of the subject. In this case, I paint with the paper vertical and turn it so the sun is at my shoulder, but still slightly behind the paper (see Fig. 12-1). In this way, the sun is neither on the paper nor in my eyes as I paint.

If you paint with your paper flat, it is best to be in the shade or to

When I must get out in the sun to paint, I paint with the paper vertical and turn it so the sun is at my shoulder, but still slightly behind the paper.

I cut a rectangular hole in the bottom of a cardboard box and covered it with opaque acetate. When I project a slide onto it from the outside, it's dark enough around the screen to allow me to see the image while painting.

FROSTED ACETATE

VIEW

2

turn your back to the sun and let your body shade the work. It's not necessary to face the subject matter.

WHAT I PAINT

I'll paint anything I feel like painting and won't paint anything I don't want to paint!

This sounds arbitrary, but there is wisdom here: everyone does their best when allowed to do what they like to do most. They'll naturally spend more time and take more pains to do the job well. Conversely, inferior products usually result when people are required to work at unpleasant tasks.

The same is true of artists and art; after all, artists are people, and art is work. It has been said an artist must "literally fall in love" with

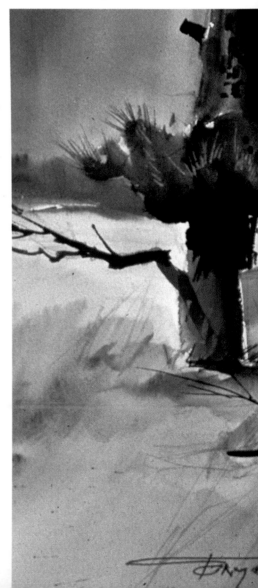

Sunny Side Up,
15"x22

the subject matter to do the best work. I believe this is what Rembrandt meant when he wrote, "If you can't be an apple you can't paint an apple."

Perhaps you like to paint barns and have heard "judges" or others influential in your art community downgrade your work because "everybody paints them; they're a dime a dozen—old hat." Should you then cease including barns in your paintings? Not at all. If you like to paint barns or any other subject, paint them until you're sick of them. *That's* when you should move on to something else. In the meanwhile, you'll do your best work because you like the subject. And you might win an award or two with them; a good painting is a good painting,

barn or not, and not all judges are biased against them.

On the other hand, I can't paint the same subject twice in a row without becoming bored with it, and a one-man show of only one subject or even the same technique is deadly. As I said elsewhere in this book, painting should be an enjoyable pursuit for us or we won't be at it very long, and variety is a key to this end. If we are not entertained when we paint, how can we be entertaining to others?

Since I want to grow in my painting ability, I am also wary of any circumstance that traps me into painting the same subject or type of painting exclusively. It typically takes this form: (1) An artist progresses to a point at which a credit-

able job with some subject matter can be performed. (2) Artist enters art fairs and discovers this particular subject matter "sells." (3) For economic reasons, artist concentrates on that subject and rarely seriously paints anything else. How boring. And it's a dead-end street. Our artist will probably never grow into better work until he or she escapes from this trap.

I recall attending a sidewalk art show a few years ago and seeing a large display of nothing but flower paintings. Each was a squat vase filled with red roses with a dark background. The only variety was in the size of the canvases, and that wasn't very much. The artist was trapped.

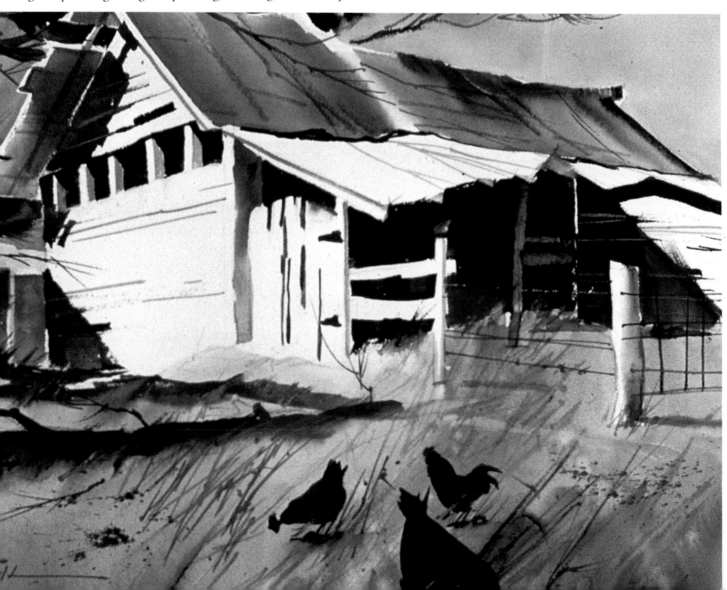

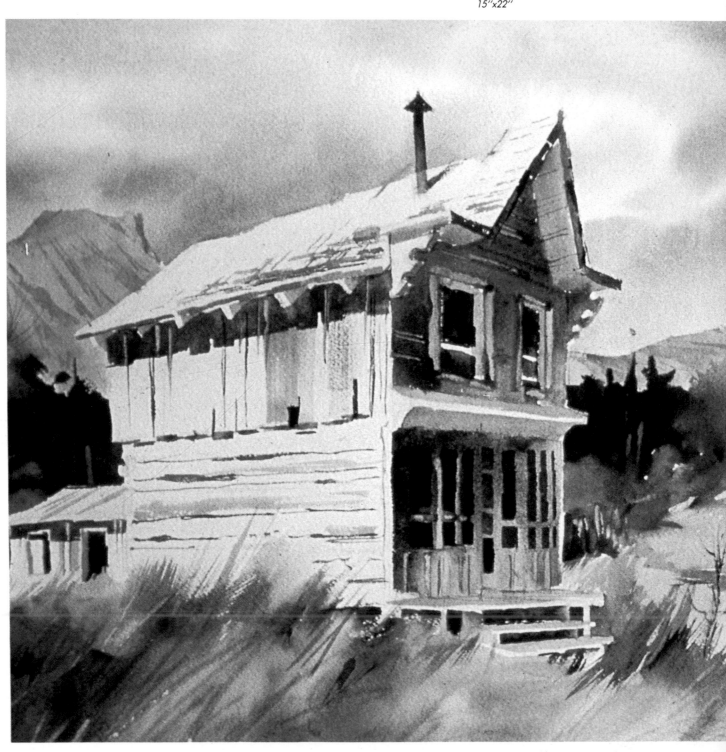

How I Paint
Three Demonstrations

On a sunny day in the Colorado Rockies, I did a felt-tip pen sketch of the town store of an old, abandoned mining ghost town. I included a stand of dark fir trees and a background of snow-covered, jagged mountains to give the site a "Rocky Mountains" setting (see 1).

Back in the studio, I decided to do a painting from this sketch. I found that in it I had solved most of the design problems, and I was able to transfer it to my small value sketch with few changes. One change I had to make, however, was an increase in the angle of the large roof, and I flattened the angle of the bottom edge of the store. In the felt-tip sketch, these two angles were too similar, one a mirror image of the other. This repetition without variation would have been boring.

The value pattern I selected is E from Group II (refer to page 68): a small, light shape within a larger dark shape in a field of mid values (see 2).

I transferred the value sketch to a 15-by-22 inch piece of 140-pound cold-pressed watercolor paper by lightly drawing in the outlines of the buildings, background trees, and mountains. Then I wet the entire paper and painted the sky, making it cool at the top and warm at the bottom.

Next, I went right to my dark shape, painting the trees first so I would get soft edges where the paper was still wet. When the paper was drier, I painted the front of the building, the cast shadows, and the distant mid-value hill (see 3).

Next, I put in the background mountains, being careful to vary the edge of the ridge and the distance between peaks. I varied the angles and thicknesses of the dark ravines and gave their edges a rough texture to express "snow." Since my value pattern calls for the mountain range to be mid value, I painted a light to mid-value blue glaze over the entire mountain range. This was done rapidly, after the ravines were dry, painting into the dark green trees with a single stroke to keep from lifting pigment from them (see 4).

By now the foreground had dried, so I rewet that area and flooded in various warm hues, allowing them to mix on the paper. At the same time, I added darker value hues on the left, gradually lighter on the right. With a rigger, I ran the "weed" symbol into the white, dry paper on the side of the store, the upper edge of the foreground, where it can be read clearly. Then, with the sharp end of the handle of a brush, I scraped other weed symbols into the still-wet interior (see 5).

Next, I put in the distant abandoned buildings and the near valley. My white shape was blank and uneventful, so I painted a few darker, rough-textured boards there and indicated a few horizontal logs on the side and shingles on the roof with calligraphy (see finished painting, left).

I first did a felt-tip pen sketch of the abandoned store on location. 1

Back in the studio, I produced a small value sketch based on value pattern E from group II. 2

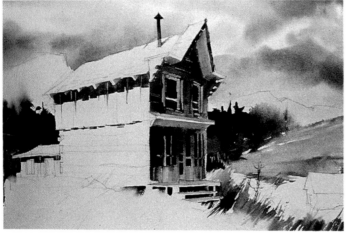

After outlining the larger shapes, I painted the sky and dark background trees. 3

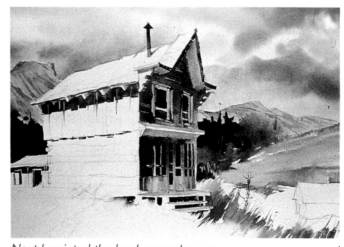

Next I painted the background mountains in a mid-value range. 4

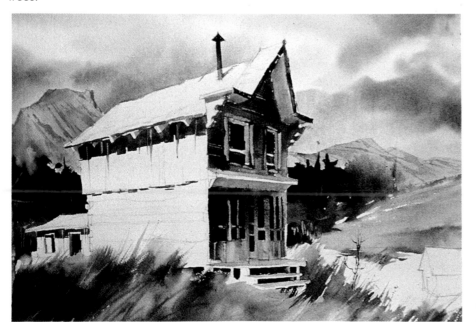

5

Examining the completed painting, I can total the pluses and minuses: I see I have a dominance of warm hues. The directional dominance is oblique, and the shape dominance is the building shape; the three buildings are well related (obliquely). I wish, however, I could have made the dark shape larger and/or the light smaller, since they are too near the same size. Also, the distant, dark group of trees are too symmetrical on either

The foreground was then washed in with the darker values on the left. I added weeds, and details to the side of the store and the building in the distance to finish.

I did the sketch of the tuna boat as an "information" sketch with plenty of detail from which to develop a painting later.

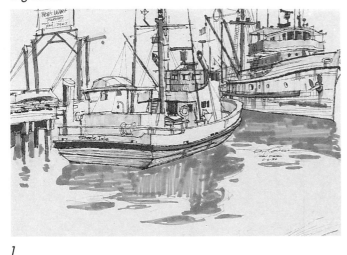

1

Using the sketch as a reference, I did a few postcard-sized value sketches and settled on this one.

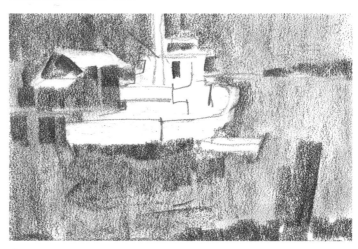

2

side of the large building. I could eliminate both these mental lapses by enlarging and lengthening the trees to the right of the building, but this would obliterate most of the mountains, which are a key to the "Rocky Mountain" theme. So I left well enough alone.

On a trip to San Diego, I had a few hours to spare, and with my sketch pad and a felt-tip marker, I went down to the waterfront. Among the clutter of Navy ships and fishing boats, I found a tuna boat tied to a pier and sketched that (1).

This sketch was done in the same manner as explained in the last chapter; I sketched most of what I thought I might be able to use in paintings. So there are two boats in it, as well as a dock. It's a terribly complicated mass of lines and shapes, but this is an "information" sketch. I wanted a wealth of information from which to choose later, when I paint.

A few months later—long after this scene had faded from memory—I decided to paint a marine painting in the studio. Leafing through my sketches I came upon this sketch, which produced an idea for the painting: I thought I would use the near boat tied to a dock as the center of interest—maybe not *that* dock, rather something more interesting. So I made a few post-

card-size value sketches and settled on the one above (2). The value pattern I picked could have been any, but a large, light shape on a mid-value field seemed to be easiest: the large boat would be the light shape; everything else would be in mid-value hues.

After lightly outlining the large shapes with an ordinary #2 office pencil on 140-pound cold-pressed paper, I stepped back and checked the design from about six feet away. Design errors not apparent up close can easily be seen from this distance. I thought the overturned boat on the dock in my value sketch made that area too complicated, so I took it out. I wet the sky

I painted the sky lighter at the top and darker at the bottom to set off the boat shape and rooftop. I scraped the gaff and other light lines into the wet sky with a knife.

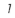

1

Next, I painted the darker areas, making sure they were dark enough to contrast with the modeled areas of the boat.

2

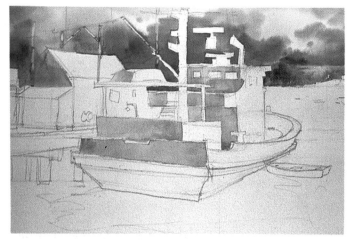

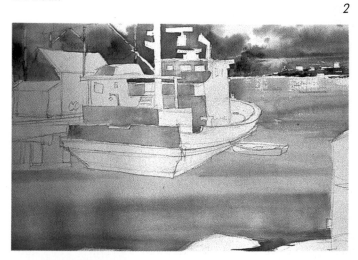

For the water, I wet the entire area and flooded in the same color as the sky, but lighter in value. A thirsty brush lifted out the horizontal swells in the water.

3

I added a few dark accents and details as well as the reflections. The sharp zigzag shape best describes the smooth, softly swelling surface of the water. The mud flat and pilings, added last, were kept very simple.

4

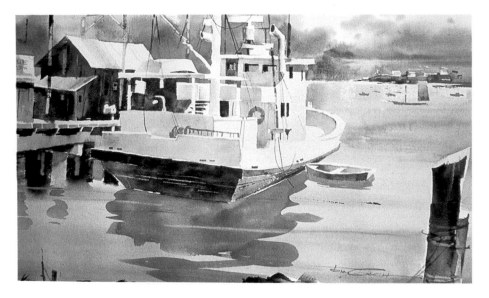

Hubbard's Cove,
15" × 22"

area with clean water, then flooded in dark to mid-value cool gray color. I made it lighter at the top and darker at the bottom, to foil the light boat shape and rooftop. I also added some warm (raw sienna) and left white pieces in the sky, for variety.

When painting the sky, I left the mast, top of the boat, and building dry paper for a sharp edge where the sky met these areas. I scraped the gaff and other light lines into the wet sky with a knife. For the water, I used the same procedure as for the sky: I wet the entire area with clean water first, outlining the white boat so the pigment would stop there, and leaving the paper near the horizon dry. Then I flooded in color approximately the same hue as the sky, but a little lighter. Since the paper near the horizon was dry I got some rough texture there, simulating sunlight dancing on distant waves. As I moved down into the wet area, I graded the value darker so the whole piece is darker at the bottom, lighter at the top. Next, with a thirsty brush and while the water was still wet, I lifted out long, horizontal streaks to simulate gentle swells.

In the previous step, I had also done the modeling in the light boat shape (the shaded side of the super

structure, and so on). It was important that I do that before any darker mids were put in so that I would know "how light not to paint" when painting these darker mid values. They had to be darker than this modeling, otherwise my light shape would have joined these same darker mids and disappeared! Next I painted the darker areas, being sure to get them quite a bit darker than the modeled areas and also to butt these darks right up against the light shape to make it stand out by contrast. At the same time, when painting individual shapes, I put warm against cool and employed gradation wherever I could so that this area would not become too boring.

After adding a few dark accents and details to the buildings and the deck house of the boat, I painted the reflections.

These need not be the same value as the boat; in fact, it is better to change the value to avoid confusion. In this case I made the reflection darker. The shape can be almost anything, as long as the edges have a zigzag shape to describe the gentle swells upon which it rests. It is also important to give these edges a hard texture, as this best describes the smooth surface of the water. In one or two places, I then dragged

the sharp edge of a thirsty flat brush into the still-wet reflection area and out into the dry, light area. This gives the illusion of a light wave in the interior, becoming darker as it goes into the lighter area.

Finally, I painted the mud flat and pilings in the foreground, being careful to keep them as simple as possible so as not to steal the show from the center of interest (the boat). They are necessary to balance all the weight in the upper left section of the painting. The change in value in the pilings from light at the bottom to dark at the top is a great exaggeration, but adds a touch of variety to an area that otherwise might have been too boring.

In assessing what I have done here, I'm particularly happy with the extension of the light shape from the deck house to the rooftops on the dock, giving me a shape that is now wider than long. Without it, the original light shape (the boat only) would have been too close in height and width. On the other hand, I wish I had made the mid-value water surrounding the boat a little darker, so that the large, light shape would be more easily read.

On a slow summer afternoon in the Beartooth foothills in Montana, I found a weathered pine whose top had been removed—by a lightning bolt, I'd guess. It gave this old veteran a bit of character that made it stand apart from the rest, while its rough texture contrasted in an interesting manner with the round rocks strewn about its base. So I did a felt-tip pen sketch of it on a large paper, similar to those described previously (see 1, next page). Some

1

The value sketch was done from a detailed drawing done on location. It shows a small light shape within a larger dark in a mid value field.

months later, I pulled it out in the studio and attempted to express what I had seen, in a painting. As usual, my first step was to make a series of value sketches, and I settled upon the one shown left (2). Because it would fit more easily, I picked E from Group II (see page 68): a small, light shape within a larger dark in a mid-value field.

The light piece would be the tops of a few of the sunlit rocks, joined to the light lower tree trunk. The dark would be the rest of the tree joined to a stand of background trees, and all the rest would be mid value. I wanted to make the dominant texture soft, so after a light preliminary drawing, I wet the entire sheet of 140-pound cold-pressed paper. Since I also wanted

2

I flooded a wet sky area with color, grading it from darker on the right to warmer on the left.

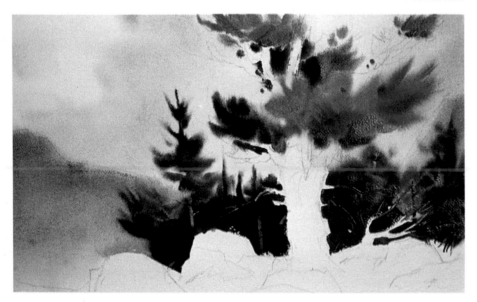

3

Since I wanted the dominant texture to be soft, I added the background mountains and dark foliage while the sky was still wet.

4

Since the dark shapes formed the hard contour of the rocks, I used the "core of the shadow" and "lift" techniques to express their roundness.

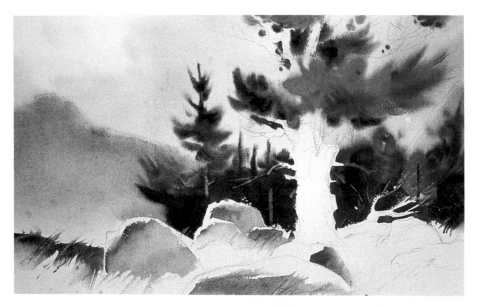

hard texture at the top edges of the rocks and at both edges of the trunk, I dried those areas with a wad of facial tissue. Working rapidly, I flooded the wet sky area with slightly grayed blue hues. I graded it darker on the right, then dropped in a little warm raw sienna near the left horizon for variety. Since the paper was still very wet, these blended into a smooth transition from light to darker, warm to cool. While the sky was still wet, I painted in the background mountains with slightly darker, slightly grayer blue, painting dry on wet so I wouldn't lose the shape (see chapter 2). Then I went directly to the dark shape to establish my darkest dark so I could key my darkest mid values to it, that is, keep them lighter so the dark shape would "pop." I also wanted to get it in while the paper was still wet so the edges would be soft (3).

Look at how much lighter the sky is now compared to the same sky when it was very wet in the preceding step. A wet wash on wet paper always dries somewhat lighter. You can see the same phenomenon in the sky of the previous painting.

Next I painted the rocks. Since the dark shape formed the contour of most of the rocks with a hard or rough edge, which is the label for "rock," I could now express the smooth roundness of the rocks with soft texture in the interior and at the same time describe their sunlit surface with back lighting. I did this with the "core of the shadow" and "lift" techniques explained in chapter 11 (4).

Since the paper was now dry, I

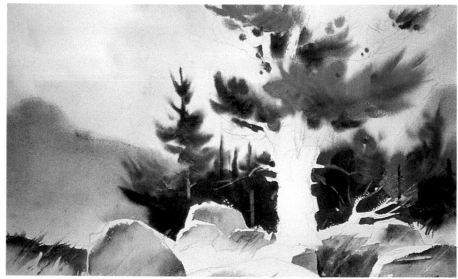

5

Then I filled in the foreground and the rocks on the right at the same time forming the light shapes shown here as white paper.

rewet the rocks. Leaving the top of the rocks white paper to give the illusion of bright sunlight, I painted the core a dark blue, since the top of the light rock reflects the blue sky. This was graded to a warmer, lighter hue as it descended the face of the rock to give the illusion of light reflected off the ground—which is always warm.

Now I filled in the foreground and the rocks on the right, at the same time forming the light shape that is shown here as white paper. Since I had painted the dark shape earlier, and I knew the light shape would be very light—even white, I knew exactly the range of values I could allow this area: it had to be

mid values that were darker than this light shape and lighter than the dark shape (5).

Aside from this, I was careful to make this light shape oblique, with two different dimensions and plenty of "incidents" along its edges. I also made this mid value a little darker where it formed the light shape, to make it easy to see.

Although the light shape is interesting enough, above, it is too near the same size as the dark shape and is about as high as it is wide. Both problems are easily solved by darkening the top portion of the tree trunk where it is shaded by its foliage, grading it to a lighter value at the bottom where the light is re-

flected from the ground. Then my light shape is reduced in area and height while the width remains the same.

I rewet the entire trunk with clean water, then in one wash, flooded in a dark, cool hue at the top, grading it lighter and warmer as it descends the trunk. The left side of the trunk was left white paper to show the direction from which the light is coming.

I finished the painting with bits of calligraphy in the foliage of the large tree, describing the smaller limbs and branches. Some texture was added to the trunk, and the long shadows from branches were also added. More line work went into the foreground with weed symbols to balance the calligraphy elsewhere. A very little splatter was added to the rocks and foreground for more entertainment in areas that were otherwise too plain (6).

I am happy with the train of light that bounces across the rocks and up the side of the tree trunk (the light shape), and that I succeeded in making the dominant texture soft. But I wish I had been more varied with the warms; the warm hue of the lower part of the rocks is the same as the lower tree trunk, for instance. A red-brown in one would have been better.

Broken Tree,
15"x22"

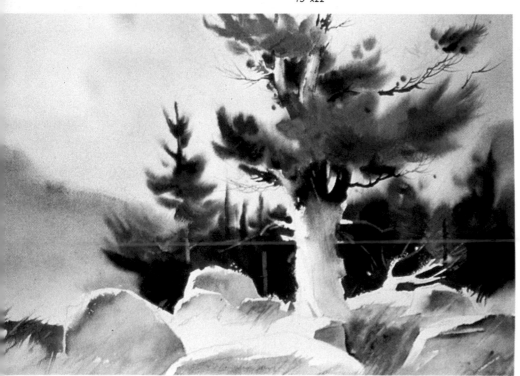

6

Some splatter and calligraphy, added for more entertainment in areas that were otherwise too plain, finish the painting.

Color Gallery
A Selection of Useful Examples

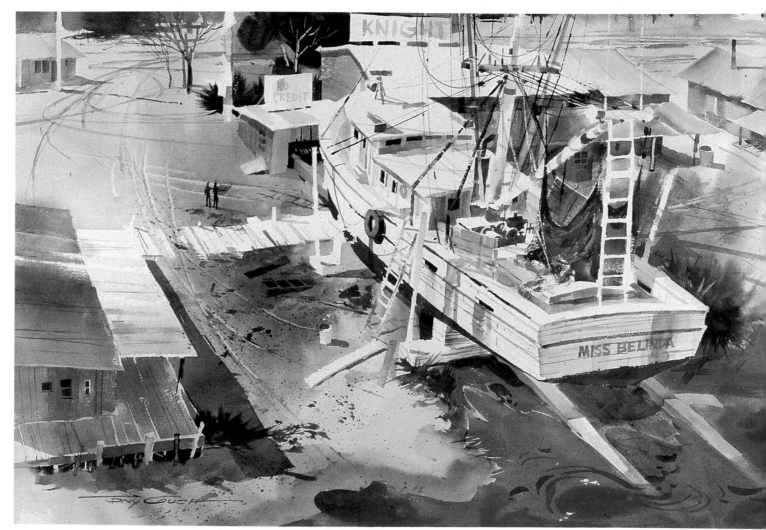

Miss Belinda,
32″ × 40″

On these final pages are a group of my own paintings with a few words about where I think I succeeded and where I failed. I also included most of the value sketches from which they were painted.

Following this group are paintings by other artists whose work I admire.

Lavender Green,
15"x22"

The vertical directional dominance is easy enough to see, but it took an abundance of vertical shapes and lines to counter the strong thrust of the horizontal paper. Notice the arbitrary vertical brush stroke in the lower left to relate that area to the rest of the painting.

The color dominance is warm, with the large area of warm green contrasting with the bits of blue-purple in the sky and tree trunk. As discussed in chapter 5, the shape dominance is the tree shape, and the dominant texture is soft.

The dark top of the large foreground tree is a little unnatural; I could have made it a more believable cast shadow by rewetting the area and wiping out a few soft, light spots that would appear as bits of light peeping through leaves.

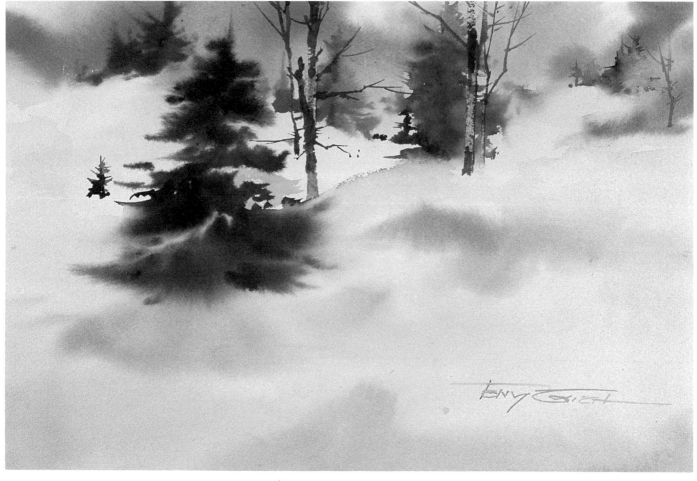

Snow Sentry,
11"x15"

Here I want to express "snow," which is best done with a dominance of soft texture and cool color and which I think I accomplished in this painting. I have a few contrasting warms in the thin hardwood trees, which also provide a hard-texture contrast with the rest of the painting. The horizontal directional dominance, which is provided by the horizontal dimension of the paper and the horizontal line of the background trees, is contrasted by the vertical trees in the foreground and mid ground.

The strong point of this work, however, is its simplicity.

Bonnie Jean,
22"x30"

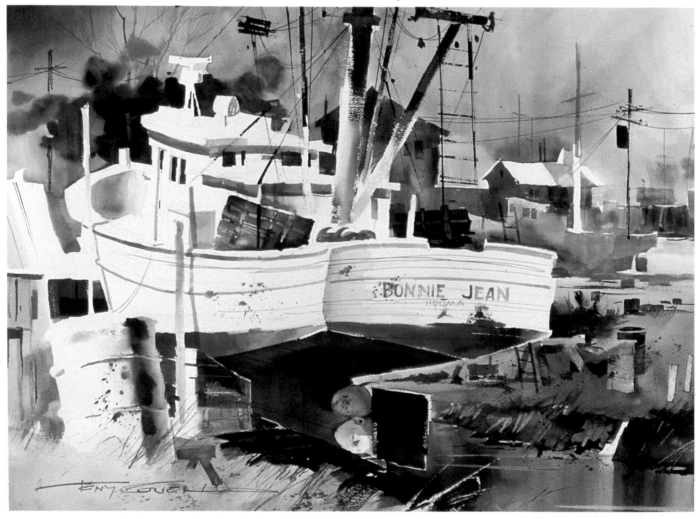

From the small value sketch, you can see that the value pattern I attempted here is D of Group II (see page 68): a large light shape on a mid-value field. In the finished painting, this light shape is fairly easy to see, but I wish I had made the mid value a little darker in the lower left to make the light shape read more clearly there.

I left the rooftop of the distant building on the right white paper as a repeat in that area of the light shape to aid unity. The sky was graded dark on the left to lighter on the right in order to provide interest in an otherwise boring area, and I invented various proportioned dark shapes around most of the perimeter of the light shape (the boat) to ensure it would "pop" against the mid value.

Eagle Pass,
15"x22"

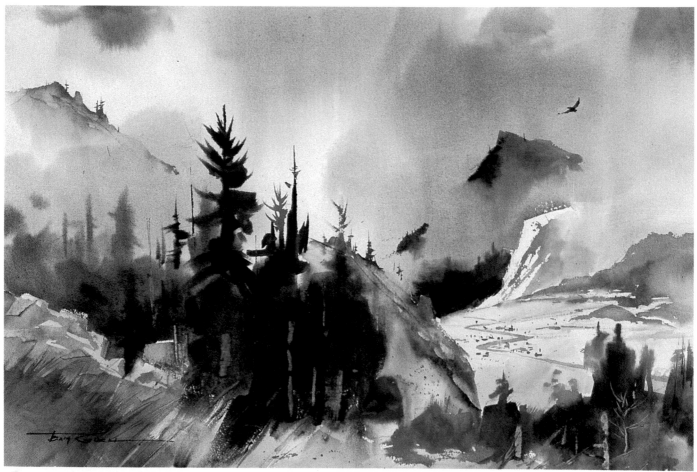

In the value sketch, my plan for this painting was value pattern E of Group II, the dark being the trees and distant mountain on the right and the light being the sunlit valley.

In the painting, this pattern is fairly easy to see, but a darker mid value would have made the light piece more dramatic, telling the story of a shaft of sunlight lighting the valley. The height of the light shape is also too close to the width—a boring shape. These are things I might have avoided had I taken more pains with the value sketch.

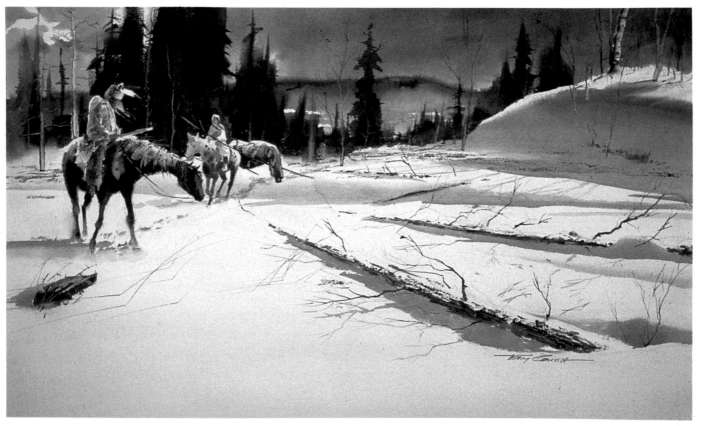

Mobile Society,
19"x30"

The value pattern for this painting is a large dark in an overall mid-value field C of Group II. In this case the mid-value field ranges from very light—white, in fact—to about a 4 mid value. Since the white paper does not form a shape, it joins the mid-value field. The dark shape is the group of fir trees in the background and the two figures on horseback. These figures are lighter at the top so they will read against the dark trees. The dominance of cool hues and soft texture again expresses "snow." The dominant direction is horizontal with contrasting verticals in the upper part of the painting. A vertical repeat or two in the lower part would be an improvement.

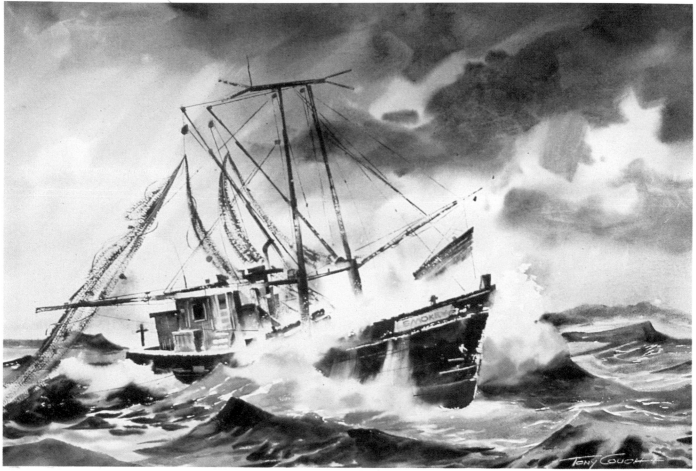

Smokey in the Rough,
22"x30"

As the value sketch proves, what I was after here is a small light shape within a larger dark in an overall mid value (Group II E), but what I ended with in the painting is something else. The upper right sky is darker than I intended, as are the waves, all of which are too close in value to the ship, which was the original dark shape. Still, the light shape holds together with a light repeat in the sky, and the dark foreground waves are close enough to the ship to join it in one large dark shape, albeit not the one I intended.

Aside from this, I think it is one of my more successful paintings, giving the feeling of a rolling ship in crashing waves and flying spray that is often the shrimp fisherman's lot.

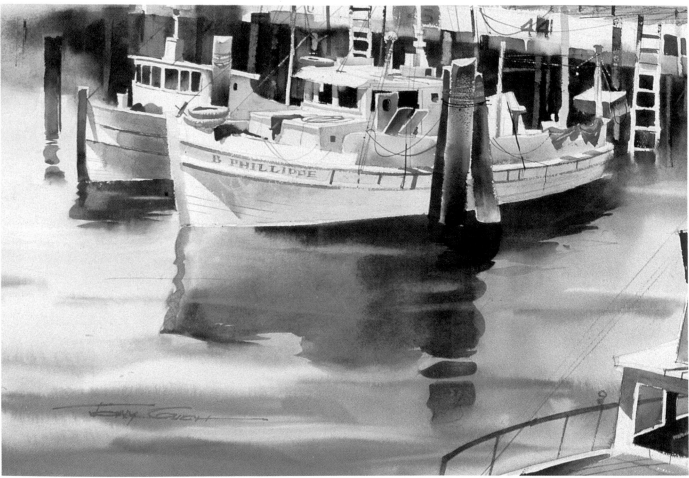

Phillippe,
15"x22"

The large light shape in a mid-value pattern (D, Group II) is easy enough to see, both in the value sketch and in the painting. The dominant shape is easily the tuna boat, reinforced by the second, smaller boat alongside. The dominant direction is horizontal, thanks to the horizontal shape of the hull, the horizontal waves in the foreground, and the horizontal dimension of the paper. And there are contrasting verticals: the ladders, pilings, and the lone vertical reflection into the foreground, which relates the bottom of the painting to the top. The color dominance is warm with contrasting cool shadows in the boats. Note the small section of another boat in the lower right: this also relates the bottom to the top and keeps the painting from appearing top-heavy.

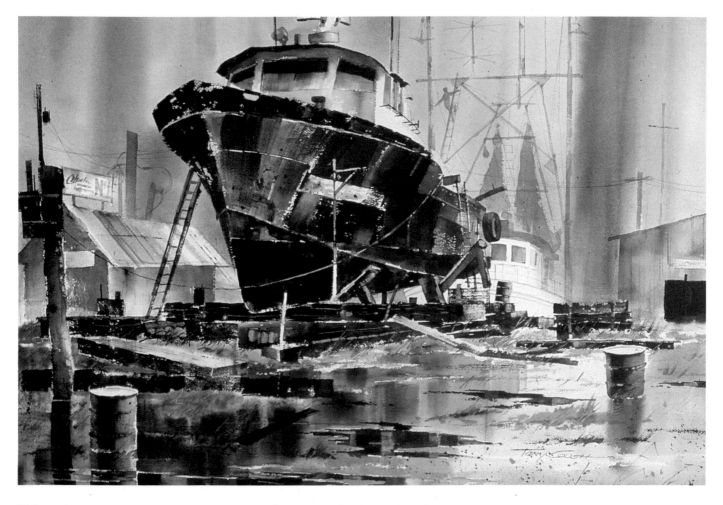

PT Conversion,
22″x30″

There is no doubting that the PT boat is the dominant shape in this painting after the repair job discussed on page 81. The dominant direction is vertical, but the horizontals come close to challenging that dominance. The color dominance is easily warm; brown in fact. Although dull chroma may describe a shipyard on a rainy day, I think color balance in chroma requires a touch or two more of bright color in this painting.

The value pattern is a small light (small boat) in a larger dark (big boat) in an overall mid value (E, Group II). I would have been better off moving the light shape to the other end of the big dark boat, resulting in the lightest light against the darkest dark at the center of interest, which is at the bow.

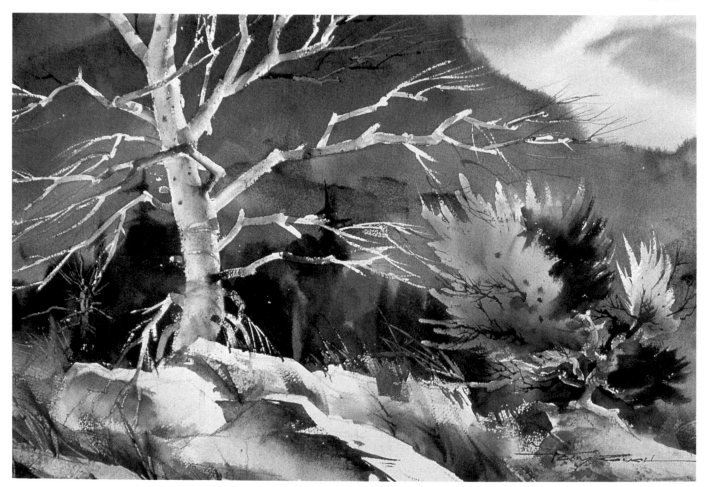

The value pattern, although hard to pick out, is a small dark shape in a larger large light shape in an overall mid value (F, Group II). The light piece is the large dead tree joined to the sunlit rocks below it. The dark shape is the stand of dark green pine behind it. Although I am happy with the effect of bright sunlight on the tree and rocks, the overabundance of hard-edged shapes in the foreground is a bit boring. While hard texture at the edge describes "tree" and "rock," so does rough texture, and more of that at the edges would have added more variety to the foreground.

The mesquite bush at the right, particularly, could have been done with more rough or even soft edges.

Rock and Roll,
22"x30"

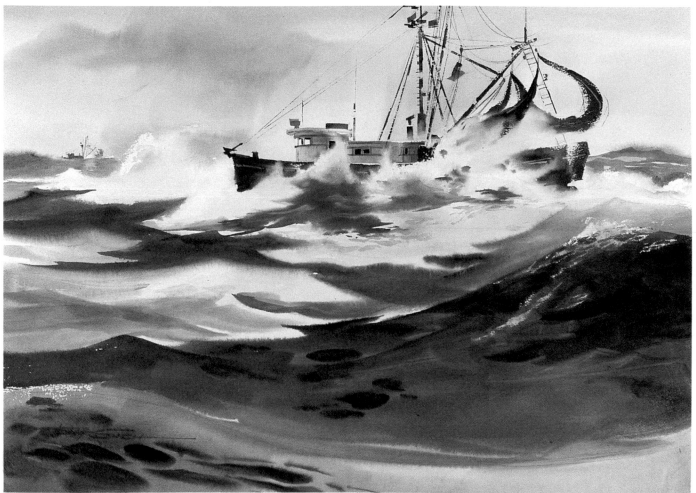

In my value sketch, you can see that the plan was a small dark shape (the ship) in a larger light shape (the foam and spray surrounding the ship) in an overall mid value, or pattern F of Group II.

In the value sketch, I saw that the dark shape was too close to the same size as the light shape and made a mental note to make the light shape larger in the painting. In the painting, you can see things didn't work out quite that way. The foam and the ship are still about the same size, so I darkened the waves in the mid ground and attached them to the dark ship, making a larger dark shape (waves and boats) and leaving the smaller original light shape. Result is value pattern E of Group II. Unfortunately, in the heat of battle, I also made the foreground wave dark.

So, although I consider this one of my better marine paintings, it would have been more successful if that foreground wave remained mid value.

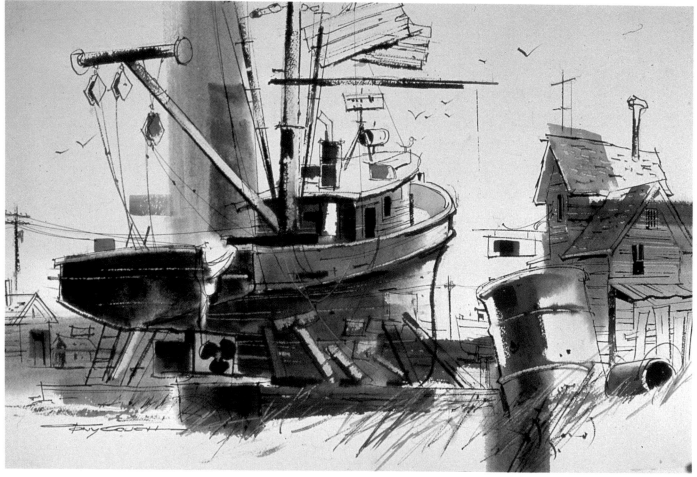

Jackie's Pick,
15"x22"

Jackie's Pick is a vignette, which is a shape or collection of shapes surrounded by white paper—a design made popular by commercial artists. Vignettes are a departure from traditional painting and do not fit into any of the value patterns covered in this book. Rather they are simply a mid-value shape surrounded by white paper with extensions running off the edges so as to divide the surrounding white into various sized rectangles. Within this mid-value shape are small, darker shapes.

Jackie's Pick is also done in "line and wash," a technique which makes maximum use of the exciting contrast between line and shape (wash). Care must be taken that either the line or wash is dominant; here, it is the line. Notice that, although the wash roughly follows the line, it often forms shapes of its own, as does the line.

First Flight,
15"x22"

Here the value pattern is a small, dark shape—the cockpit, within a larger, light shape—the aircraft, within the overall mid value (F of Group II).

There are several light repeats of the light shape in the clouds—too many, perhaps. If there were fewer—only one, even—the light shape of the aircraft would be more easily seen.

The aircraft was done with gouache, an opaque watercolor, and the sky with the usual transparent watercolor. I used gouache because it produces a "satin" texture which more closely resembles painted metal and because there was considerable detail to go into the airplane.

The sky was done almost entirely in soft texture as that is the label for "clouds." The exception is the small piece to the right of the tail that is rough, for a touch of texture contrast.

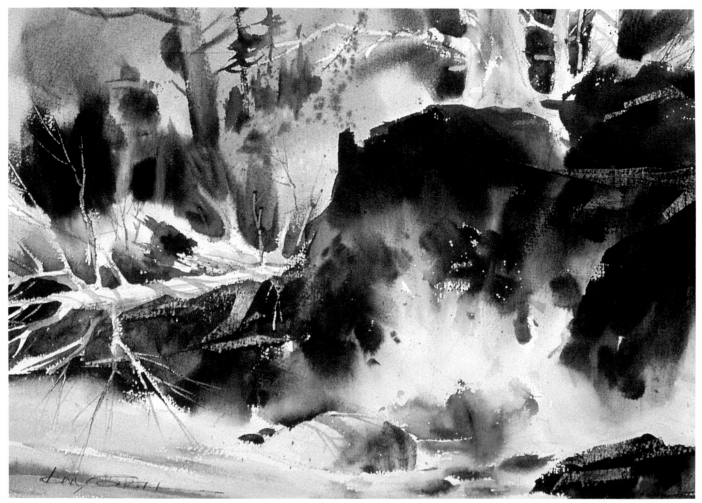

Cold and Swift,
15"x22"

From the value sketch, you might see that my intent was to produce a small light (the spray) against a large dark (the large rocks) on a mid-value field, which is value pattern E of Group II.

In the painting, you can see I did that all right, but I also left almost the same size light piece at the top in the trees directly above the dark rock, and again in the fallen tree in the lower left. This produces not one, but three interesting light-against-dark areas! We can overlook the spot at the top as there is less detail there. But the tree at the left has more detail and just as much value contrast as the spray at the right, making it challenge the spray as the center of interest. A more successful painting would have had the fallen tree in the same area as the spray, so there would be only one center of interest.

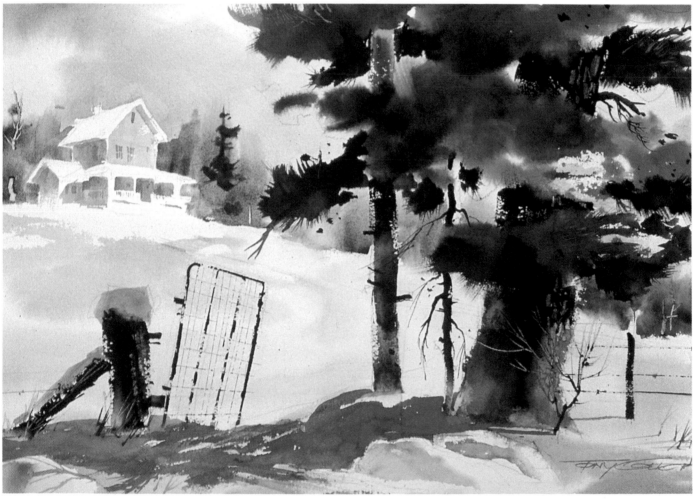

Entrance,
15"x22"

Here is a fast-reading value pattern: a large, dark shape upon the overall mid value; see C, Group II. The large dark shape is the foreground trees, cast shadow, and large post that supports the broken gate.

The painting has a cool hue dominance, but some contrasting warms at the base of the foreground trees and in the foliage. There is maximum use of soft texture along with the cool dominance, since I am expressing "snow." The rough texture is reserved for the foreground tree trunks and fence posts, as that texture best expresses "tree trunk." Note the house in the background, which was effected with as few strokes as possible, no detail, and with values close together. This is so the house will not compete with the foreground trees and gate as the center of interest.

At the Top,
15"x22"

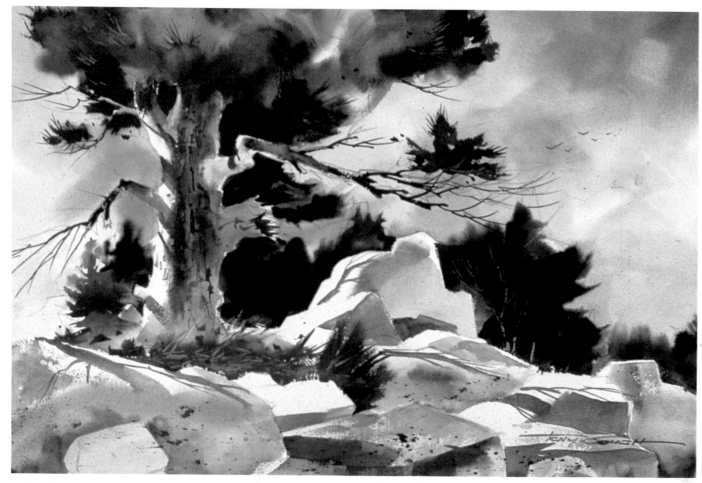

In the value sketch, I was after a small, light shape (rocks around the tree) against a larger, dark shape (foreground tree and background trees), on an overall mid-value field, or value pattern E. I knew that if I lost the light shape, I would still have a simple dark shape on a mid-value field, which is value pattern C.

In the painting, I did indeed keep the light shape on the sunlit side of the rocks and large tree. The painting has a cool hue dominance, but I'm afraid it is challenged by the warms. I used the same blue throughout: the purple-blue ultramarine. I could have obtained more variety by also using the green-blue Prussian blue—in the sky, for instance. I was careful to keep the texture at the edge of the rocks hard with a little rough, as this best describes "rock," but the area is so large I could have afforded a touch of soft texture, which would have added variety without sacrificing the overall feeling of rock.

In the value sketch, you see I attempted a large, light shape (the ship and surrounding foam) in an overall mid-value field; value pattern D.

In the painting, I succeeded in doing that. While painting the sky, I left a light shape on the left, intending it to be an isolated light repeat to my light shape, related obliquely to it. Instead it joined the light shape, making it larger than I intended. Still, the light shape is smaller than the overall mid value, so I left it there.

I kept the sky quiet to make the sea more dramatic by contrast. I varied the dominant cool hues by using the purple-blue (ultramarine), the blue-green (Prussian blue), and purple in the sea. I wish I had been more convincing with the burst of spray at the bow. A little rough texture at the left edge would have done it.

Foam,
by Edgar A. Whitney, ANA, AWS

Here the subject is spray as the sea crashes against the immovable rock of a seacoast. Notice how simply and effectively the spray is expressed by giving this shape soft texture, with a bit of rough here and there at the edges for variety. The illusion of a tossing sea is effected in an entertaining fashion by providing three different heights to the spray shape, which contrasts with the flat sea beyond.

The sky, although subdued to lend drama to the violent sea, is still entertaining because of the variation in value and the overall gradation from dark at the left to lighter on the right. Contrasting with the cool, soft foam and spray is the solid, warm rock, which has, of course, hard texture with a little rough texture at the edge. The value pattern can be read from twenty feet away: small dark in a larger light on a mid-value field.

Pittsburgh's Market Square,
22" × 30"
by Frank Webb, AWS

The staccato of the many small shapes, combined with the sharp value contrast and splashes of bright color makes this an exciting watercolor and produces the illusion of the hustle, bustle, and noise of a busy downtown marketplace.

Still, there is order in this well-designed piece: the riot of color is organized into a dominance of yellow-orange. There is sharp value contrast, yet most of it occurs under the canopies in the lower left, with a minor repeat around the sign at the top. There is less value contrast elsewhere, avoiding confusion with the center of interest under the canopy. The directional dominance is easily oblique, which best expresses the activity of this busy scene.

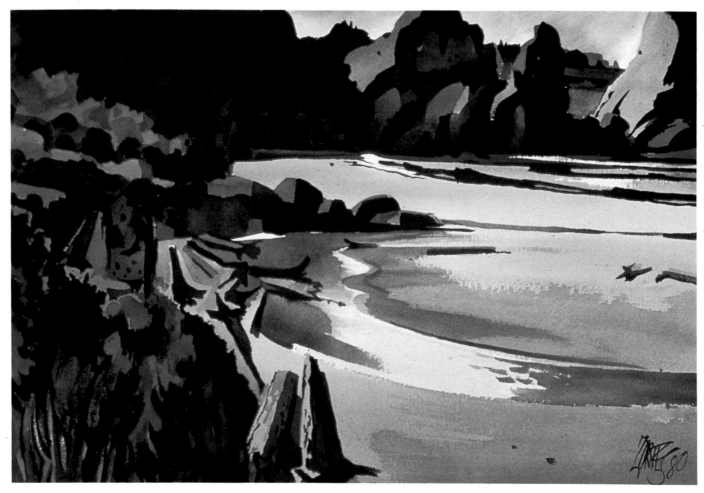

Oregon Coast
22" × 30"
by Milford Zornes, ANA

The beauty of this painting is apparent in its simplicity and powerful, sure marks. The fast-reading value pattern is a simple dark shape (the rock formations) upon an overall mid-value field, pattern C.

The color dominance is easily warm, in fact it is yellow-orange. Entertainment is provided by the contrasting blues in the sky, sea, and puddles. Note the variety in these blues: purple-blue in the sky, green-blue in the sea, and a gray-blue in the puddles.

Attention is directed to the center of interest at the lower left with the clutter of rocks, tree trunks, and foliage, plus sharp value contrast. It is kept there by the contrasting calm elsewhere in the painting. For the sake of unity, there is an oblique repeat of the rock shape and clutter in the upper right.

Silver and Black,
22" × 30"
by Robert E. Wood, ANA

About this painting, Bob Wood writes: "I find I face the same problems painting figures as I do with landscapes. Certainly the human form demands a degree of drawing ability, whether handled abstractly or realistically, so that one need not 'fake it.' However, I find the primary challenge in constructing a figure painting is creating luscious lively paint, of presenting a dramatic composition of shapes, and of establishing a mood and unique color quality that is outside my practiced vocabulary. These are the same struggles I face in approaching any subject."

Homestead,
22" × 30"
by John A. Neff, AWS

There is no doubting that the house is the dominant shape, with the buggy joining it as part of the center of interest. The attractiveness of this painting, as with Milford Zornes's, lies with its simplicity and the sure, crisp marks—particularly at the edge of the shapes.

Something else is worth note here: the subtle way in which John Neff "walks" us back in depth: although the entire painting appears to be in the foreground, still the overhead branch is in the near plane and points to the buggy in the next plane. The buggy then points to the house in the more distant plane, which is surrounded by the soft hint of foliage in the plane most distant.

Mutual Love,
15" × 22"
by John Droska

Simplicity again wins the day in this striking painting. Who could miss the dominant shape here? In contrast, the tiny butterfly flits about on the left. The dominant color is warm, with a contrasting bit of cool blue on the figure's left shoulder and in the arbitrary vertical brush stroke on the extreme right of the painting. The green of the dress also contrasts with the red headpiece.

Notice the oblique tilt of the figure; this is certainly more interesting than the static effect of a figure done vertically. Although we scarcely notice the background, Droska was careful not to leave it a boring, blank white field. Rather he "whispered" here and there with soft, very high-key, warm color, so it *appears* white, but is still entertaining.

Reflections,
22″×30″
by Paul Grant

Paul Grant lives in Michigan and spends considerable time fishing in the many lakes there. In this painting he takes us to his favorite spot and shows us what it is like fishing in the late afternoon. The mood is set with the mist on the left, the quiet water, and the lone fisherman.

Also, as we saw on page 69, this is a good example of the rare gradation value pattern. In this case, the light values on the left gradually become dark on the right as they move across the breadth of the painting.

The dominant direction is horizontal, thanks to the horizontal dimensions of the paper, the horizontal stand of trees, and the horizontal boat at the center of interest. But there is good oblique directional contrast in the direction of the foreground water, which runs counter to the direction of the mist, also oblique.

Ship Painters,
22" × 30"
by Robert Wade

Here Bob Wade tells us about the drama and bustle of ship repairs at his native port of Melbourne, Australia. Although the painting is simply done with rectangular shapes, the activity and excitement of a busy shipyard is conveyed by the dangling figures and lines, stark value contrast and ever-changing color,

and value and texture.

The painting is divided into three rectangulars: the sky, the upper hull of the ship, and the lower hull. Notice that Wade is careful to vary the widths of these three. The even spacing of the figures is disguised by the variety in distance between them, the vertical lines around

them, and the variety of distance between the lines, themselves.

We are entertained also by the contrast of the yellow-orange rust against the gray-blue of the lower hull. This same yellow-orange is repeated in the two upper rectangles, which helps make this work a unit.

Bibliography

Barr, Alfred H., Jr. *What is Modern Painting?* New York: Museum Modern Art, 1943.

Betts, Edward. *Master Class in Watercolor.* New York: Watson-Guptill, 1975.

Bradbury, Charles Earl. *Anatomy and Construction of the Human Figure.* New York: McGraw-Hill, 1949.

Brandt, Rex. *Watercolor Landscape.* New York: Van Nos Reinhold, 1953.

Brandt, Rex. *Watercolor Techniques and Methods.* New York: Van Nos Reinhold, 1977.

Bridgman, George B. *The Human Machine.* New York: Dover, 1972.

Carlson, John F. *Carlson's Guide to Landscape Painting.* New York: Dover, 1973.

Claus, Karen, and R. James. *Visual Communication through Signage.* Cincinnati, OH: Signs of Times, 1976.

Croney, Claude. *My Way with Watercolor.* New York: Watson-Guptill, 1973.

Dobkin, Alexander. *Principles of Figure Drawing.* Cleveland, OH: World, 1948.

Edwards, Betty. *Drawing on the Right Side of the Brain.* Los Angeles: Tarcher, 1979.

Fitzgerald, Edmond J. *Marine Painting in Watercolor.* New York: Watson-Guptill, 1972.

Galbally, Anne. *Arthur Streeton.* rev. ed. Melbourne, Australia: Lansdowne Editions, 1979.

Graves, Maitland. *The Art of Color and Design.* New York: McGraw-Hill, 1951.

Henri, Robert. *The Art Spirit.* Philadelphia: Lippincott, 1923.

Jamison, Phillip. *Capturing Nature in Watercolor.* New York: Watson-Guptill, 1980.

Kautzky, Ted. *Ways with Watercolor.* New York: Van Nos Reinhold, 1963.

Kautzky, Ted. *The Ted Kautzky Pencil Book,* New York: Van Nos Reinhold, 1979.

Lauer, David A. *Design Basics.* New York: Holt, Rinehart & Winston, 1979.

Lindsay, Norman (Edited by Lin Bloomfield) *The World of Norman Lindsay.* Melbourne, Australia: The MacMillan Company of Australia Pty. Ltd.

McDonogh, Jack. *An Approach to Landscapes in Watercolour.* Australia: Whitcombe & Tombs Pty. Ltd., 1979.

Munsell, Albert H. *A Color Notation.* 10th ed. Baltimore, MD: The Munsell Color Company, 1954.

Pike, John. *John Pike Paints Watercolors.* New York: Watson-Guptill, 1978.

Prohaska, Ray. *A Basic Course in Design.* Westport, CT: North Light Pub, 1980.

Reid, Charles. *Portrait Painting in Watercolor.* New York: Watson-Guptill, 1973.

Schider, Fritz. *An Atlas of Anatomy for Artists.* 2d rev. ed. New York: Dover, 1954.

Schmalz, Carl. *Watercolor Lessons from Eliot O'Hara.* New York: Watson-Guptill, 1974.

Stanton, Reggie. *Drawing and Painting Buildings.* Westport, CT: North Light Pub, 1978.

Szabo, Zoltan. *Landscape Painting in Watercolor.* New York: Watson-Guptill, 1971.

Taubes, Frederick. *A Judge of Art: Fact and Fiction.* Westport, CT: North Light Pub, 1981.

Vickrey, Robert. *New Techniques in Egg Tempera.* New York: Watson-Guptill, 1973.

Webb, Frank. *Watercolor Energies.* Westport, CT: North Light Pub, 1983.

Whitney, Edgar A. *Watercolor: The Hows and Whys.* New York: Watson-Guptill, 1958.

Wood, Robert E. *Watercolor Workshop.* New York: Watson-Guptill, 1974.

Self-service,
22″ × 30″

Index

Other Art Books from North Light

Graphics/Business of Art

The Art & Craft of Greeting Cards, by Susan Evarts $15.95 (paper)

An Artist's Guide to Living By Your Brush Alone, by Edna Wagner Piersol $9.95 (paper)

Artist's Market: Where & How to Sell Your Graphic Art (Annual Directory) $16.95 (cloth)

Basic Graphic Design & Paste-Up, by Jack Warren $11.95 (paper)

Complete Airbrush & Photoretouching Manual, by Peter Owen & John Sutcliffe $23.95 (cloth)

Color Harmony: A Guide to Creative Color Combinations, by Hideaki Chijiiwa $14.95 (paper)

The Complete Guide to Framing, by Jenny Rodwell $16.95 (cloth)

Design Rendering Techniques, by Dick Powell $24.95 (cloth)

Dynamic Airbrush, by David Miller & James Effler $29.95 (cloth)

The Graphic Arts Studio Manual, by Bert Braham $22.95 (cloth)

The Graphic Artist's Guide to Marketing & Self-Promotion, by Sally Prince Davis $15.95 (cloth)

Graphic Tools & Techniques, by Laing & Saunders-Davies $24.95 (cloth)

Graphics Handbook, by Howard Munce $12.95 (paper)

How to Draw & Sell Cartoons, by Ross Thomson & Bill Hewison $15.95 (cloth)

Illustration & Drawing: Styles & Techniques, by Terry Presnall $22.95 (cloth)

The North Light Art Competition Handbook, by John M. Angelini $9.95 (paper)

North Light Dictionary of Art Terms, by Margy Lee Elspass $10.95 (paper)

Print Production Handbook, by David Bann $14.95 (cloth)

Studio Secrets for the Graphic Artist, by Graham et al $27.50 (cloth)

Type: Design, Color, Character & Use, by Michael Beaumont $24.95 (cloth)

Watercolor

Basic Watercolor Painting, by Judith Campbell-Reed $15.95 (paper)

Capturing Mood in Watercolor, by Phil Austin, $21.95 (cloth)

Getting Started in Watercolor, by John Blockley $17.95 (paper)

Make Your Watercolors Sing, by LaVere Hutchings $22.95 (cloth)

Painting Flowers with Watercolor, by Ethel Todd George $17.95 (paper)

Painting in Watercolors, edited by Yvonne Deutsch $18.95 (cloth)

Transparent Watercolor, by Edward D. Walker $24.95 (cloth)

Watercolor Energies, by Frank Webb $17.95 (paper)

Watercolor for All Seasons, by Elaine and Murray Wentworth $21.95 (cloth)

Watercolor Interpretations, by John Blockley $19.95 (paper)

Watercolor Options, by Ray Loos $22.50 (cloth)

Watercolor Painting on Location, by El Meyer $19.95 (cloth)

Watercolor—The Creative Experience, by Barbara Nechis $16.95 (paper)

Watercolor: You Can Do It!, by Tony Couch $24.95 (cloth)

Mixed Media

A Basic Course in Design, by Ray Prohaska $12.95 (paper)

The Basis of Successful Art: Concept and Composition, by Fritz Henning $16.95 (paper)

Catching Light in Your Paintings, by Charles Sovek $16.95 (paper)

Colored Pencil Drawing Techniques, by Iain Hutton-Jamieson $22.95 (cloth)

Creative Drawing & Painting, by Brian Bagnall $29.95 (cloth)

Drawing & Painting with Ink, by Fritz Henning $24.95 (cloth)

Drawing and Painting Animals, by Fritz Henning $14.95 (paper)

Drawing and Painting Buildings, by Reggie Stanton $19.95 (cloth)

Drawing By Sea & River, by John Croney $14.95 (cloth)

Drawing for Pleasure, edited by Peter D. Johnson $15.95 (cloth)

Encyclopaedia of Drawing, by Clive Ashwin $22.50 (cloth)

Exploring Color, by Nita Leland $26.95 (cloth)

The Eye of the Artist, by Jack Clifton $14.95 (paper)

The Figure, edited by Walt Reed $14.95 (paper)

Flower Painting, by Jenny Rodwell $19.95 (cloth)

Keys to Drawing, by Bert Dodson $21.95 (cloth)

Landscape Painting, by Patricia Monahan $19.95 (cloth)

The North Light Handbook of Artist's Materials, by Ian Hebblewhite $24.95 (cloth)

The North Light Illustrated Book of Painting Techniques, by Elizabeth Tate $26.95 (cloth)

On Drawing and Painting, by Paul Landry $15.95 (cloth)

Painting & Drawing Boats, by Moira Huntley $16.95 (paper)

Painting Birds & Animals, by Patricia Monahan $21.95 (cloth)

Painting a Likeness, by Douglas Graves $19.95 (cloth)

Painting Nature, by Franklin Jones $17.95 (paper)

Painting Portraits, by Jenny Rodwell $21.95 (cloth)

Painting Seascapes in Sharp Focus, by Lin Seslar $24.95 (cloth)

Painting with Acrylics, by Jenny Rodwell $19.95 (cloth)

Painting with Pastels, edited by Peter D. Johnson $16.95 (cloth)

Pastel Painting Techniques, by Guy Rddon $23.95 (cloth)

The Pencil, by Paul Calle $16.95 (paper)

Perspective in Art, by Michael Woods $12.95 (cloth)

Photographing Your Artwork, by Russell Hart $15.95 (paper)

Putting People in Your Paintings, by J. Everett Draper $22.50 (cloth)

The Techniques of Wood Sculpture, by David Orchard $14.95 (cloth)

Oil Color/Art Appreciation

Encyclopaedia of Oil Painting, by Frederick Palmer $22.50 (cloth)

Controlled Painting, by Frank Covino $14.95 (paper)

Painting in Oils, edited by Michael Bowers $18.95 (cloth)

Painting with Oils, by Patricia Monahan $19.95 (cloth)

To order directly from the publisher, include $2.00 postage and handling for one book, 50¢ for each additional book. Allow 30 days for delivery.

North Light Books
1507 Dana Avenue, Cincinnati, Ohio 45207

Prices subject to change without notice.